Black in White America

Leonard Freed

With a foreword by Brett Abbott

The J. Paul Getty Museum
Los Angeles

Original edition © [1967/68] Leonard Freed
Foreword © 2010 J. Paul Getty Trust
Current edition © 2010 J. Paul Getty Trust
5 4 3 2 1

**Published by the J. Paul Getty Museum,
Los Angeles**

Getty Publications
1200 Getty Center Drive, Suite 500
Los Angeles, California 90049-1682
www.getty.edu/publications

Original edition
Photography, text, layout: Leornard Freed
Design, typography: Josje Pollman

Gregory M. Britton, *Publisher*

Dinah Berland, *Editor*
Stuart Smith, *Designer*
Stacy Miyagawa, *Production Coordinator*

Color separation and press supervision
by Robert J. Hennessey and Sue Medlicott
Printing by Wai Man Book Binding, China

Library of Congress Cataloging-in-Publication Data

Freed, Leonard.
 Black in White America / Leonard Freed ; with a foreword by
 Brett Abbott.
 p. cm.
 Originally published: New York : Grossman Publishers, 1969.
 ISBN 978-1-60606-011-7 (pbk.)
 1. African Americans—Social life and customs—Pictorial works.
 I. J. Paul Getty Museum. II. Title.
 E185.86.F76 2010
 305.896'073—dc22
 2010002036

Foreword

While working in Germany in 1962, photographer Leonard Freed (American, 1923–2006) noticed a black American soldier guarding the divide between East and West as the Berlin wall was being erected. It was not the partition between the forces of communism and capitalism that captured Freed's imagination, however. Instead what haunted him was the idea of a man standing in defense of a country in which his own rights were in question. The experience ignited the young photographer's interest in the American civil rights movement raging on the other side of the globe. In June of 1963 Freed headed back to the United States to embark on a multiyear documentary project, published in 1967/68 as *Black in White America*, that would become the signature work of his career.

More than forty years later the Berlin wall has come and gone, but the issue of race in America remains ingrained in the national conscience. To be sure, America has made progress addressing racial divides since Freed surveyed the situation in the 1960s— the election of a black president being the most recent and significant cause for celebration. Still, in the first decade of the twenty-first century, few could argue that issues of race have disappeared entirely from the country's cultural fabric, and Freed's deep and evocative exploration of America's collective past continues to resonate among today's viewers.

Black in White America is a visual diary with a moral purpose. It is highly personal and socially engaged with an implicit goal of effecting change through communication. While Freed made pictures of important events in the civil rights struggle, including the 1963 March on Washington, he quickly found that his interests lay not in recording the progress of the civil rights movement per se but in exploring the diverse, everyday lives of a community that had been marginalized for so long. Penetrating the fabric of daily existence, his work portrays the common humanity of a people persevering in unjust circumstances. His sensitive and empathetic approach sought not to stimulate outrage but to foster understanding and bridge cultural divides as a means of transcending racial antipathy.

Freed began his project by photographing the African American neighborhoods around New York City, connecting with the community by visiting churches and outdoor religious gatherings, recording life on the streets, photographing people at work and play, and capturing the way in which protests and other forms of activism had become a regular part of existence in the urban environment. The following year he bought a car and traveled through the southern United States, conducting a similar survey. He photographed jails and jazz funerals in New Orleans, an abundance of segregated businesses, religious gatherings, and former plantations on which the descendants of black slaves still lived.

The bulk of *Black in White America*'s running text is drawn from notes that were made by the photographer over the course of his travels. It details, as a diary would, his experiences and conversations with the people he encountered, and it exists alongside the pictures as a parallel evocative medium. The text also works as a part of Freed's larger rhetorical strategy, complicating and adding depth to the circumstances portrayed. Indeed, there is a considerable amount of gray explored in *Black in White America*.

Freed's project was aimed not so much at telling the story of a particular day or week but at relating the contours of an overarching conceptual narrative about racial tensions in America. As such, his work provides a balance to the era's familiar press images of intense strife. Indeed, his book project runs counter to the speed that characterizes much journalistic practice of the 1960s, when television—a relatively new medium that was particularly well suited to telling the news with unparalleled immediacy—became increasingly dominant. His publication marked an alternate approach to reporting on the world—one characterized by a focus on large, deeply rooted issues and timely, rather than immediate, dissemination. Meant to be more than a factual record of a newsworthy subject, Freed's work communicates in evocative ways.

Amid the transformations in the news industry, Freed was at the vanguard of independent photojournalists who found a niche for themselves as the authors of nuanced accounts of socially relevant events that demonstrated a higher degree of visual creativity, complexity, and depth than could be achieved through television and the daily press. From the 1960s onward, variations on this kind of reporting would become increasingly popular in the hands of documentarians interested in engaging the world from a personal point of view.

Freed was fundamentally interested in understanding the world through his photography. In the end we are given a book that describes, both visually and textually and in a remarkably fluid, empathetic, and effective manner, Freed's perception of African American life during one of the most intense social struggles of our times. The J. Paul Getty Museum has renewed Freed's pursuit to come to terms with this crucial period in American history through the publication of this facsimile edition in the hopes that present and future generations might continue to take part in his journey of reflection. The Museum extends its gratitude to Brigitte Freed and Elka Susannah Freed for making this possible.

Brett Abbott
Associate Curator, Department of Photographs
The J. Paul Getty Museum

Leonard Freed (1929–2006) was born in Brooklyn, New York, to a working-class Jewish family. An aspiring painter, Freed discovered his passion for photography while on a trip to Europe in 1953. In 1956 he moved to Amsterdam, where his career began. Working as a freelance photojournalist in the 1960s, he traveled the world, including many trips to the United States to photograph the civil rights movement. He eventually moved back to the United States and continued to pursue photographic projects with socially conscious themes. In 1972 he joined the prestigious photographers' collective Magnum Photos. He published more than fifteen books, including *Police Work*, documenting the New York Police Department's activities in the late 1970s, and several volumes surveying Jewish communities around the world. His work is included in the collections of the International Center of Photography and The Metropolitan Museum of Art, both in New York, and the J. Paul Getty Museum.

Brett Abbott is associate curator in the Department of Photographs at the J. Paul Getty Museum. His previous publications include *Engaged Observers: Documentary Photography since the Sixties; Edward Weston's Book of Nudes;* and *In Focus: Edward Weston.*

'Volumes have been written in defense of slavery, but I have never heard of any of these authors wanting to be slaves themselves.'

Abraham Lincoln, in a political debate

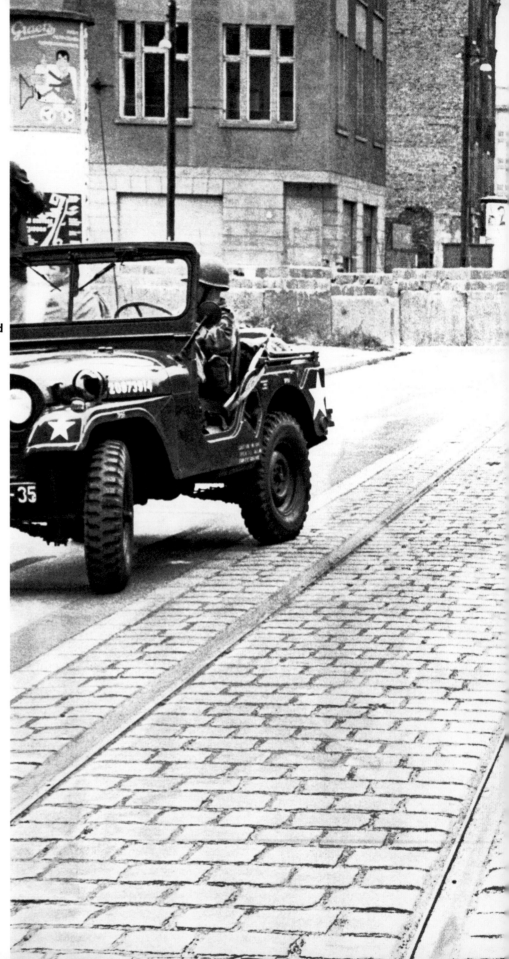

We, he and I, two Americans. We meet
silently and part silently. Between us,
impregnable and as deadly as the wall behind
him, is another wall. It is there on the trolley
tracks, it crawls along the cobble stones,
across frontiers and oceans, reaching back
home, back into our lives and deep into our
hearts: dividing us, wherever we meet.
I am White and he is Black.

Berlin, Germany

In defense of Western Civilization, an
American soldier's hand rests on his gun.

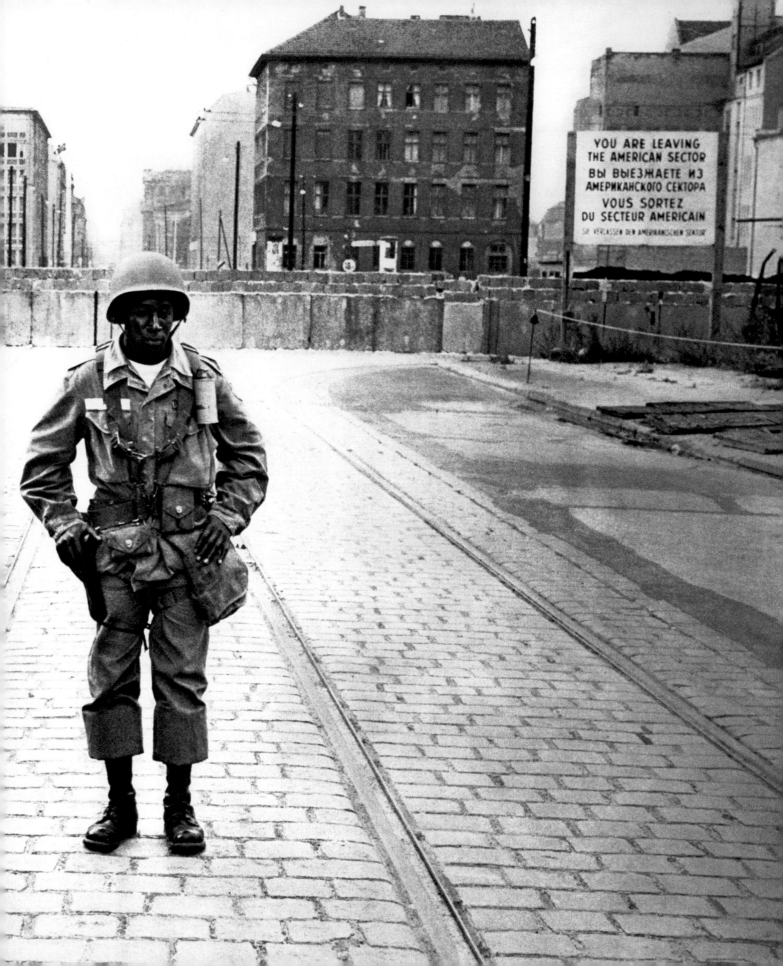

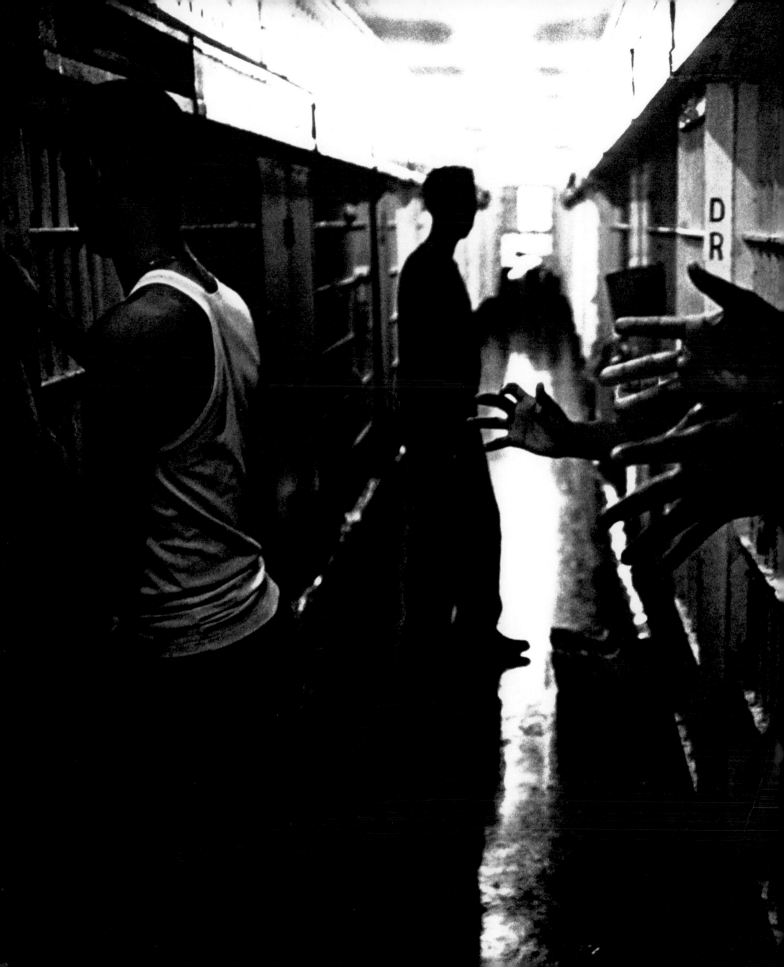

Louisiana, U.S.A.

Printed over the electric door, 'Colored Tier.' The guard said, 'What'd you want wasting time looking at colored?' Hands reached out to me from the cells. 'Help me,' said a voice. 'You, you, I need a lawyer, I been here three months waiting for a trial.' Calling to me as I passed along the cell blocks: '. . . no one knows where I am.' '. . . tell my family where I am.' '. . . you, I am innocent.' Out of the shadows a voice said to me, '. . . I can not live here.' 'It will be a blood bath, yeah, a blood bath.' The guards watched me suspiciously from their office chairs. 'Yeah, a blood bath,' they said to me, 'desegrate this place and it will be blood . . . mixing white men with animals . . . can't make us do that.' The guard said, 'When it gets too crowded in the colored tiers, we try weeding out the hardened homosexuals and separating them from the newcomers.'

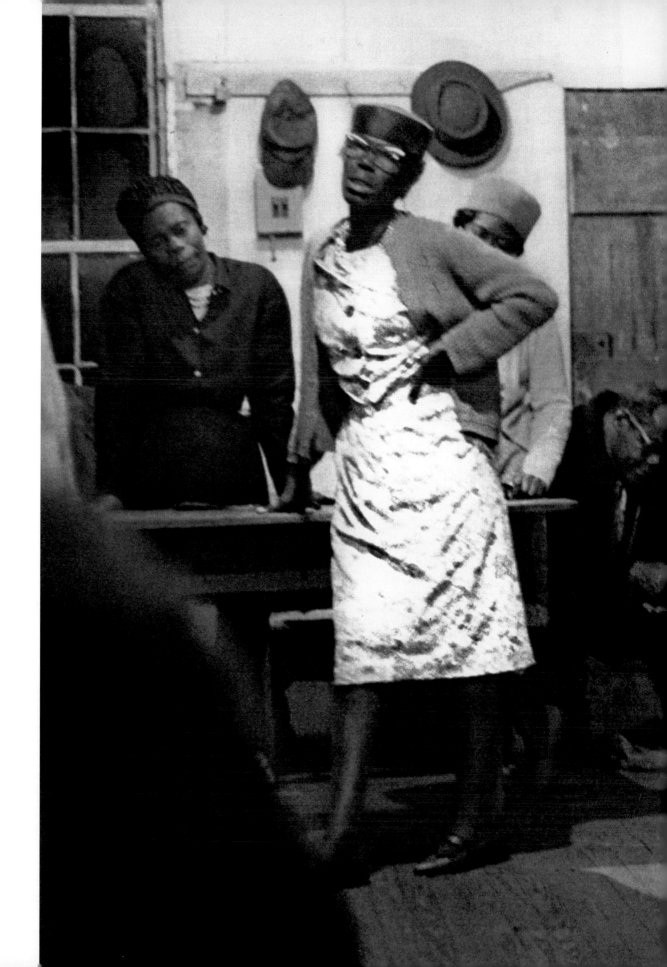

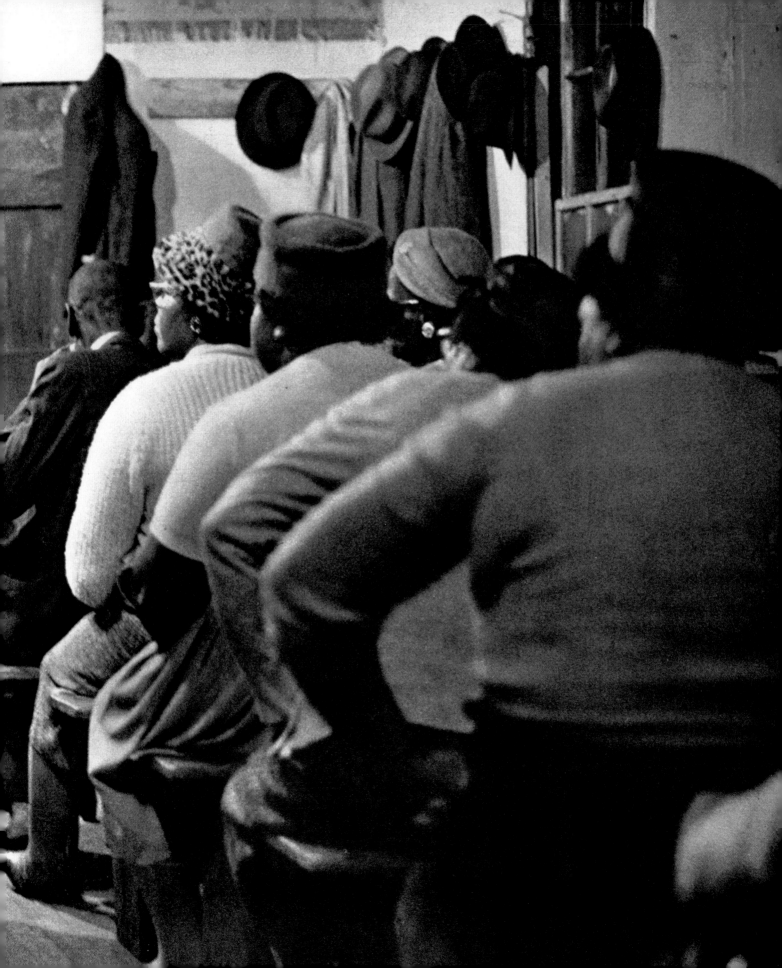

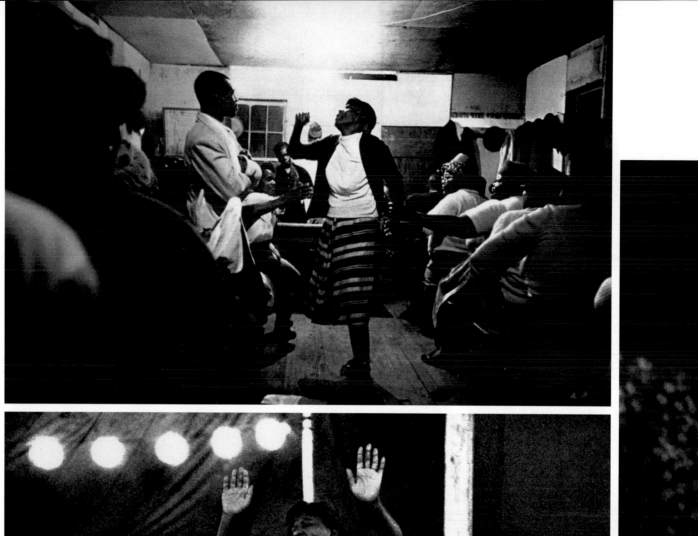

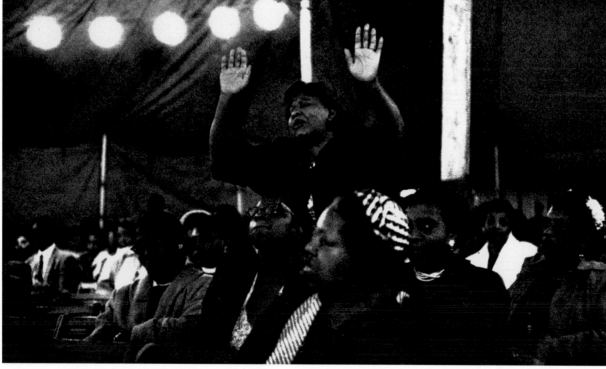

below:
New York

Open Bible Gospel Tent meeting.

p. 10-17:
South Carolina

All night prayer and Gospel meeting at the 'Moving Star Hall.'

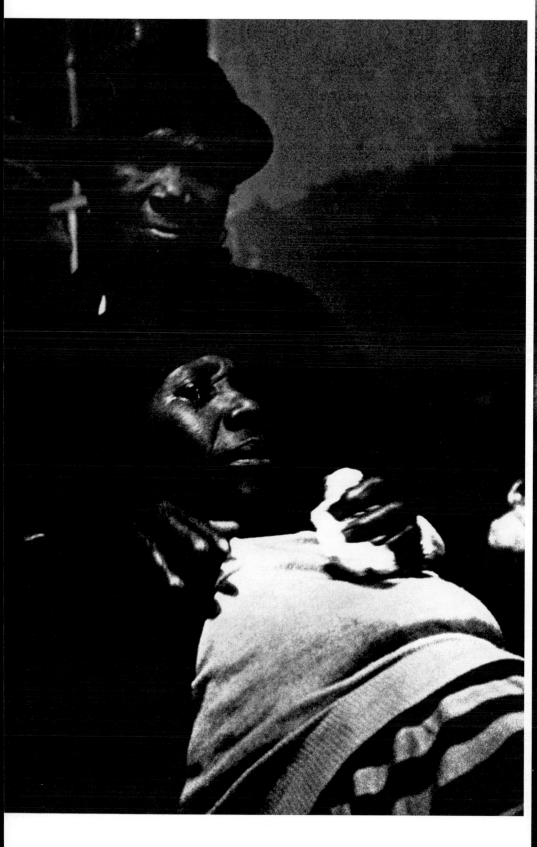

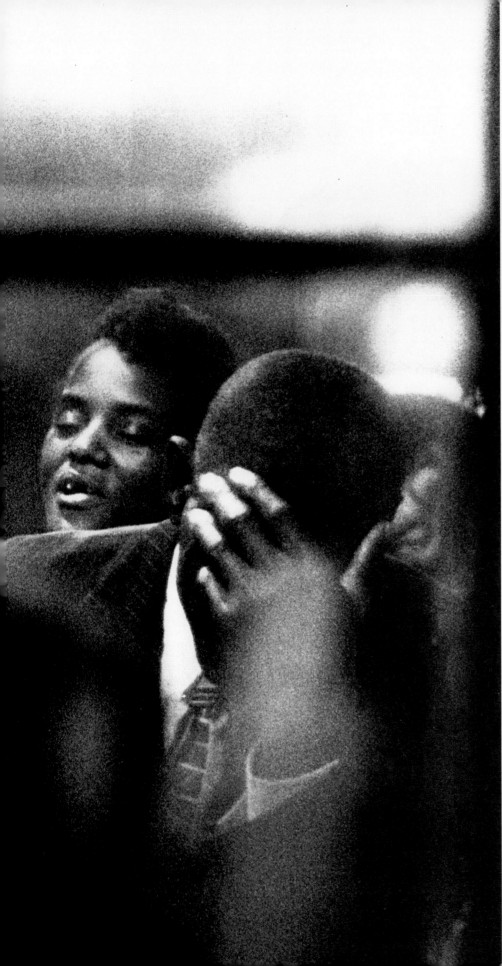

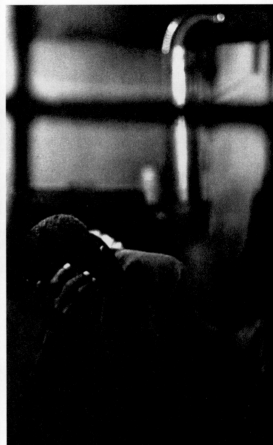

I'm troubled, I'm troubled,
I'm troubled in mind,
If Jesus don't help me I sho'ly will die.

O Jesus my Saviour, on Thee I'll depen',
When troubles am near me, you'll be my
true friend.
I'm troubled, I'm troubled, I'm troubled in mind
If Jesus don't help me I sho'ly will die.

When ladened wid trouble, an' burden'd
wid grief,
To Jesus in secret, I'll go for relief:
I'm troubled, I'm troubled, I'm troubled in
mind,
If Jesus don't help me I sho'ly will die.

from an old spiritual

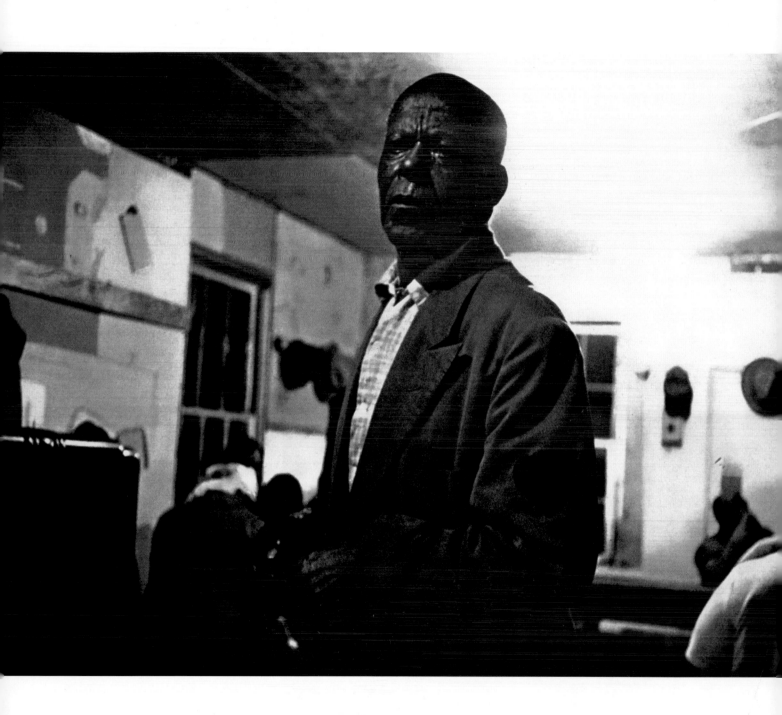

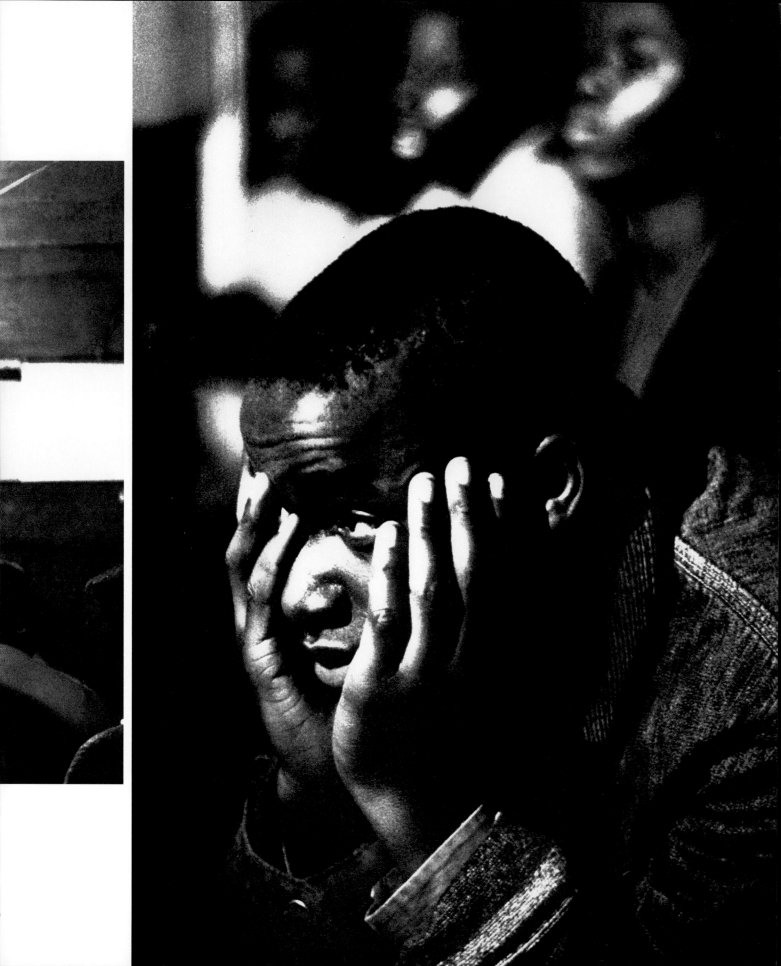

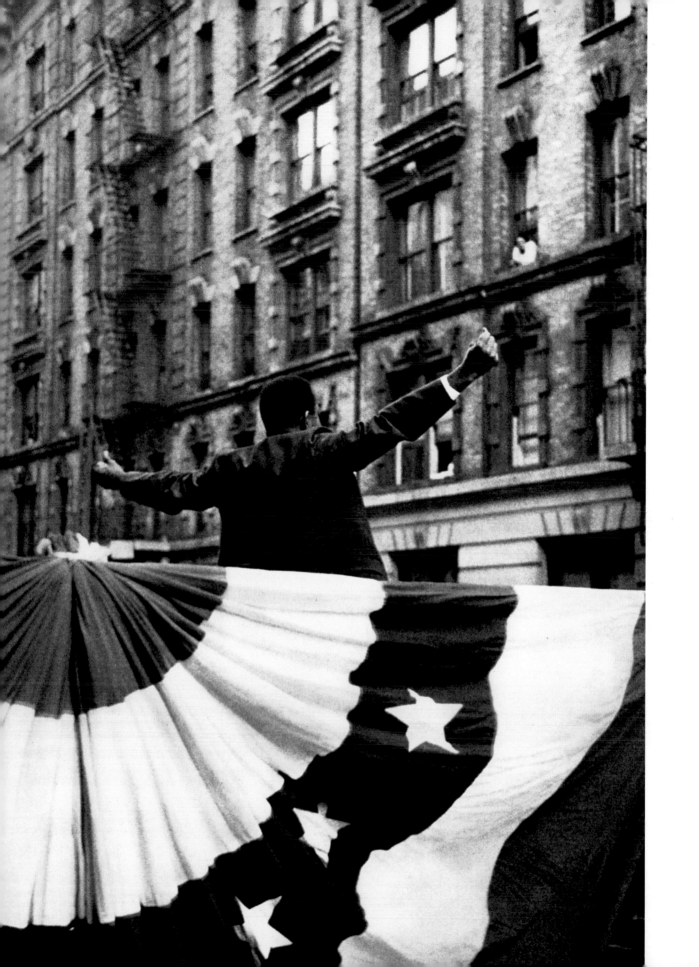

South Carolina, Johns Island

Christmas Eve I rode out into the darkness over lonely dirt roads through jungles of weeping willows and wintered cotton fields and finally stopped. Down the road I could hear the singing, reaching me in this immense solitude. The cotton pickers' cabins could be made out under the willows, and there, under the starry sky – alone in an open field with windows ablaze, the floor being pounded drum-like – was the 'Moving Star Hall.' It rested a few feet above the ground, supported on posts of irregular field stones, a one-room, never-painted, wooden structure.

'Yep, it used to be like that all over the island when I was a kid,' the man was saying. I had told him of my intention to participate in the all night 'Christmas Night Watch.'

'Didn't know it was still done,' he continued, 'T.V., autos and all that have changed things around here. They sing Christmas carols in church now. Kids don't know the old spirituals anymore. Don't even know the old Gullah language.'

Wanting to prove it to me, he called in Gullah to his daughters out in the kitchen. Gullah is what they once all spoke on the island. Because of the generally unhealthy climate and malaria, the white land owners left the slaves alone to run the plantations by themselves. It remained one of the few places where the slaves continued speaking an African dialect.

'Bet you if I went to Africa now, there would be places I could still speak the old language,' he said.

A few years ago some neighbors tried to revive the 'Christmas Watch' but nothing came of it. He remembered that each year it would be in a different church; once for two years in a row a white family came to welcome in the Christ child. They had come from the North and had bought a house down the road.

'Life was hard, the summers was lots of work. Seems Christmas, people danced and sang to last a year. The three Christmas nights and the New Year the people would just shout, sing and dance; it was a time of year you didn't forget. All the folks would be there and then about twenty minutes before midnight, just when the New Year was to come, the lights would be blown out. We'd all kneel on the floor praying. There'd be a man in each of the four corners of the room with a lighted candle and pocket watch. Then, the people would start calling out the "Midnight Watch." One of the four men would read out the time, "Seventeen minutes," he'd say while looking hard at the watch using the candle light, and so till midnight. Then all the lights would go on – we used oil lamps those days – and the people would jump up shouting for joy, and for about an hour or two they'd just go on without stopping, grabbing at one another, shaking hands, kissing, singing, praying, shouting, dancing and calling to one another, "A Happy New Year" – that was New Year's Eve, Christmas Eve it would be more religious – until they were completely exhausted. It was fine and dramatic; wasn't much else to do on the island.'

Now it was three a.m. at the 'Moving Hall' and coffee was being served. They had prayed continually for each other, for those in the hospitals, those up North, those in Heaven and those in jail. They said, 'We pray until the light of day shines, then we know the Christ child has arrived. Then we go home to bed.'

As I left the 'Moving Star Hall,' a few older folks were cleaning up and the sun was shining. It was Christmas morning, and the children were running about showing each other their new toys.

My watch said ten minutes to nine; on the dirt road two little boys came up to me with their new toy guns and shot me dead before the church.

p. 18:

Political meeting in Harlem.

Washington, D.C.

The white-haired lady looked at me and smiled kindly. A sign on the wall behind her said in large letters, 'Central Station Travelers Aid Society.' Her motherly warmth saturated me.

This, my first night in the South, and she, my first Southerner: terrible fears in accumulated layers, acquired from readings, Northern friends and the dread of the unknown quickly left my thoughts as I stood before her.

'I have made arrangements for you to stay at the 'Central Union Christian Mission House'. It's an upper class mission, clean, respectable and only the finer types are permitted within; the room is ten dollars a week.' Then gently meeting my eyes with hers and wanting to indicate the greatest degree of trust, she said: 'You needn't worry, this mission is for whites only.'

'. . . our colored are good folks, we love'm like our flesh 'n' blood.'

heard many times in small Southern towns

Young, well dressed, and charming, she fondled the store owner's dog. 'He is so friendly I would love to take him home with me.' She said she came from York, Pennsylvania, and was down South accompanying her father, who she said was an important man back home. The elderly refined store owner smiled, while the young woman showed photos of her own Great Dane. It was a meeting of minds; they became friendly, discussing the matching of male and female dogs, how best to keep them apart, and other fine points dear to dog lovers.

I went on looking at books and old prints. Through the window tourists looked in and then passed on to the other charming little shops along this street looking for antiques. 'A large dog is a great protection,' the young lady continued. She said she never went out without her dog. Three times her auto was stopped, and each time the dog scared the people away. The elderly Southern lady said, 'Niggers?' And the young lady from the North said, 'Yes.' The conversation became warmer, more personal. They discussed the deteriorating state of affairs in America: how the Negroes were to be seen all over town, the government was corrupt and how it was only through the Nigger vote, the fixing of ballot boxes, and other such crookedness that such people as the President get elected: all this she knew from a congressman who was a friend of her father. The young lady sympathized with the lady from the South and said the situation up North was getting unbelievable. Murders everywhere, the only way to drive through where the Negroes lived was to speed through with locked windows, otherwise one's life wasn't worth a cent. Even at college she now had to live in the same building with one of them. The elderly lady could hardly believe this. 'Is it true?' 'Yes,' she said, 'the school authorities force us. They say we must leave the school otherwise. Now, it is well known that this Negro girl went out one night with two boys and murdered an old woman in a store.' The eldery lady turned white from horror, saying, 'Yes, one hears so much about these

beasts, that's why I never want them in here.' The young woman went on, 'They found out later, that this girl had three children and was drawing more money from relief than I could earn working full time. I later saw her around the campus, walking scot free while waiting for her trial. These people can get away with all kinds of murders in the North, can do anything with impunity because the authorities want their votes.' The colored were truly like beasts it was agreed: 'Let them run about freely and in two weeks they will be back swinging in the trees.' 'With all the children they have this country will soon be overrun by them.' 'X-Ray machines should sterilize them In mass,' the well dressed young lady said. 'Do they really have such a machine?' the refined old lady asked hopefully. 'I don't know, but they could invent one that would pick out the colored in the street as they went by and sterilize them.' She had discussed this before with friends and all agreed this probably would be the best solution.

From this they went back to the best methods of dog breeding until her father, a distinguished looking gentleman, entered and left with his daughter's arm locked through his.

The store keeper looked out the door for a while, then half to me asked if the auto outside could be a local one. 'I would like to get it away from before the front door and put a chair there.'

'Doesn't seem much one could do about it, the street's for the public. 'Yes,' she answered sadly, 'I know, but I have some friends coming and I should like to have a place for them.' She thanked me for coming as I left. It was the voice of an old friend, full of love, soft as a pillow, the kind one wants to know, stay with and never leave.

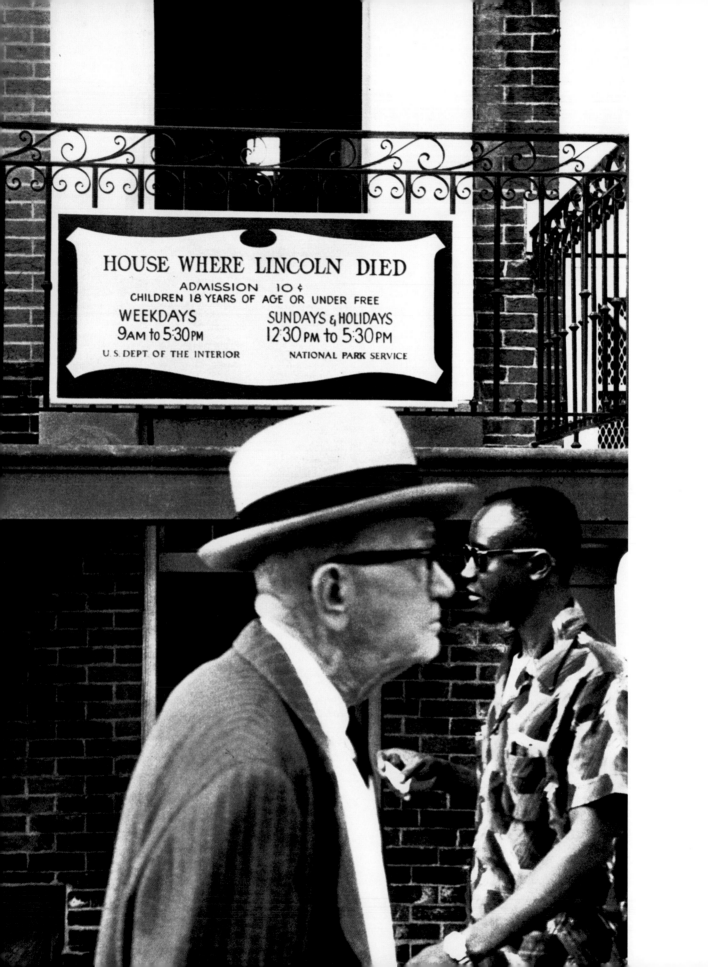

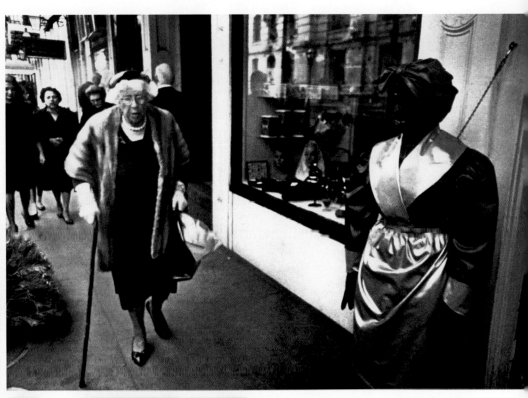

What the barber pole is to the barber shop, the Negro 'Mammy' is to the shop selling gifts from the 'Old South.'

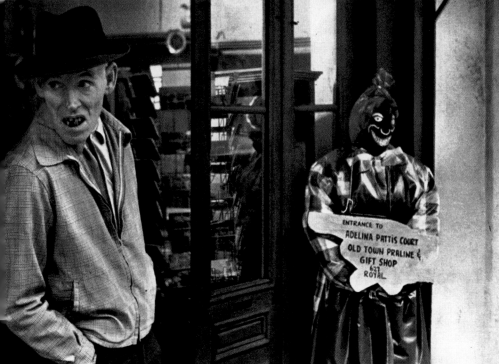

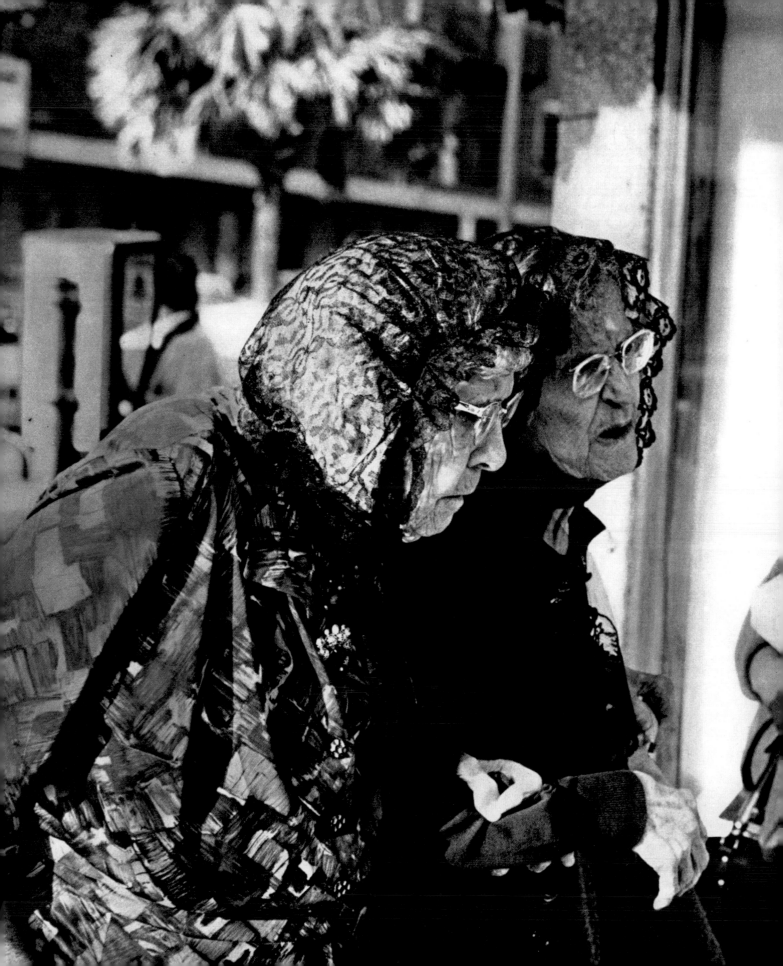

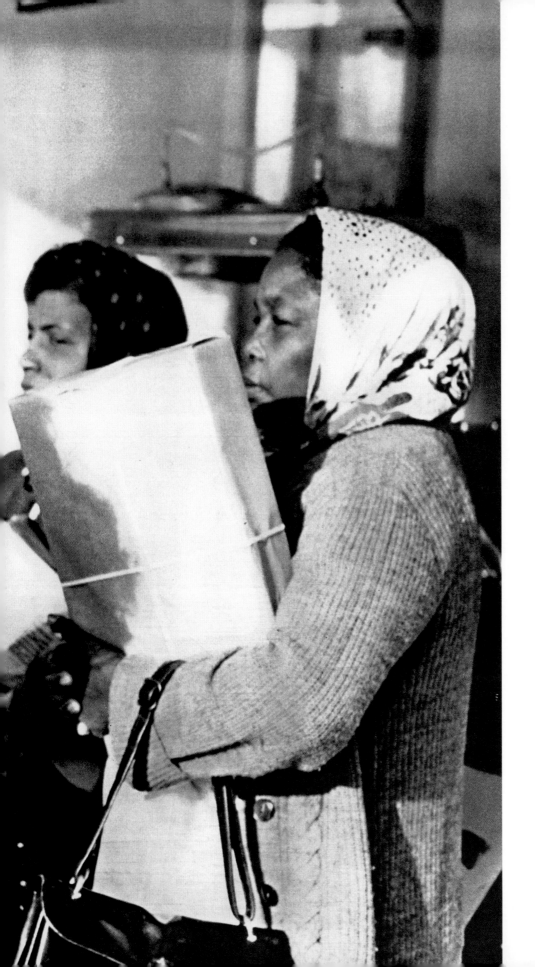

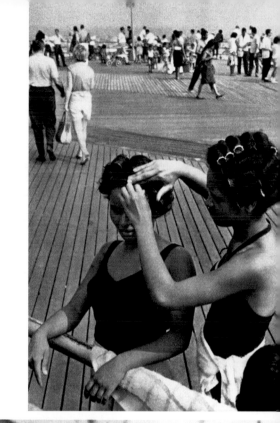

THE GREATEST INVENTION SINCE THE STRAIGHTENING COMB!

1 Is your hair 'GOING BACK' faster than you can press it?
2 Has it been ruined by chemicals and dye?
3 Do you have balding spots on your head?
4 Is your hair so embarassingly thin that your scalp shows regardless of how you style it?
5 Have you tried a wig only to find it hot and bulky?
6 MOST IMPORTANTLY would you like to have a gorgeous, thick and lustrous head of hair? Hair that is beautiful to see and delightful to touch? Hair that is exactly like your own?
 Let work its miracle FOR YOU.
 TRAINED TECHNICIANS will weave human hair to your own so that it defies detection by the most searching eye. Your best friend need never know. Can be any length from 2 inches to 2 feet.

from an advertisement handed out in a Northern Negro community

27

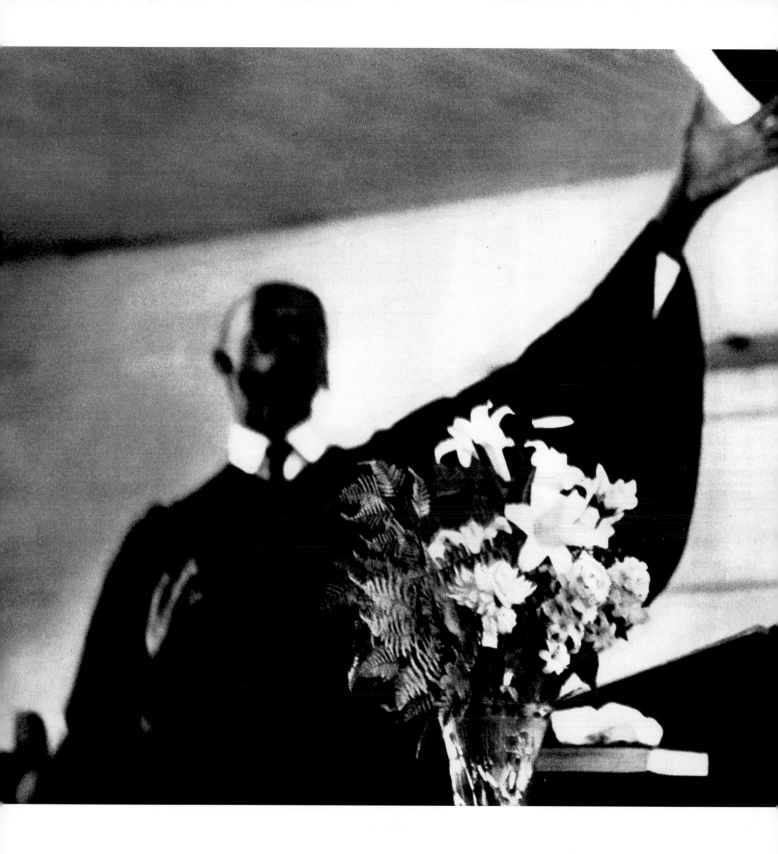

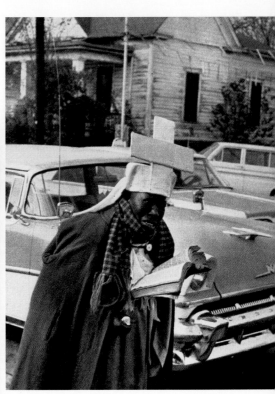

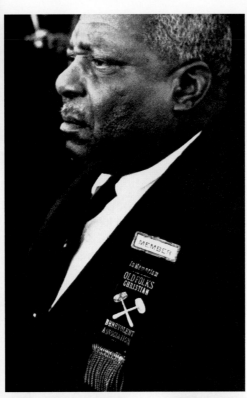

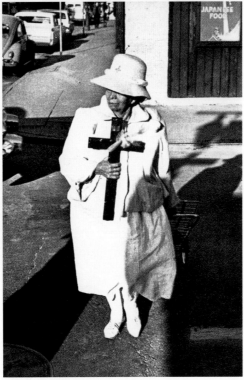

He was a young white North Carolinian, and had some business to do in a nearby town. We drove along the super highway, past new homes and modern factories, tobacco fields, swamps and colonial churches (he liked pointing out historical buildings) then on to the smaller roads until he reached his destination.

'Won't be long,' he said. 'There's a good place in this town for beer drinking . . . we'll go there after I'm finished with my work.'

Not having been in this town for some years, he searched the main street, at last finding the bar near the court house. On the door in big white letters, a sign said: 'For Members Only!'

'What does it mean?' I asked.

'The sons-of-bitches!' he mumbled, 'It means no Niggers!'

A law recently passed to desegregate eating places was being contested by this new method of making private clubs out of public bars.

'Any white stranger can go in and be served,' he said. 'It's only the colored who can't join the club.'

'What about the beer?' I asked.

'I'll be damned if I drink their beer,' he said. 'Let's go home, I've got a few bottles in the ice box.'

Raleigh, North Carolina

The state capital of North Carolina is Raleigh, perched on a hill with the capital building at the summit, giving a fine view of the surrounding country side. Around this building is a small park, forming a square, and facing the square are the official buildings, and churches in the pseudo-Gothic, Greek and Romanesque styles popular in the last century.

From a portable radio nearby, three Sunday-dressed white girls were listening to a church sermon. Words about God, brotherly and motherly love, peace and good will to all men reached me across the green grass. I rambled through the park looking at the statues and read:

'To the North Carolina women of the Confederacy' – a monument of a woman holding a Bible, and a child holding a sword.

The next statue seemed a genuine work of art, the ancestor of all the ancestral monuments in the park. Smaller then most of the others it said simply, 'George Washington.'

Next, a statue of a man, 'Aycock, 1859-1912.' Written on the side, 'I would have all our people believe in their power to accomplish as much as can be done anywhere on earth by any people.' And on the back, 'Aycock's Ideals of public service:

'EQUAL! That is the word! On that word I plant myself and my party . . . the equal right of every child born on earth to have the opportunity to burgeon out all there is within him.

No man is so high that the law shall not be enforced against him, and no man is so low that it shall not reach down to him to lift him up if may be and set him on his feet again and bid him God's speed to better things. There is but one way to serve the people well, and that is to do the right things, trusting them as they may ever be trusted, to approve the things which count for the betterment of the state.'

Did he mean, since Negro children have only recently been permitted to enter this public park, that Nego children were to burgeon out also?

A statue for a young man: 'Worth Bagley, Ensign, U.S.N., first fallen, 1898.' On the back, 'Killed in action at Cardenas, Cuba, May 11, 1898.' A cannon stood guard beside the statue.

Next, the most monumental monument in the square: 'To our Confederate DEAD.' Life-size soldiers stood on all four sides. Large letters said, 'First at Bethel, last at Appomattox, 1861-1865.' Giant cannons were there for the children to play on and a burnished bronze plaque read: 'Taken in June, 1861 when the navy yard at Norfolk was abandoned by the United States . . . Presented by the United States War Department 1902.'

Along a bush-lined path: 'Samuel A'Court Ashe, LLD, 1840-1938. Patriot, soldier, historian, legislator, Christian citizen. Captain, C.S.A. (Confederate States of America). Vice-Commander of the United Confederate Veterans. The last surviving

commissioned officer of the Confederate States Army.'

On the back: 'Unveiled Sept. 13, 1940, the one-hundredth anniversary of Capt. Ashe's birth.'

Now again a statue to a young soldier: 'Henry Lawson Wyatt, Private Co. A. Bethel Regiment, North Carolina Volunteers. Killed at Bethel Church, June 10, 1861. First Confederate soldier to fall in battle in the War Between the States.' (It's called the Civil War in the North.) On the back: 'Erected by United Daughters of the Confederacy, June 10, 1912.'

Behind the capital building, a large monument: 'Presidents N. C. gave to the nation:

James Knox Polk, 1795-1849. He enlarged our national boundaries.

Andrew Jackson, 1767-1845. He revitalized American democracy.

Andrew Johnson, 1808-1875. He defended the constitution.'

Then a monument to 'Charles Duncan McIver, 1860-1906. Educational Statesman.' One side: 'Founder and first president of the state's normal and industrial college for women.' On the back: 'Erected by the school children, the teachers and his other friends and admirers, 1911.' And the other side: 'People – not rock and rivers and imaginary boundary lines make a state: and the state is great just in proportion as its people are educated.'

A statue to: 'Vance, 1830-1894.' One side: 'If there be a people on earth given to sober second thought, amenable to reason and regardful to their plighted honor, I believe that . . . it is the people of North Carolina.' The other side: 'The subjection of every passion and prejudice . . . to the cooler sway of judgement and reason, when the common welfare is concerned, is the first victory to be won.'

p. 31:

'Service for Colored at Window' is a sign on a local white bar. Negroes may buy bottled beer only through the window, they may not enter through the door. It is against the law to drink on the street.

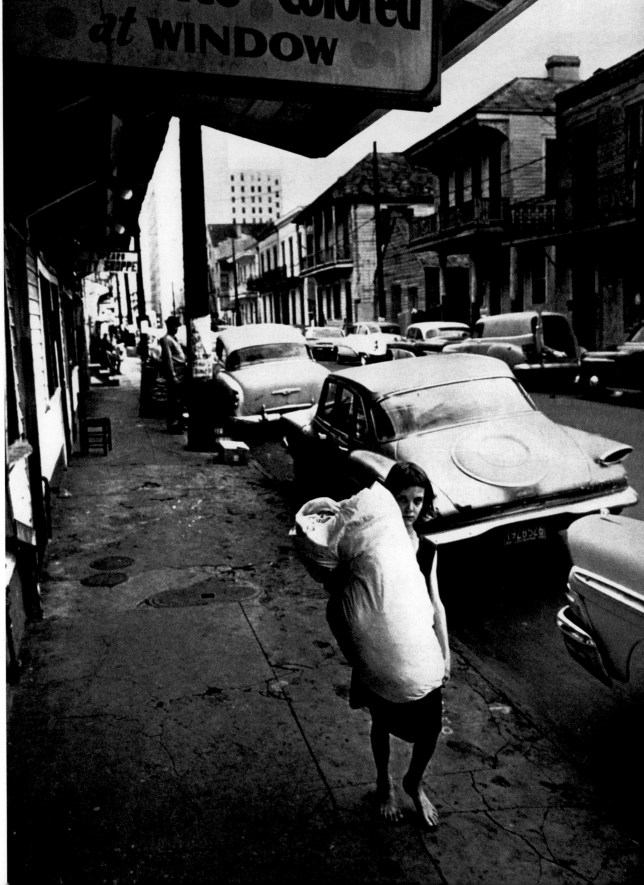

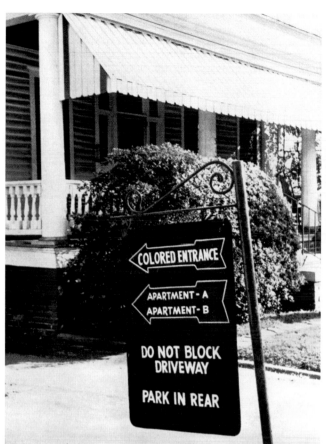

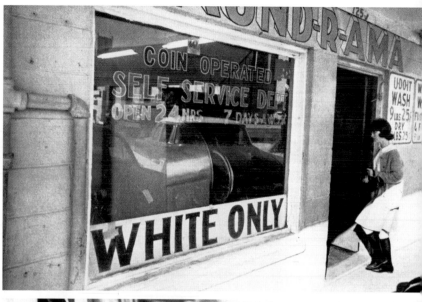

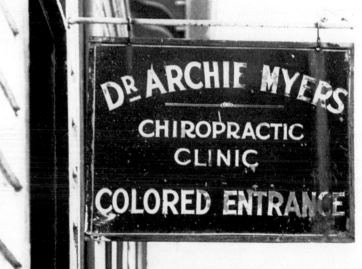

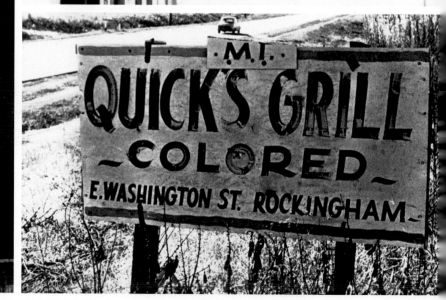

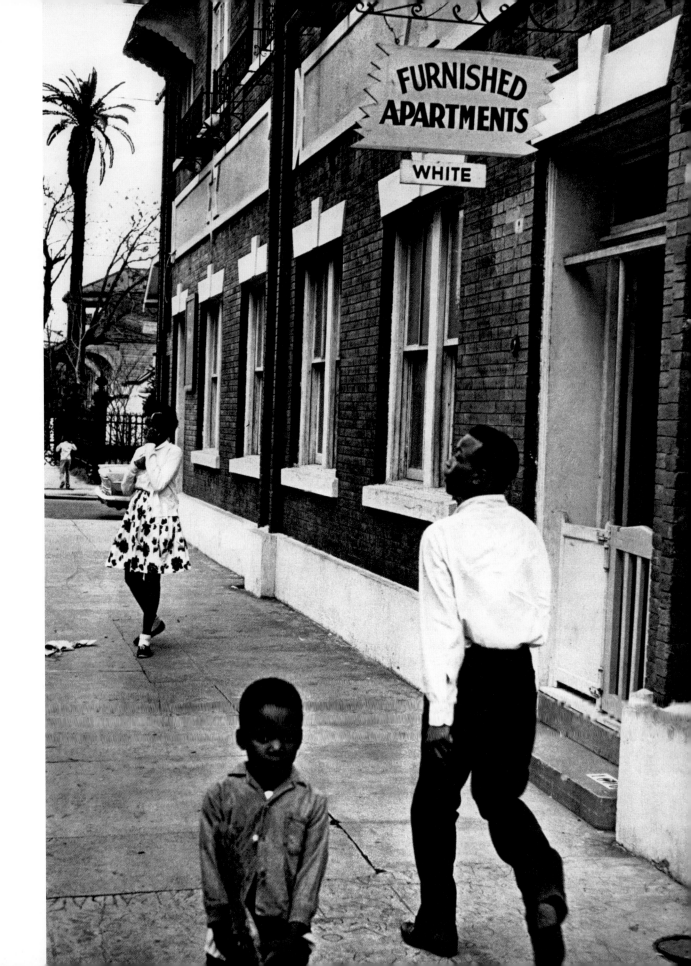

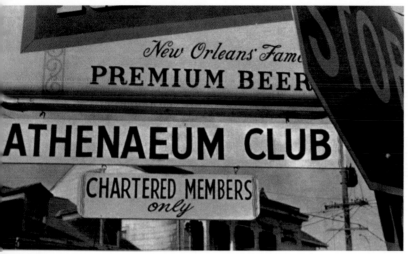

p. 32:

To circumvent the anti-discrimination laws, many public businesses in the South have formed themselves into private clubs (open only to whites) or have posted placards stating 'THIS IS A PRIVATELY OWNED BUSINESS.'

In the prison, itself the ultimate form of segregation, the prisoner is still directed and regulated by the local rationale existing outside its walls.
'White Female' over the prison door indicates for White Prisoners Only.

Symbols guide the Negro upon entering a strange Southern town. If he looks in the telephone book, he will know that the name 'Lincoln' means 'Negro': Lincoln Hospital, Lincoln High School, Lincoln Hotel, Lincoln Taxi Co., Lincoln Movie House or Lincoln Barber Shop. Until recently only the white residents had a Mr. or Mrs. before the name.

. . . am listening to the radio. A traffic report of an auto accident. Three white ambulances (for the white victims) and one Negro ambulance were sent to the scene.

p. 33:

'White' under the sign for furnished apartments means, 'White people only need apply.'

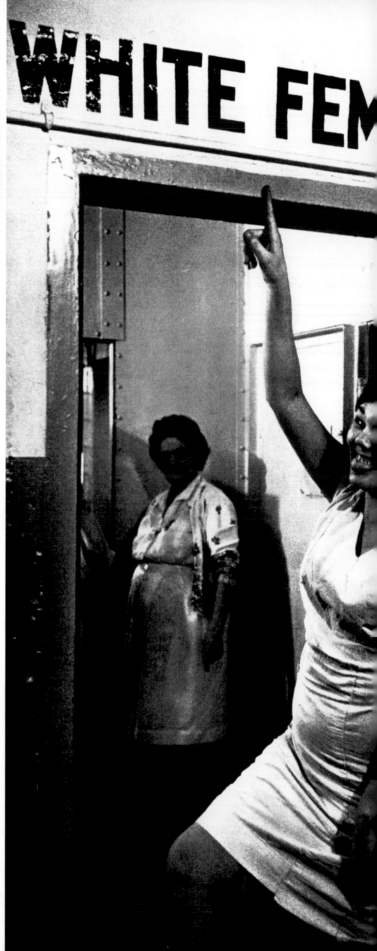

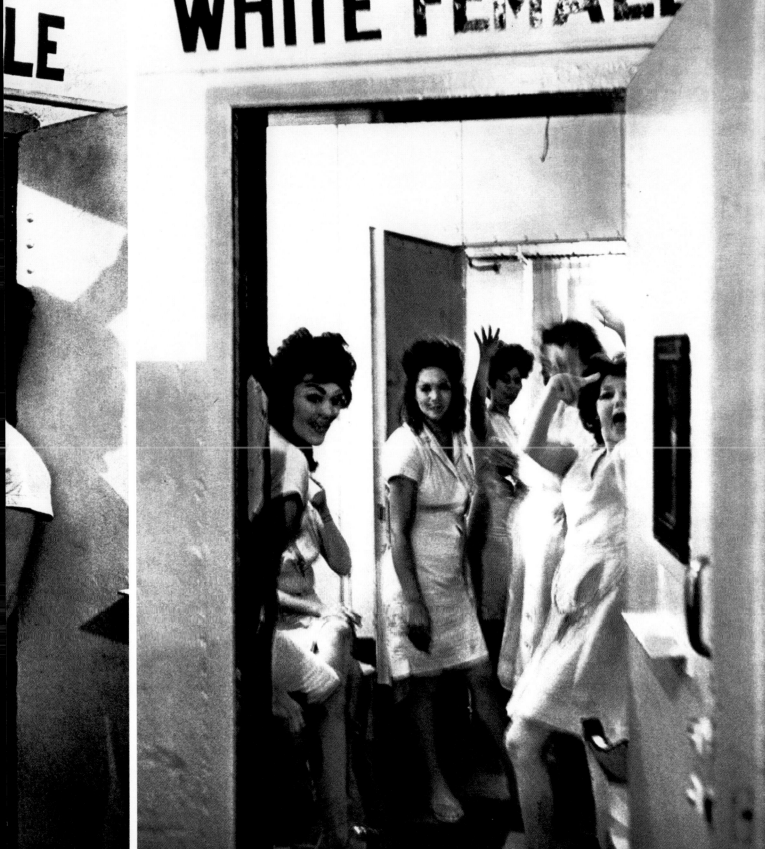

p. 36-37:
Louisiana

A Daughter of the War of 1812.

In the local museum an exhibition centering
on the famous battle of New Orleans was
being shown. The earliest prints, made
shortly after the battle, show prominently in
the foreground Negro slaves fighting side by
side with the whites. (They were given their
freedom if they fought bravely, but not
citizenship.) Later prints tended to
emphasize other aspects of the battle;
Negro participation moved to the
background and then out of the picture,
never to return. The Negro had been
washed out of American history. No Negroes
participated in this public celebration and
only within the last few years have Negroes
been permitted into the little park where
the monument to this battle now stands.

p. 38-39:
North Carolina

. . . on the other side of the railway tracks.
The 'other side' means the 'colored side,'
even the people living there speak of
themselves as living on the 'other side.'
To avoid a long detour to the shopping
center or work in the white community, the
Negro is forced to cross the dangerous
tracks because the white civic leaders
have failed to provide a better route.

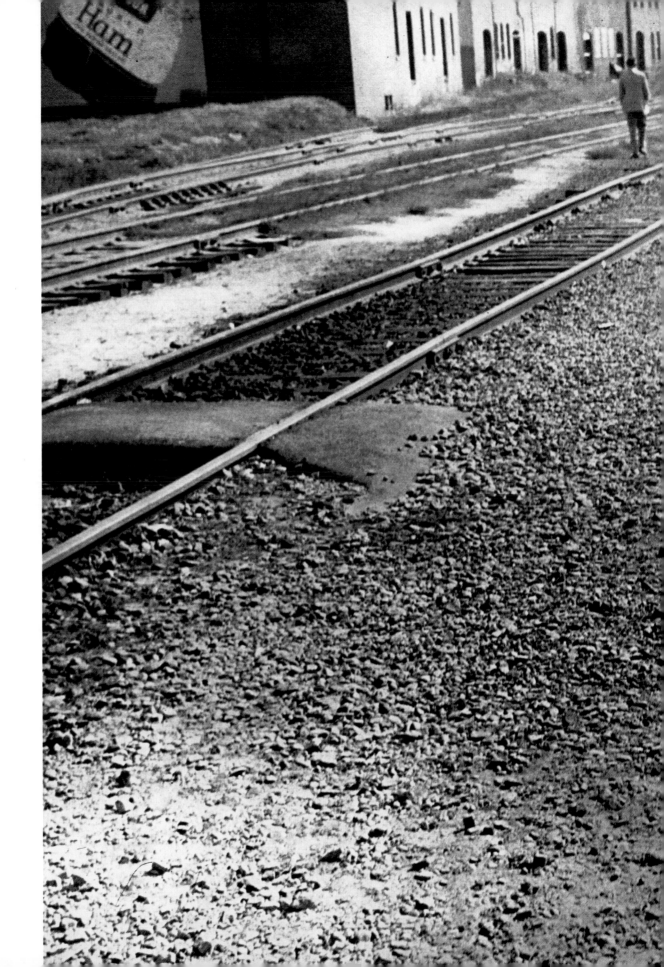

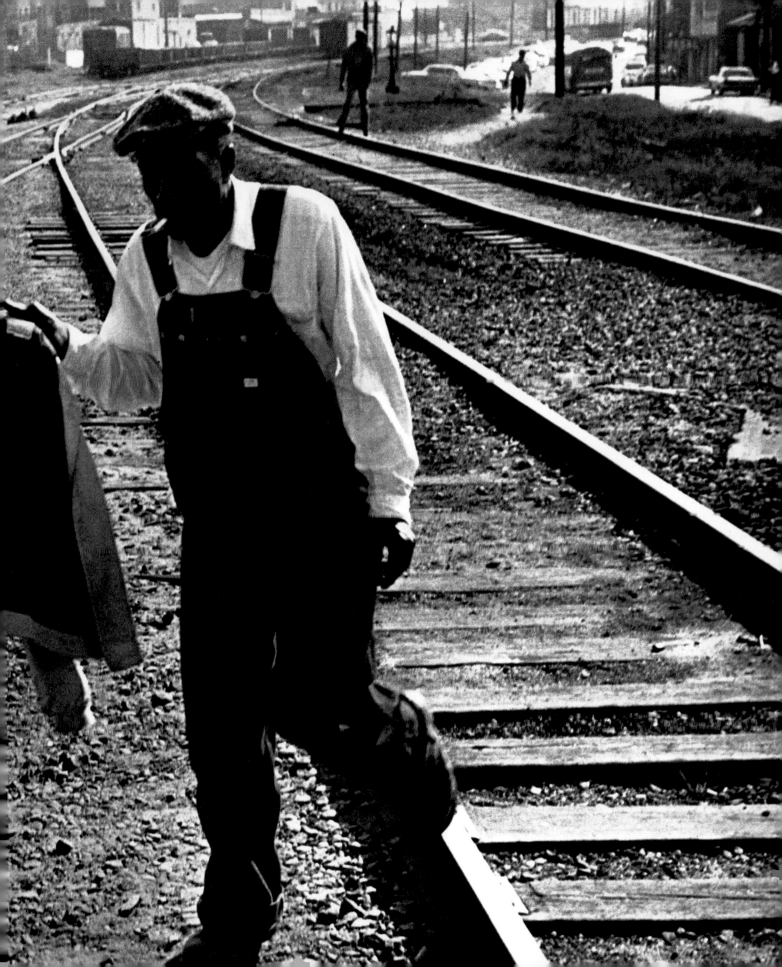

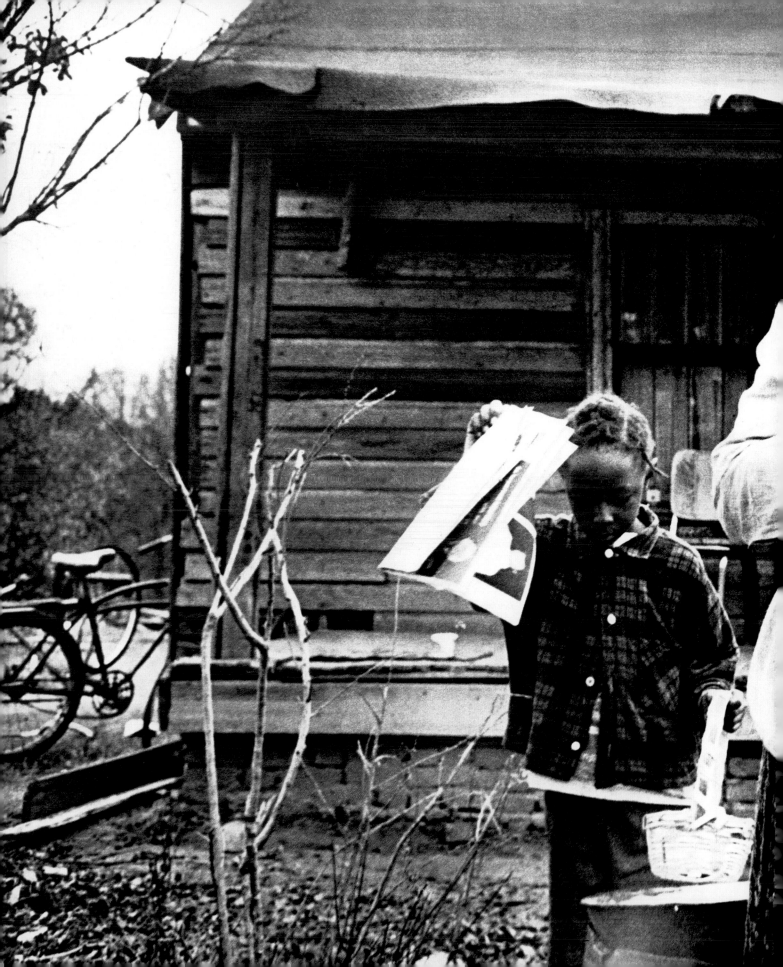

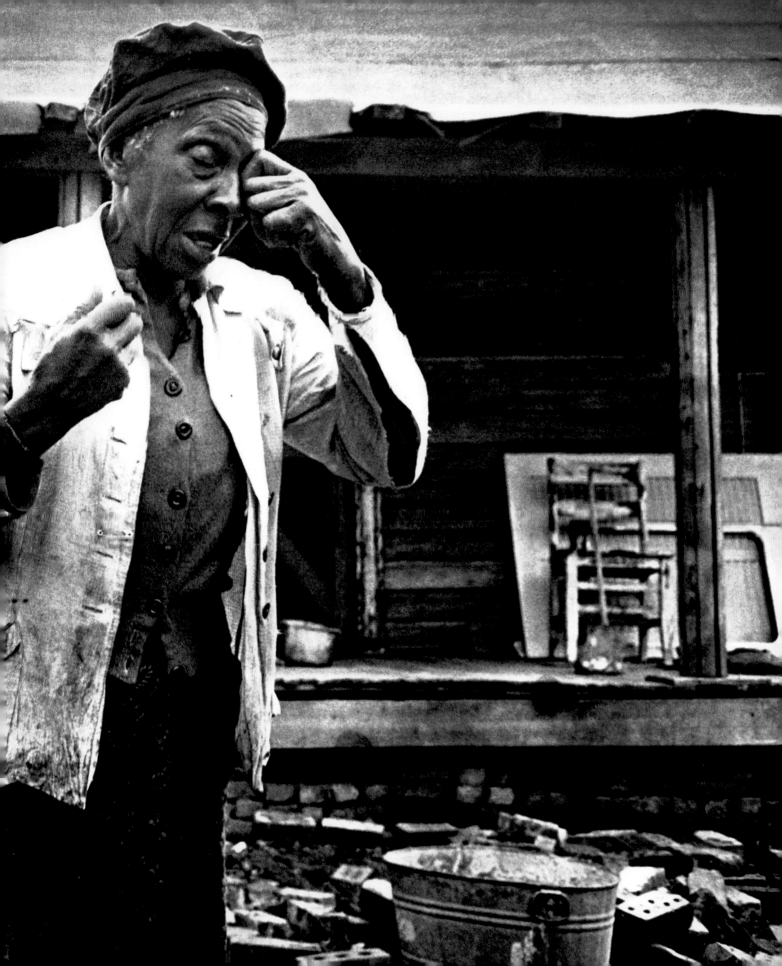

'What happened to the porch roof?' I asked the young girl.

'A tree fell on it during a storm.'

'When, recently?'

'Nah, a long time ago.'

'Why doesn't someone fix it?'

'It don't belong to us.'

'Don't you all live in this house?'

'Yeah.'

'Well?'

'Our half of the house ain't broken.'

'Who lives in the other half?'

'Some old woman, by herself.'

'How does she get out, if the roof blocks the door?'

'She squeezes through.'

'Why doesn't she fix it'

'She's too old.'

'How many rooms in your part of the house?'

'Two.'

'Who owns the house?'

'A white man.'

'Well, why doesn't he fix it?'

'He never fix anything.'

'Does he know about this roof?'

'Maybe.'

'Do you think he'd fix it if he knew?'

'Nah, he never fix anything.'

'Where are your parents?'

'They out working.'

'Shouldn't you be in school now?'

'Yeah.'

'When was the last time you were in school?'

'A few days ago.'

'What do you do when you're not in school?'

'Nuffin!'

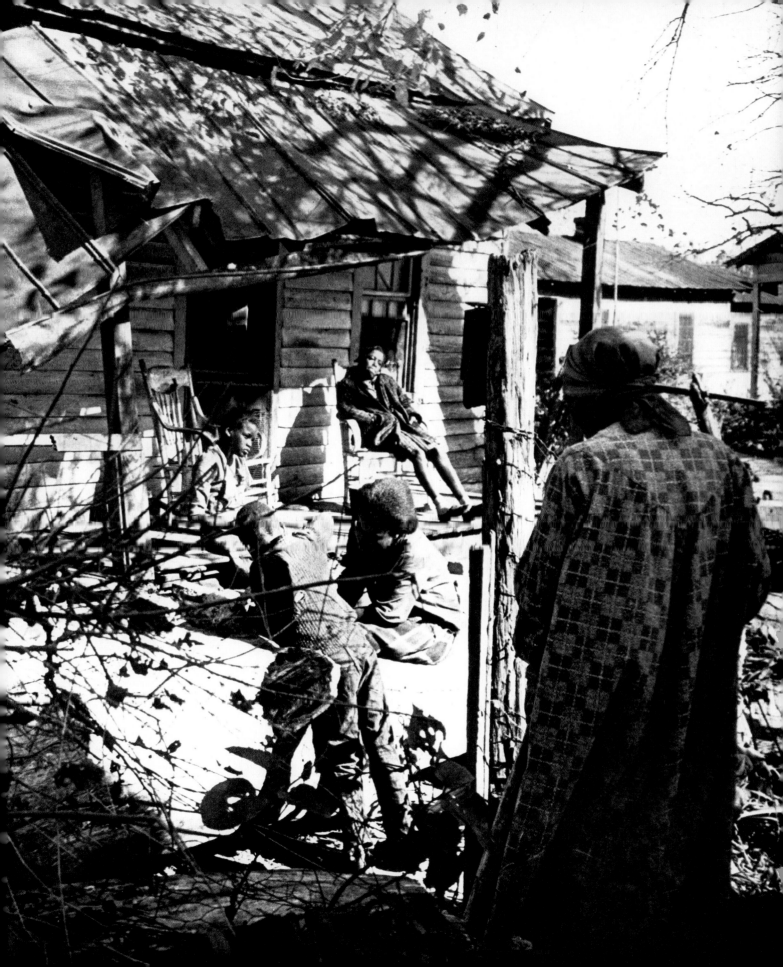

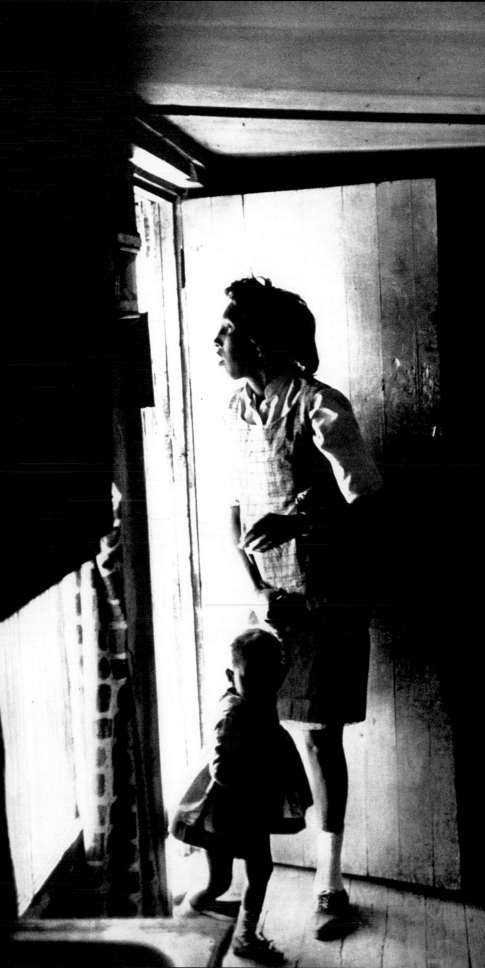

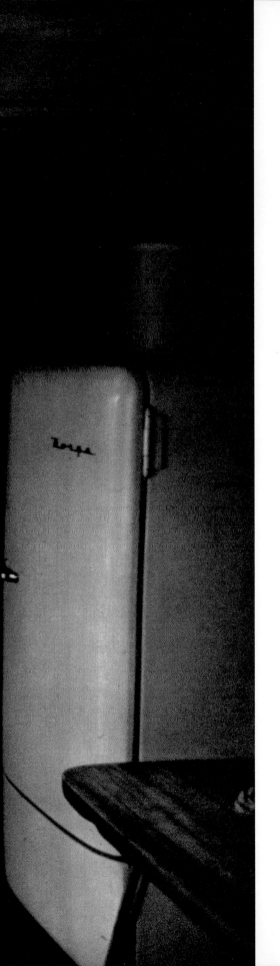

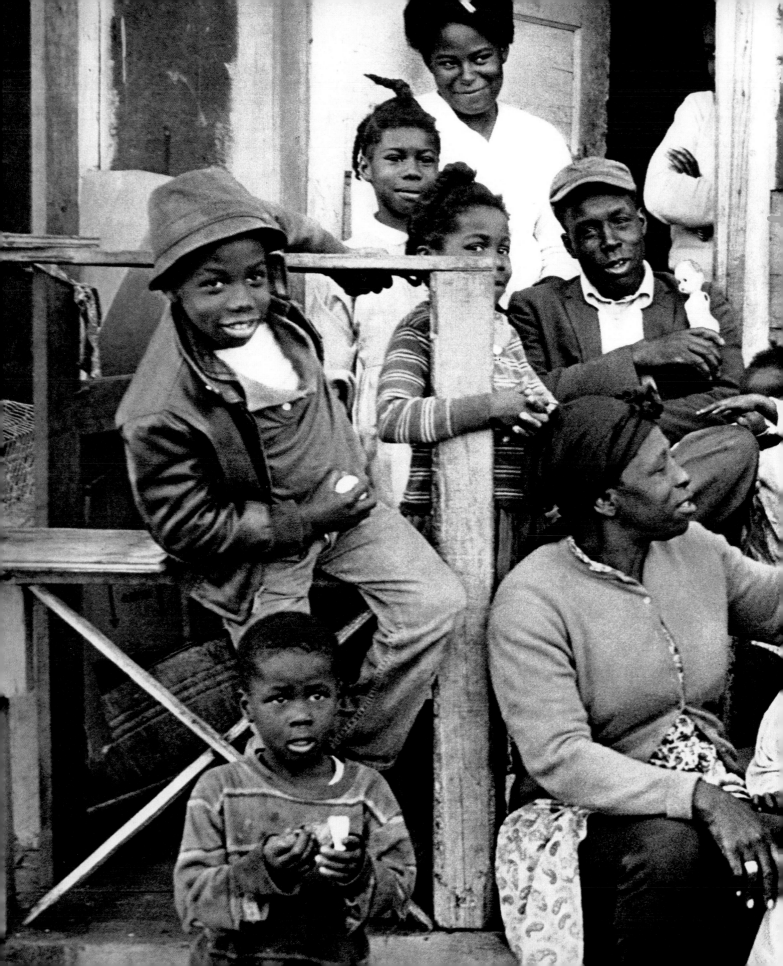

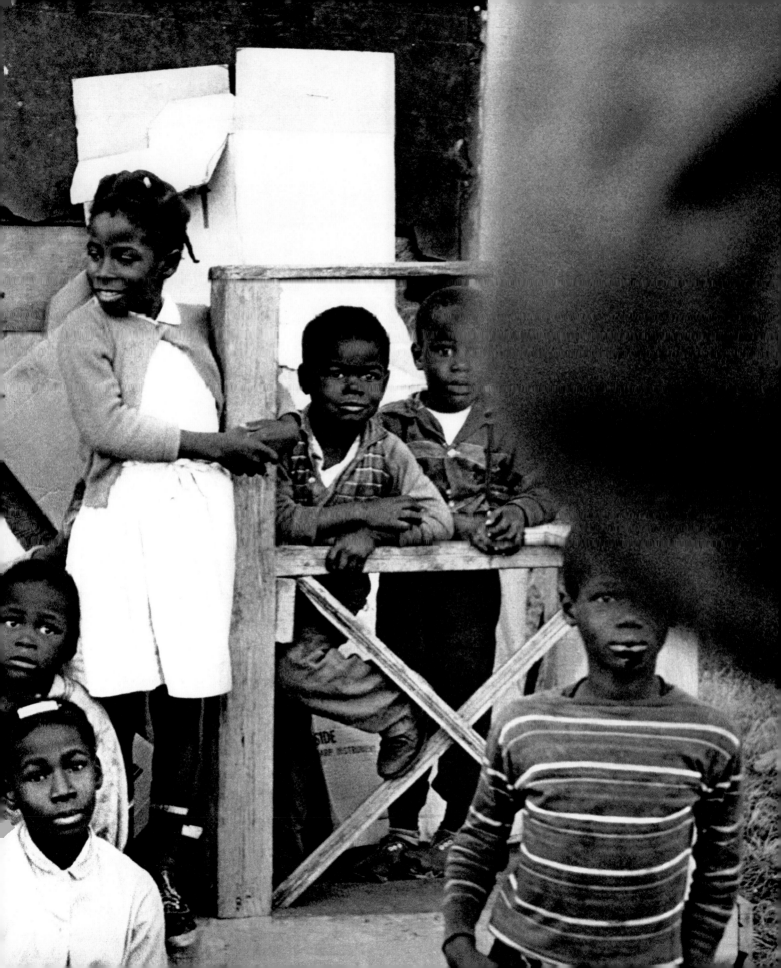

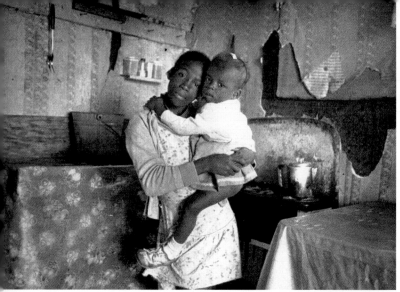
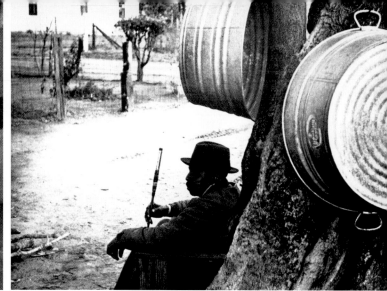
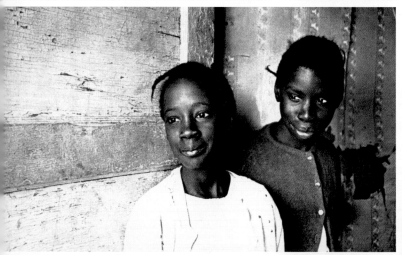
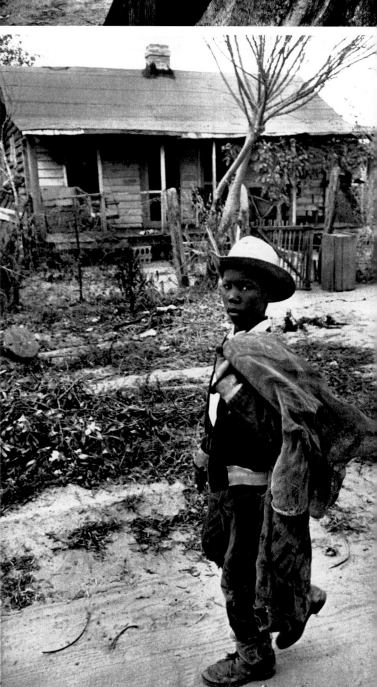
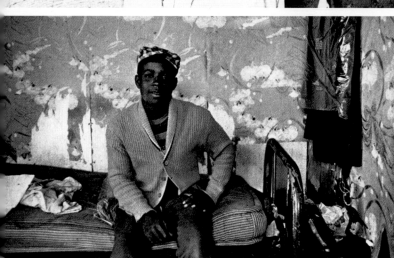

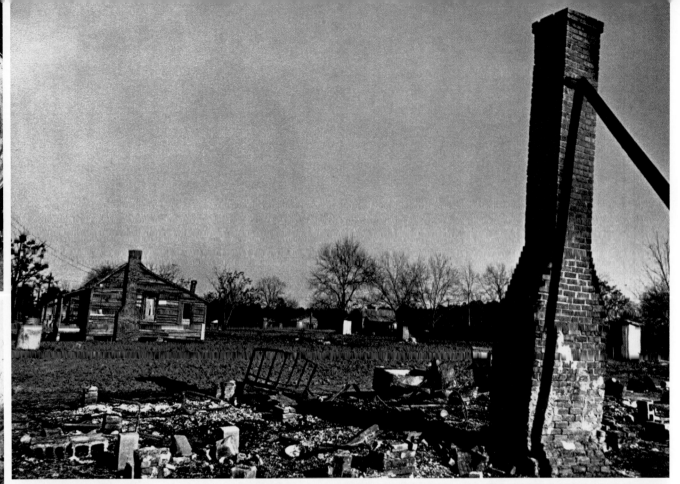

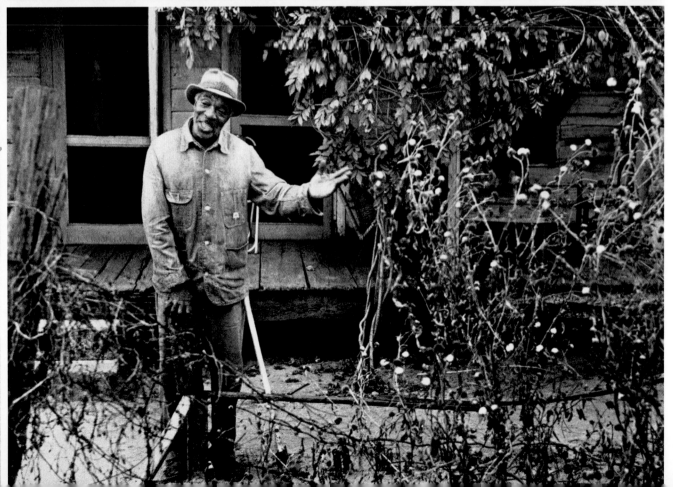

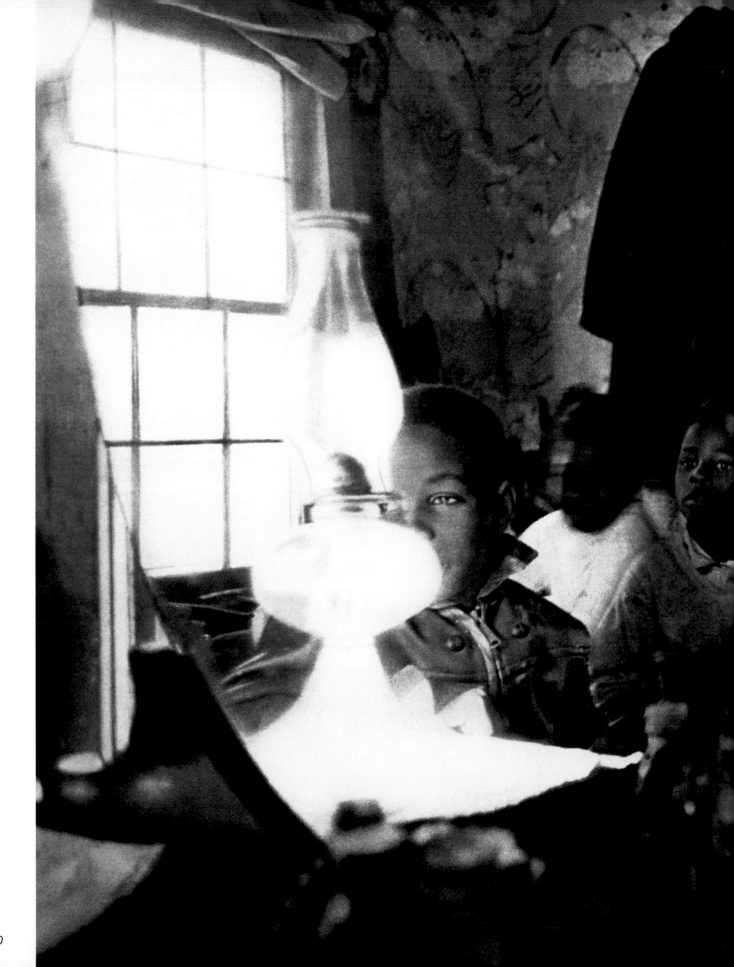

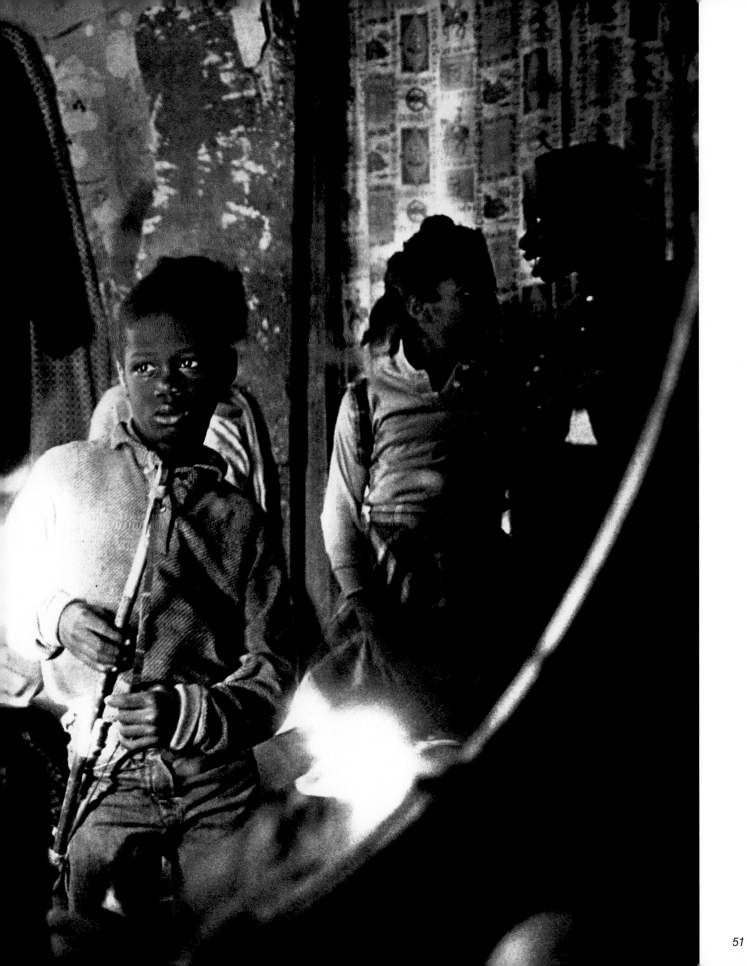

Louisiana

PO-BOY (poor boy) originally the name for a sandwich the poorer working people bought for lunch, a lot of food for little money. 'I am the PO-BOY,' said the owner of the fruit stand.

Georgia

Children selling flowers and decorations in a white neighborhood.

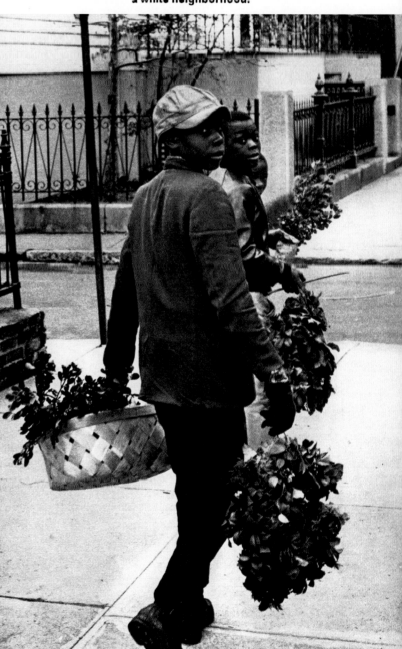

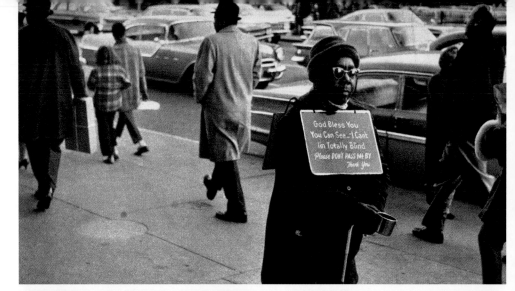

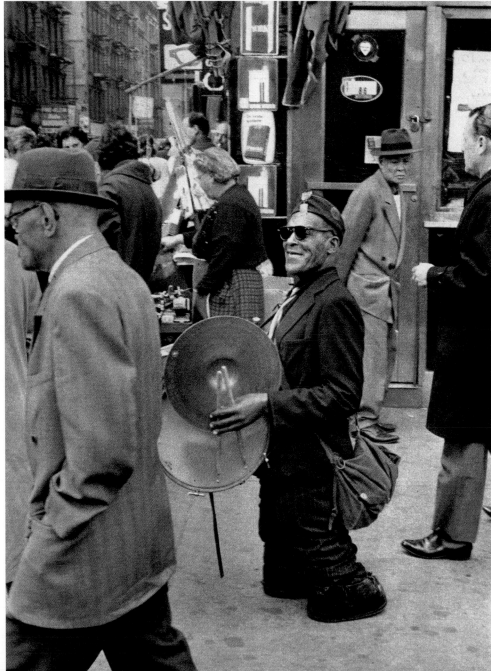

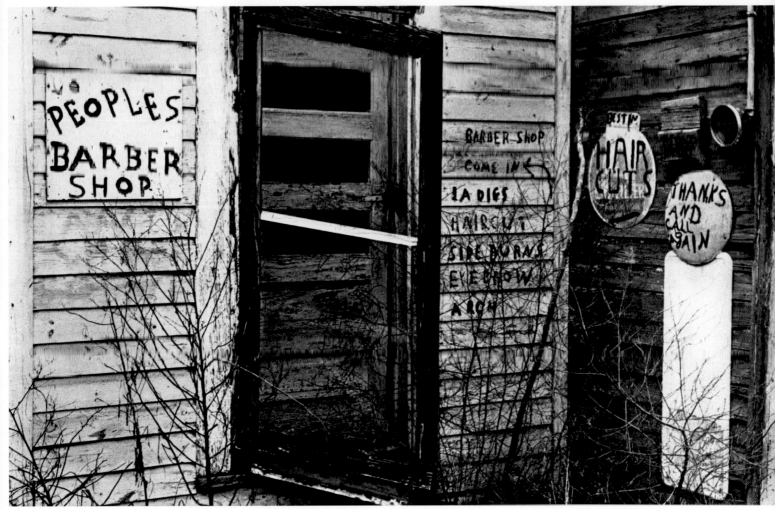

The town isn't big; one tidy business street and at the dirty end a small side street of dilapidated buildings for the colored. For the colored: colored bars, colored barber shops, colored eating places and a colored poolroom. Weekends the side street is packed and noisy while the money flows from the hands of poor farm laborers. Sitting in what he called his office, he said he wanted me to get it straight before I left town. 'What I need is a large hall for more tables. Without the extra tables I do little better than break even. Joke about poolrooms, but this is the only clean recreation the kids have in this town, and I keep it clean, no gambling. The trouble is, the kids come up here, see all tables occupied and go back downstairs to the bars, and wind up in jail.' Why didn't he get a larger place if he needed it, I asked. 'This is the only place they'll let me have,' he said. He tried often to move away from the bars onto neighboring streets, but the whites owned the land, and no amount of money was sufficient when a Negro wanted to establish himself in another part of town. The whites just laughed in his face when he approached them with his proposition. 'They would just laugh and laugh,' he said, 'just laugh.'

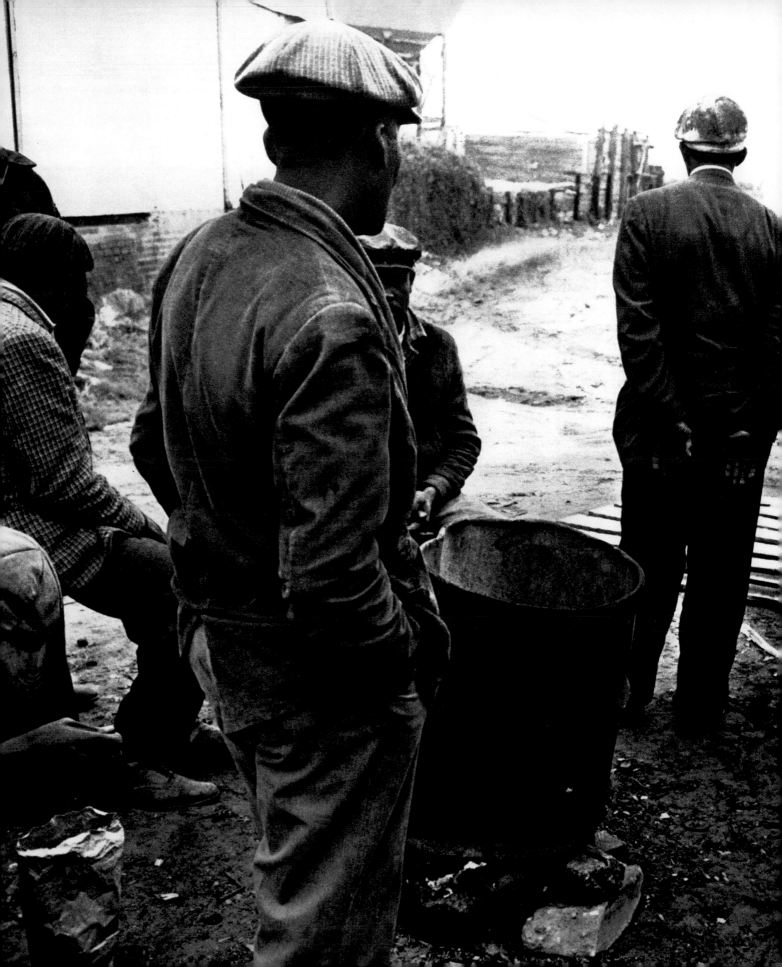

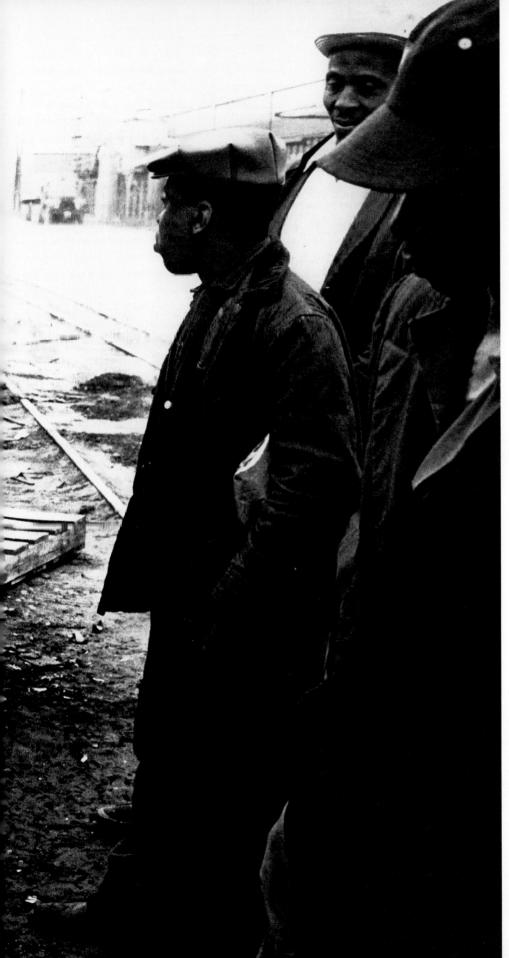

South Carolina

'What'd you be doing here with that camera?
Mister.
Don't be fooling around here.
We ain't in no good mood.
You're looking at unemployed, hungry men.
Some been sitting here for weeks waiting
for work.
It's getting close to shutting time:
won't be no work for us here today.
Mister.
Don't be fooling around here.
We ain't in no good mood.'

p. 40-41:

The ceiling had been covered with sheets of cloth and was falling down in places; the effect created was of being in a tent. Only the windows and the door frames had been painted – sky-blue, to keep the bad spirits away. Blue is the color of Heaven, and no bad spirits may enter Heaven. To be on the safe side, the walls are pasted with newspapers; if spooks should get in, first they must read everything in the newspapers before turning upon the people living in the house. Because there is so much to read, daylight soon drives them away and they have to start all over the next night.

p. 44-45:

The massive superfluity of America's wealth reaches down into the poorest cabin. Even when there's no electricity, the second hand refrigerator protects food from the rats.

p. 49, above:
Georgia

The flames sprang up into the night sky, about a mile away. 'No sense in going over,' my companion said. 'It's usually over in about fifteen minutes. The dry unpainted wood goes up like a match box, started mostly by some sleepy kid knocking over an oil lamp after returning from the outhouse standing in the field between the cabins. It's a tragedy when the kids don't wake up in time. They try to save the brick fireplace, that's the most costly part of the house. Usually everyone helps and the wooden frame is back within a few days.'

p. 59:
Coney Island, New York

Through the slats of the boardwalk above, the sun shines upon the figures below, and self-imposed laws operate to segregate the people at this great city beach.

p. 66-73:
Angola State Penitentiary, Louisiana

'The Hot Box.' 'I sat in a black box, unable to stretch out, heat coming from pipes overhead, hearing and seeing nothing, after five minutes the effect begins to work, don't know if one has been in there five minutes or five hours, five hours or five days, five days or five weeks, five weeks or five months, five months or five years, its frightening.'
The institutions – the churches, the prisons, the mental institutions – have conditioned the Southern Negro, more than the white man. The institutions have molded Negro life. The sensitive Negro has four choices: to kill himself (a solution many have chosen), to become psychotic (and the full institutions testify to this), to conform, or lastly, to become superhuman and overcome his human sickness.
The white prisoner said: 'A Southern prison is like Southern life, the corruption inside is the same as outside: in or out, it adds to "Zero" for the Nigger.'
The Negro prisoners were shouting at me, trying to make some contact; they felt they had been forgotten. Time and its meaning were being lost to them.
The white prisoner said: 'In prison there is no order. There is a book of regulations but none of the guards have read it; everything depends on chance. A good hospital has order, a good prison has order, an intelligent prisoner will want strict order applied to all. All should know where they stand in relation to one another. The South with all its regulations has no order, it's all chance, depending upon the personality of the individual you meet. The Nigger never really knows if the white boss is going to castrate him the next day. It's to keep him in constant fear. The laws should be applied. The trouble is some laws are unjust. There are Niggers in here for crimes no white man would be tried for. The government just wants cheap labor and the Nigger is it.'
A white prisoner lives in hope and concerns himself with getting out, but the Southern Negro prisoner loses his sense of time: time for him is motionless. Inside or out, he remains a prisoner, a man living in fear with little hope. A man living in fear needs a moment of fearlessness, a moment when he can claim existence and manhood. He may shout out knowing it will be the hole, the Hot Box, but for the moment he has been master of his fate. Prison riots often result. No order means no hope; only the expectation of order brings hope.
And in Heaven, could the Southern whites believe they would still be the masters and that God would segregate the colored? Thank God, no one could say what Heaven would be like. In Heaven, God kept his order and as a human being the Negro could hope to be given his just place within the Heavenly society.
Joyful events came in churches where one could relax and sing out, or it came in death. In death a man was made free and so for the first time lived. A man enters Heaven as a man, responsible only to God and himself. So, the funeral becomes the greatest moment of one's life. It leads to Heaven and yes, why not, why not go in a grand style, let the whole world be joyful and let's have music, yes, the music was important. A whole band, even two bands if one could afford it. Tempo, tempo, it's a long way to the cemetery. To lead, we will have Grand Marshals, they must strut, it all must be sharp, and they must give precision, it must be all exact, as if they were leading a military parade. Their movements must start to bring order to one's life, and it must be order leading the way.
The 'Second Liners' with their umbrellas, shouting, singing, strutting – they will let the whole town know, come and see, order now is leading. At last a holiday for all, for there are no other holidays for black folk. Now, everyone is stopping work to join in, the procession gets longer and longer; let the sun shine and 3000, 4000 will strut down the line to guide him into Heaven.
And the band will be playing:

'When the saints go marching in,
When the saints go marching in,
I want to be in that number,
When the saints go marching in.'

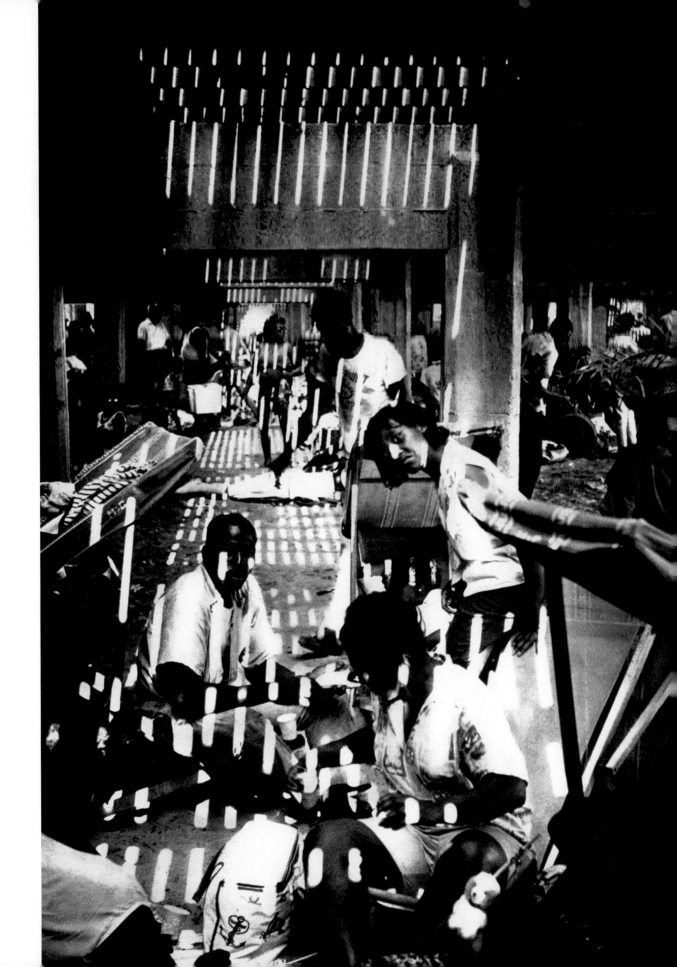

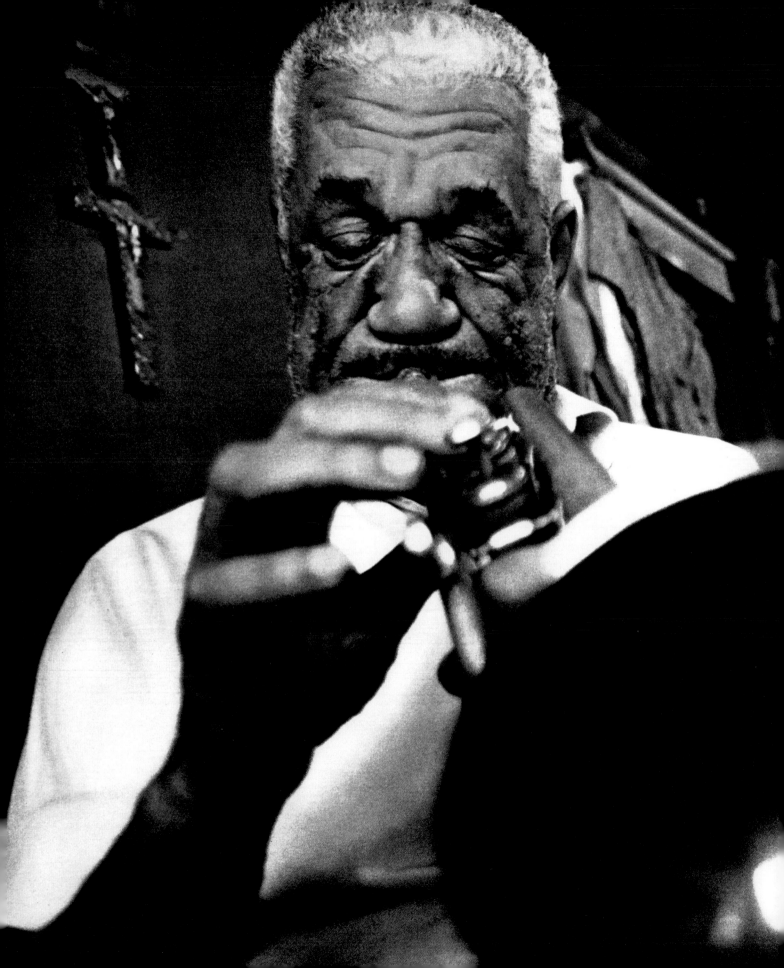

p. 60-62:
New Orleans

It is said, Jazz men never retire – they are always in need of money. This is especially true of the original Jazz men who stayed behind in New Orleans, never making it big in Chicago, in the white world.
Blind DeDe Pierce is one of the last old New Orleans Jazz men. Living in a three room, cinderblock house, built for him by his nephew. To reach it, one goes through a narrow passage, behind a building that cuts it off from the street.
Billie Pierce, DeDe's wife, played a tune on the bedroom piano. 'I still got some of that old hot blood in me,' she said and we joked about it. 'They can't play Jazz like we did in the old days, the kids have lost the beat, it's all electric guitar now and Yea, Yea, Yea. The old music came out of the heart, out of the churches. We played at

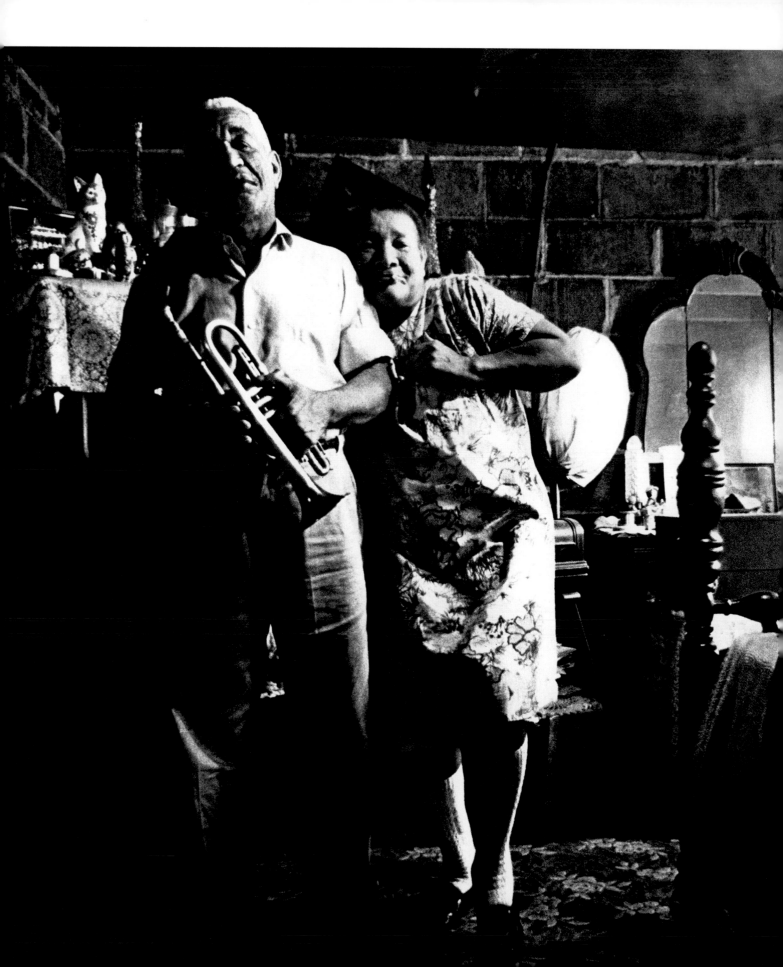

funerals, you hardly hear them playing at funerals now, just a few of us old people left.'

Above the piano, collecting dust, was a lifetime of Jazz memories, souvenirs picked up in their travels. They had been places but always returned. This was the only place where a Jazz man could truly die.

She put on her head a high school graduation cap, also used in church by the choir. Church was important and they went often and sung often. She pulled a box out of a corner and opened it carefully. It was full of their great old records, collectors' items throughout the world. 'Do you want to hear?' Then from out of the same corner she dusted off an old-fashioned record player. Then she brought out DeDe's horn and they played together. DeDe sat on the bed, his blind eyes to the window; he seemed to be reading the notes from somewhere out there. Then laying the instrument aside, he said, 'Yes, the old Jazz, the real blues, it had something to say.'

below:

A New Orleans street corner gospel singer. After his day's work, he goes out collecting money to rebuild his church; he may not ask for but is permitted to receive donations.

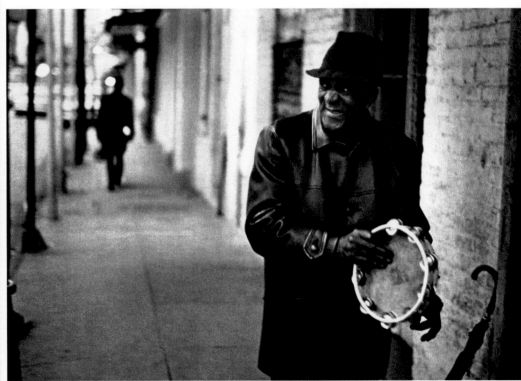

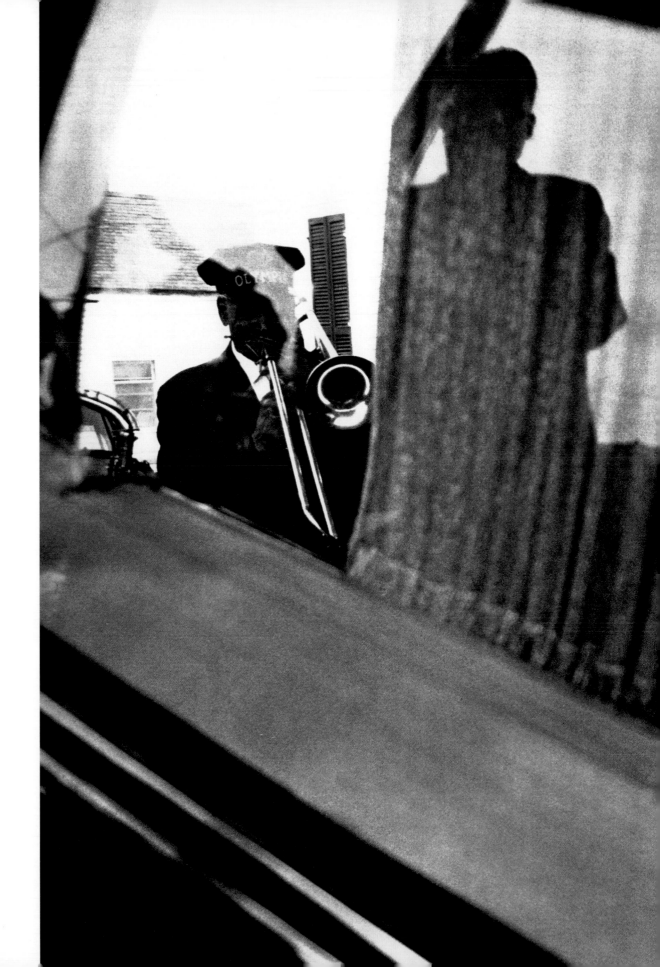

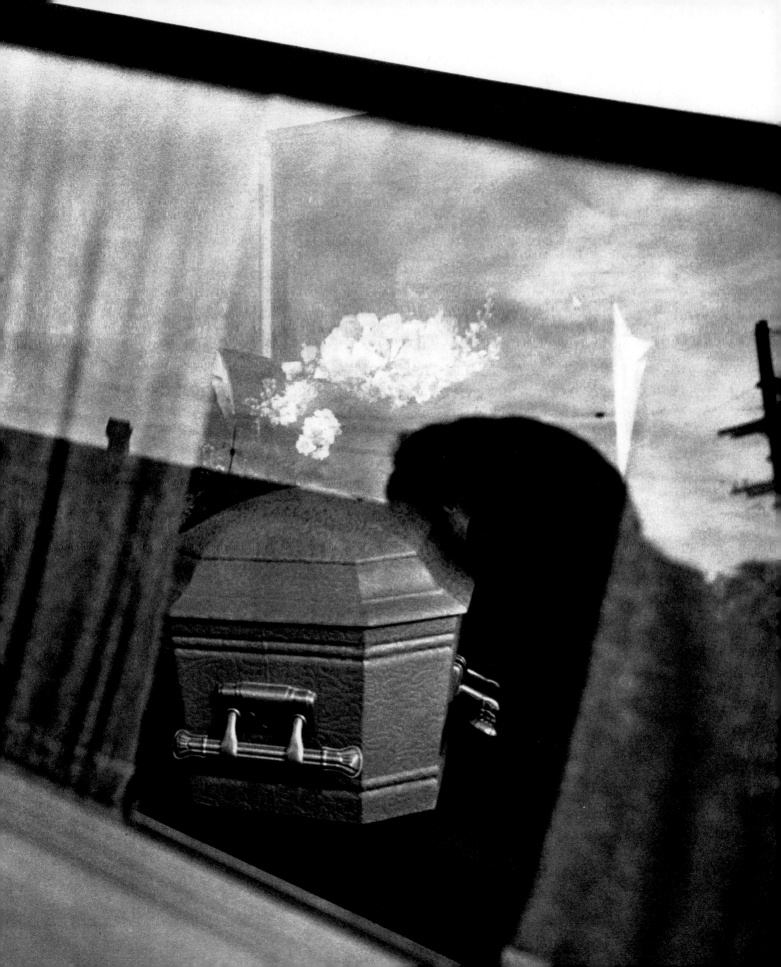

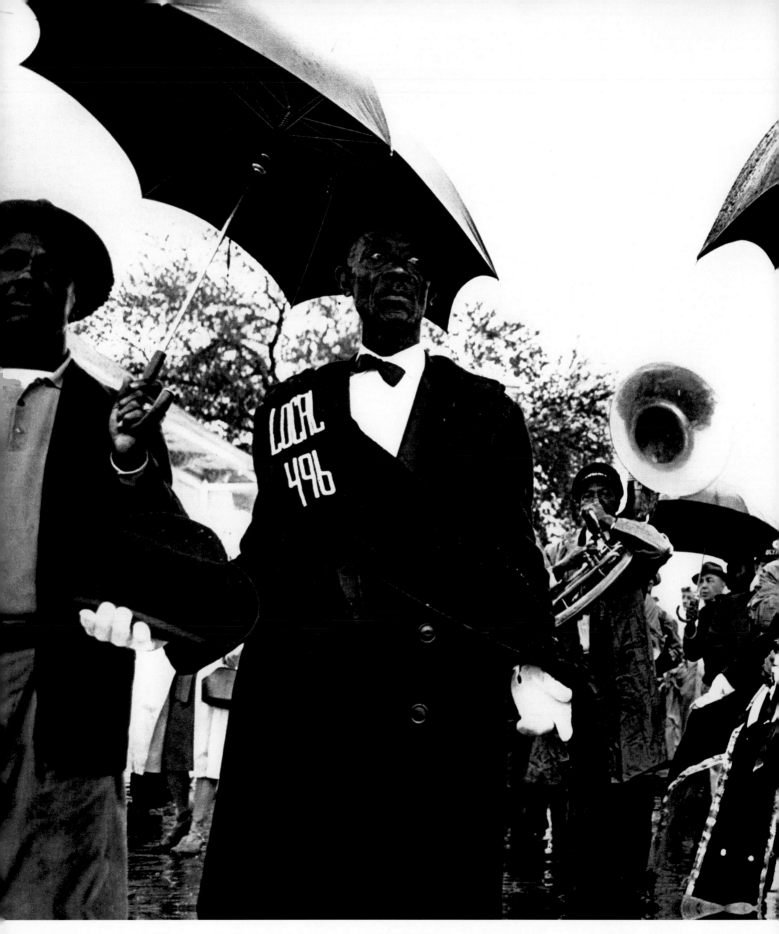

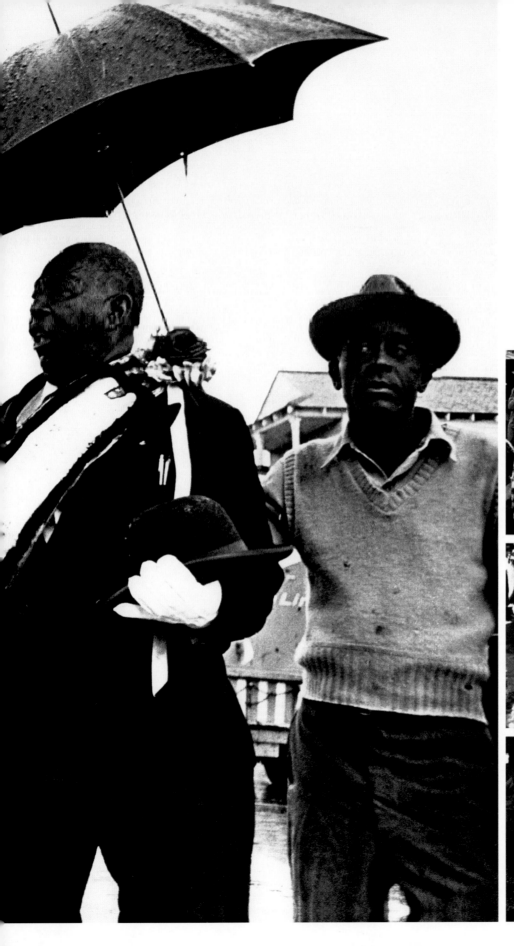

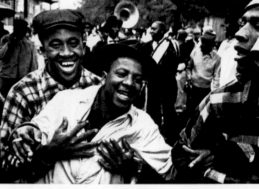

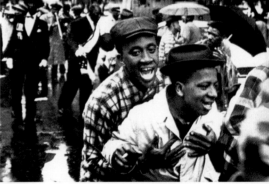

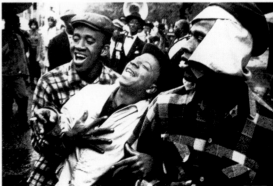

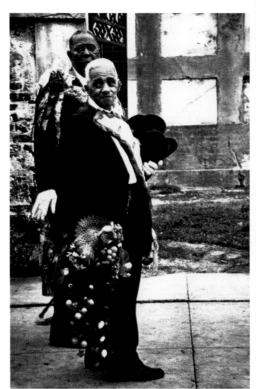

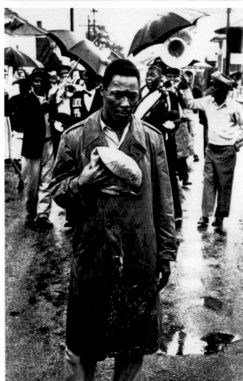

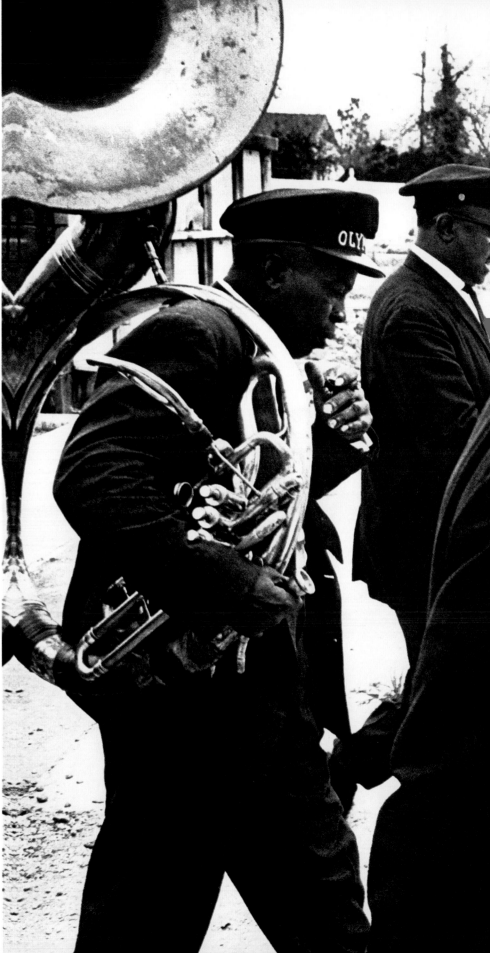

p. 64-71:

Jazz funerals in New Orleans.

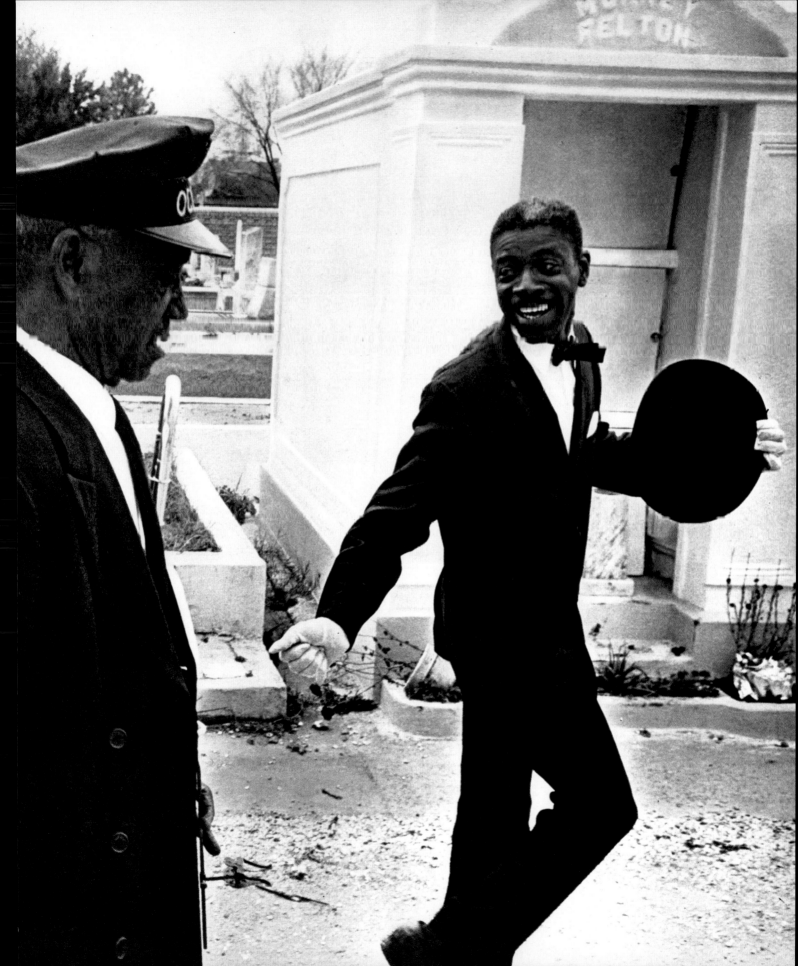

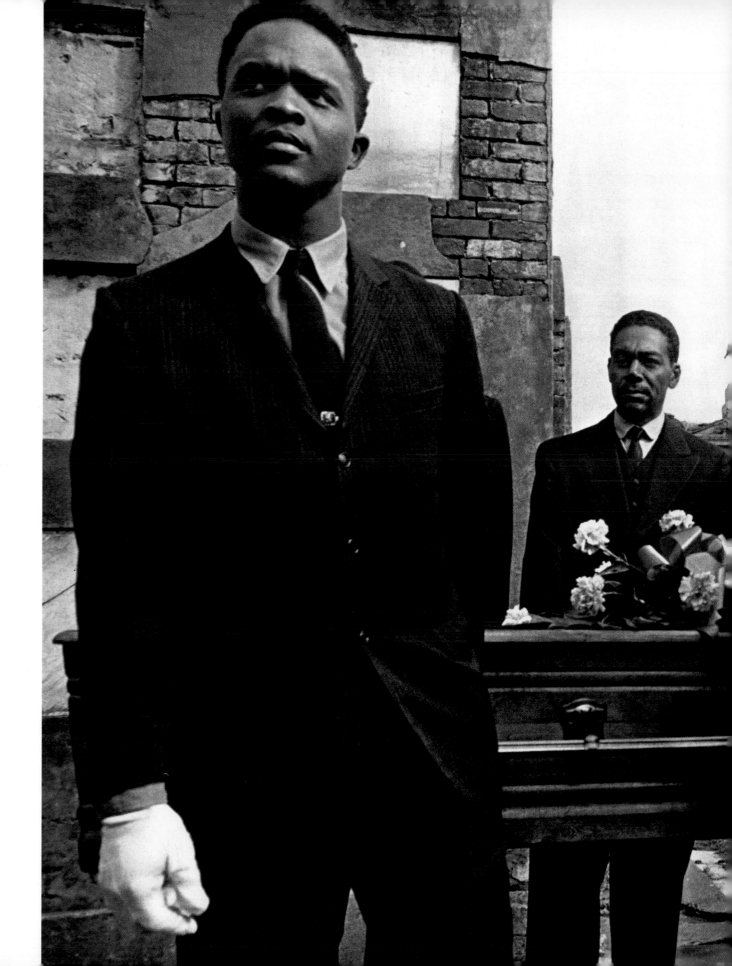

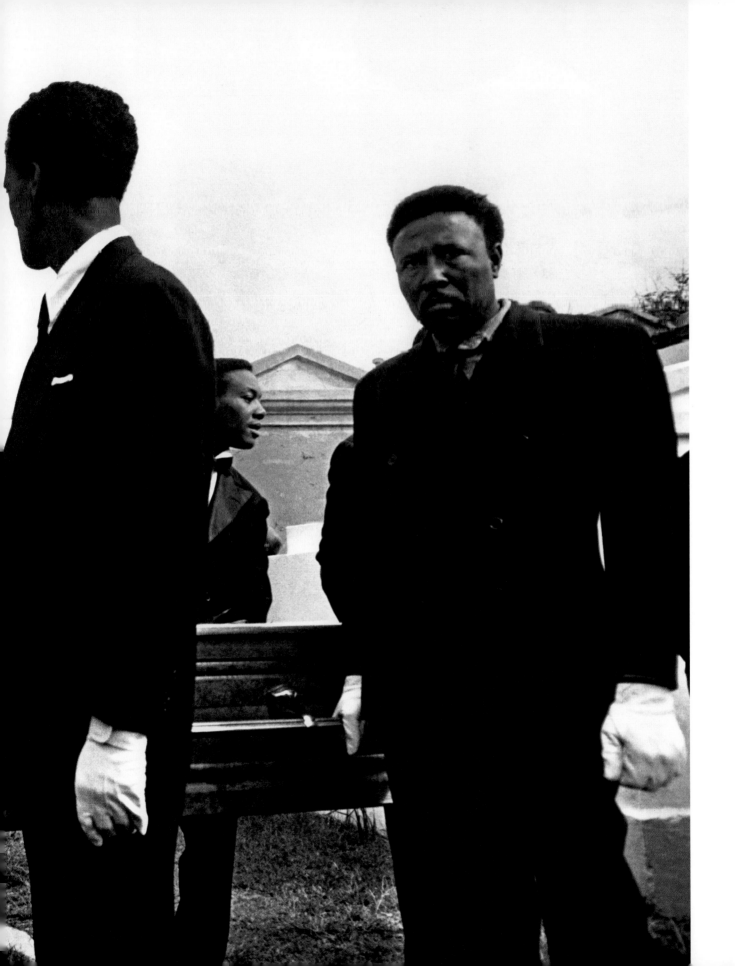

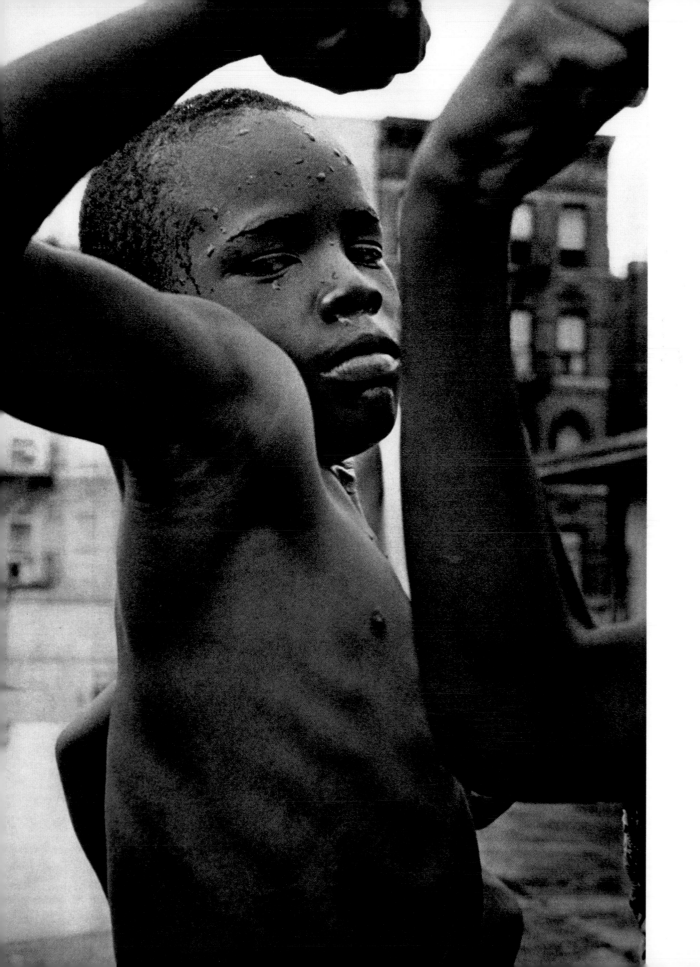

Maryland

It goes back to before the American Civil War when it was forbidden in Washington, D. C., the nation's capital, to keep slaves overnight within the city limits. (One reason was the fear of a slave uprising.) The legal minds of Washington kept their slaves quartered just over the line in Maryland. The slaves arrived at dawn and left after sunset, seven days a week, fifty-two weeks a year, to work in town at the homes of their masters. In 1865, with the war over and the slaves freed, the white man's interests were in the good cheap land to be had out West. The poor land, the hilly land, the valueless land, the land no white man wanted, this land was left to the former slaves. On such a patch of land outside Washington, a few continued their old ways, building little houses, planting gardens and bringing up their children as free men, as human beings and as citizens of their country. And continued at dawn to go into Washington, seeking whatever work they could find. In one hundred years, Washington has expanded and bypassed this hamlet. Now a housing project for whites stands nearby on what once was a great plantation; a long wire fence separates the two communities from one another. The high fence has been there for years and is now falling down in places. No one thought much of it until three white college students, working with CORE (Congress of Racial Equality) came into this neighborhood a little over a year ago. 'Things are changing around here,' explained the brown middle-aged family man who was now the leader and driving force in the community. The fence around his house was newly painted and he was proud of the handiwork. Continuing he said, 'One must have an incentive to repair all the big and little things that can break down around here.'
Protest meetings were taking place here against segregation; 'How did it all begin?' I asked. 'For most of us, it's like coming out of a long sleep; for the first time we're learning to think and act politically. The thing is to organize.' Then he told me of his uncle. In the thirties his uncle lived in New Jersey and together with the whites helped organize the workers into a labor union. Then he was warned that his position within the union was getting too strong for a black man; it would be better to let a white man take his place. Perhaps he thought being up North made it different and he would be able to outsmart them, or at least hold out a bit longer, but it didn't work. They found him one day in an alley, with a bullet through his head. 'The family doesn't talk much about it now.' Then he added, 'They've always been able to buy out the Negro one way or another, and they've started on me, but this time we're not so defenseless, they're not going to buy me out.'

'The people around here are suspicious of whites and strangers, they want to be left alone. When these three white college kids came, we couldn't figure out what they were after. But, we all had been watching T.V. and had seen Negro students being beaten at sit-ins. I started thinking it over – what did these kids have to gain from helping us? An older man or a businessman would use us in some way for his profit; the politician would want our votes if he made it easier for us to vote, but these kids were from CORE and would soon be going back to school. It was just because they were kids and couldn't stay long that I watched them and then joined them.'

What had aroused the community and become the symbol of all the wrongs inflicted upon the Negroes by the whites was the one-and-a-half mile fence. It was the one object which, when pointed out and when they thought about it, aroused indignation and commitment. 'Put there to keep us out,' one elderly woman said. 'In the old days I could walk across to the food market in minutes. Now sometimes I'm just too tired after working all day in town to walk around for the family food, it seems to be getting longer and longer.' While investigating the fence, they had uncovered surveyor's plans made before the housing project had been put up. The plans called for a highway through the colored communities but now it ran through the white communities, thus adding to the whites' land values while increasing by miles the distance the Negroes had to drive to reach home. Also, streets were meant to continue across the area where now the fence stands; this would also have added to the land value of the Negro homes. No one in the Negro community knew or was consulted about the change in plans.

It is also the little vexation that wearies. The Negro side of the fence is used as a dumping ground by both communities and the accumulated waste of years lays there now. The fence area also became the playground for the children; for the white and black boys, it was a tournament field where they could throw stones at one another; all this was watched by guards from the housing project who kept the colored kids from crossing the line.

One and all on the Negro side agreed the fence must go. Two weeks ago a mass meeting was held where many were for tearing down this symbol of white contempt. In the end, it was agreed that another public meeting should be held. The owners of the housing project would be asked to speak and any other whites interested in good community relations would be invited. But who were the owners? Most still knew it as the old plantation and assumed it still belonged to the old family. After much difficulty, it was discovered a Northern realty firm controlled this segregated project.

The public meeting brought out about fifty people, and no teenagers were permitted within the church building. Of the whites, there were three seminary students, the three from CORE, a housing official sent by the government and myself. The vice-president of the realty firm turned out to be an impressive and articulate Negro in his late forties.

'I'm one of you and I'm here to help; together we can solve this problem,' the vice-president said in a tone of understanding and concern. 'But the first one to start pulling down that fence I'll have arrested for trespassing on private property,' his voice now rising to one demanding respect and fear.

'I'm black and I'm vice-president of one of

the biggest realty firms on the east coast. We do a business in the millions and this project is but one of many we have both North and South. I have authority to make binding any decision that we can agree upon here, but I must make clear to you that any settlement will have to rest upon good business sense. I know what business sense is, that's why I've reached the top in this firm. Let me tell you a few of the things I've been doing here today. First, I've looked over every inch of the fence, then I went into town and looked through all the old and new plans for this district. I talked with the government housing official. I've been looking at the houses on both sides and listened to both points of view. So unlike most of you who want to act before knowing the facts, I know the situation exactly and most important, I know what my rights are under the law and how to prosecute those denying me them. My rights are to keep the fence there as long as I feel justified. All the maps show that the whole length of the fence stands some two yards on our side of the property line. So, although it may be unknown to you, all that junk is on our property and we shall promptly clean it up. But I want you to understand, the junk hasn't all come from the project. We have the legal right to prosecute any one of you who has been dumping there.'

'Now, for those who walk to the food market. We'll cut a path with a fence on both sides, one along the cemetery wall so as to keep the children out of the cemetery, the other to keep the kids out of the back yards where the people hang their wash. We don't have to do this, it's going to cost us money but I think you have a just claim. The real problem is that many of your grievances stem from faults in your neighborhood that can be remedied by speaking to the proper government agencies. I know personally the individuals to contact that will get things moving and I will visit their offices when we can agree on your needs. Lastly, we're both colored and I feel your problem is also mine. You need good professional advice in community matters and although my time is expensive, I'm willing to drop

what important work I may be doing to come down here and freely help you out. And let me tell you, you need the kind of help I'm in a position to give. Remember one thing, for good business reasons I'm not going to let you pull that fence down. I'll tell you why.'

There was a pause of a few moments as he watched his words sink into a stilled audience composed mostly of people who worked as porters, truck drivers or household help, and some who couldn't read or write.

'I'll tell you why. This neighborhood is a junk heap. Many of you don't want to pay the taxes it costs to pave the streets and sidewalks, so you have none. It costs money for the trucks and men needed to keep the woods, fields, lots and streets clean. You don't want to pay, so the streets and lots are heaped high with junk and auto wrecks. The whites seeing this also find it a good place to abandon valueless autos and junk. But worse, some of you think it's a sign of wealth when you have two or three abandoned autos in your front yard. I can't blame the whites for wanting that fence there.

'Now you talk about integration. You're not ready for integration. Most of you could not afford the rent nor meet the standards expected in the housing project. I'd be a fool and poor businessman to desegregate now. Make this neighborhood respectable and I'll have that fence down and the project desegregated, but not before.

'Concentrate on your real needs: clean this place up. I'll see that the government sends trucks in to haul the autos away while my firm will clean up around the fence. This will be the first step in adding value to your property and should help in making them think twice before condemning it as a slum. Make the first step and the rest will come. Can we agree upon this?'

The whites kept discreetly quiet. Yes, yes, distinctly could be heard, yes, yes, they would do as he said. A few rose to speak in agreement, while contented smiles appeared on relieved faces, relieved at the outcome of this dreaded evening. Yes, yes,

they would do as he said.

A middle-aged man stood up after some of the others had spoken. He seemed a drunkard of sorts and a groan arose as he began to speak in a voice grasping for thoughts. 'The fence is there because the whites want it that way, our integrity begins with the fence.' Shouts of annoyance, telling him to sit down and now is not the time to bring this up, stopped him. The housing official and the vice-president soon left, disappearing into the lightless night. Once more the building became the house of God as those remaining stood with their backs to the wall, linked hands and, swaying to the rhythm, sang a song learned from the students:

We shall overcome,
We shall overcome,
We shall overcome, some day.
Oh, deep in my heart,
I do believe,
We shall overcome, some day.

Outside, looking back through the window, I could see the electric light refracted through the droplets on the glass, condensation of the warm atmosphere that had pervaded the hall.

It rained the next day, enough to turn the streets into a sea of mud. The community leader and I walked along the half-fallen fence, now overgrown with bushes. On the other side some whites were going about their business, while on our side a teenager came by, picked up a broken object, studied it half in interest and then with natural agility, flung it at the fence. My companion said, 'Sometimes people can be so beaten down that they just don't care, nothing will interest them anymore, not even their own welfare. They've been thinking we're dogs, and treating us as dogs, some of us have become dogs. There's so much to be done here, even in such little things as street signs. People here just don't earn the money. The government ignores us, always rejecting our requests, in their eyes we just don't exist. The street signs: I've had to nail them up alone, with my own money buy the wood and paint, everything I've had to do alone and now

I'll fill the holes in the road, alone. Sometimes, I look at that fence and feel I'm in a cage – it overwhelms me and I want to smash at it and then I feel my bloody hands and broken bones. You're a man, not an animal, I tell myself – after a time I'm standing there hopeless and I want to forget the fence and everything on the other side, I just want to forget.'

Virginia

'My brother will be a general by the time he is forty-five, if he doesn't get killed,' said the government official working for the state's anti-poverty program. 'He is one of those brilliant career officers that shoots up to the top because he is dedicated, efficient and courageous. It's maddening how clear he can be when thinking through military problems and yet when I talk to him about the need for this anti-poverty program, he closes up and keeps repeating "creeping socialism" and "this country is going to the dogs!" and "the Negro picketing is creating division in America, while the Army is out there fighting to keep America free from Socialism and Communism." On and on he goes, saying. "All this creeping socialism will be the end of our American democratic system." Now, when we get together, poverty isn't discussed.'
He sat behind his government desk thinking, suddenly he burst out, 'What a contradictory reactionary he can be! Why, an Army is one of the most undemocratic, socialist, communist organizations that one could imagine in this world – besides all the other things that it is – and he has made the perfection of it his life work – and then calls this pitiful little that we do for the poor, "creeping socialism." '

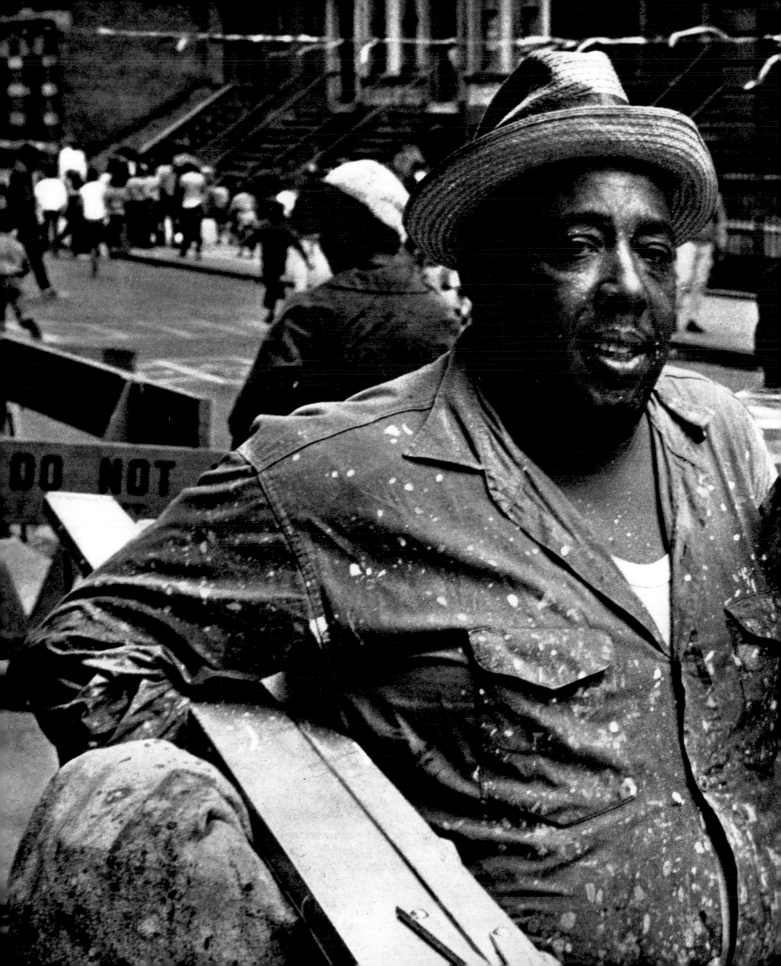

p. 78-79:

'Delivery Boys' in New York's garment district.

p. 80-81:

The overseer sat watching the men: he never smiled, he never questioned and he spoke only when giving instruction. The men's lunch break was still ten minutes off but he had already jumped the gun and was now eating alone in the cabin of the dirt truck. He refused to look at the colored work crew; he was paid to see that they worked, he was not paid to sit or eat with them.

p. 82-83:

Barber shop in South Carolina.

p. 84-85:

Sorting on a North Carolina tobacco farm.

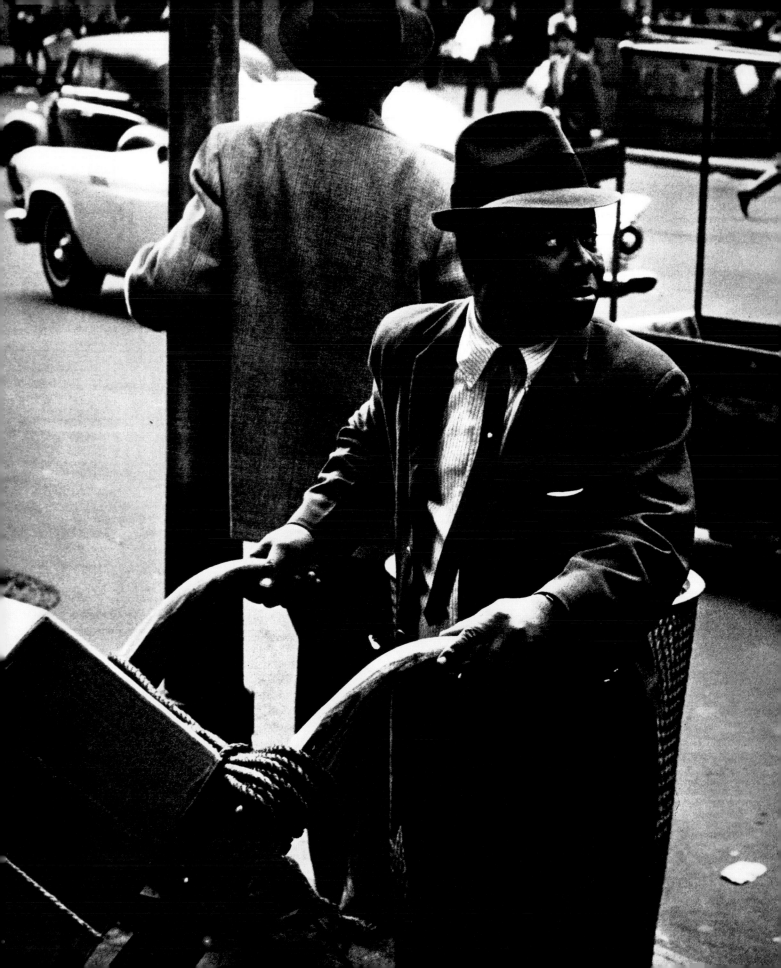

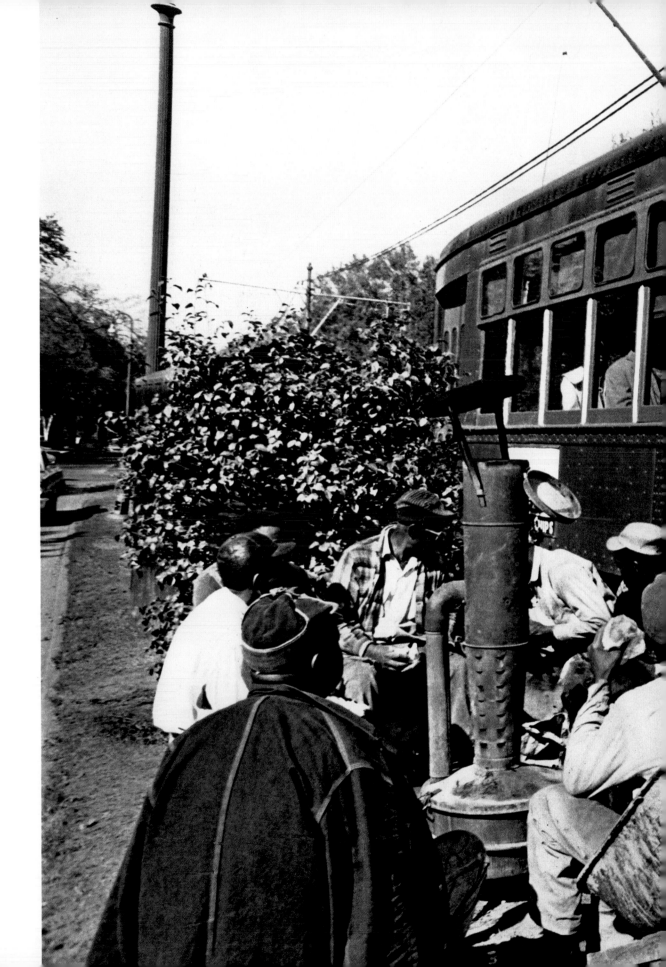

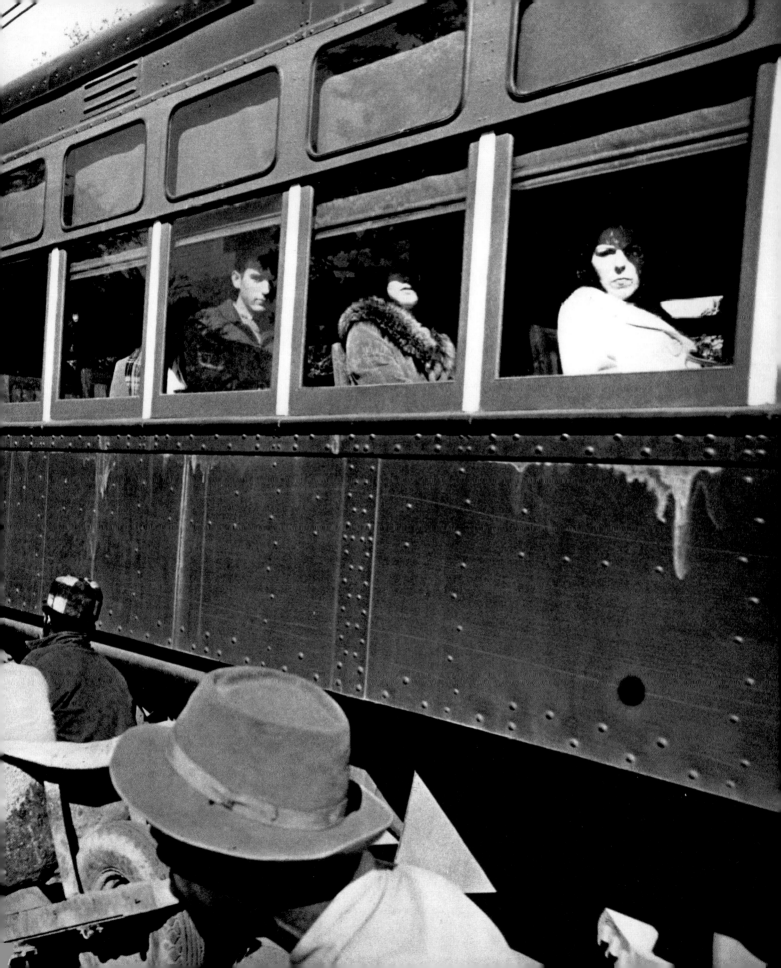

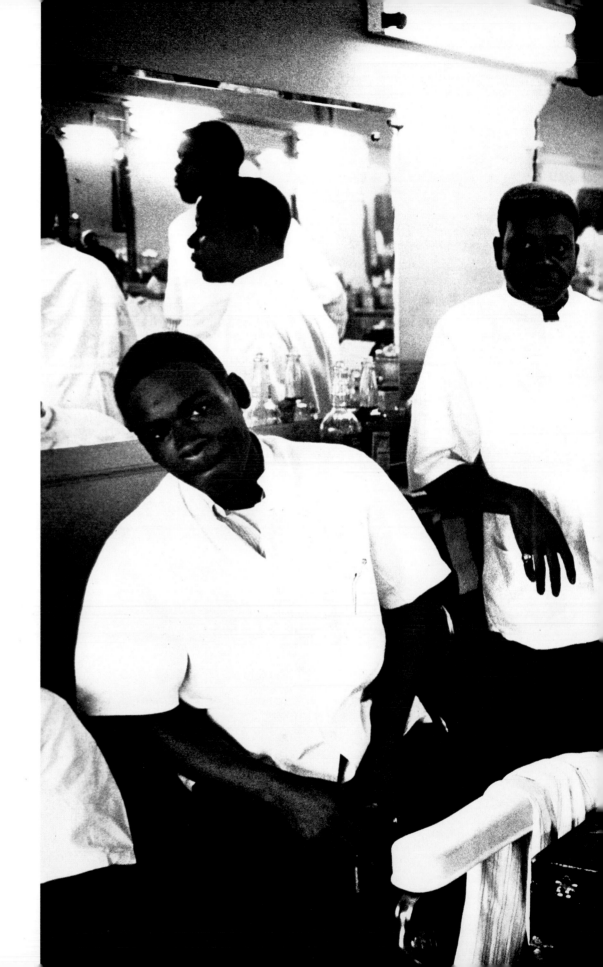

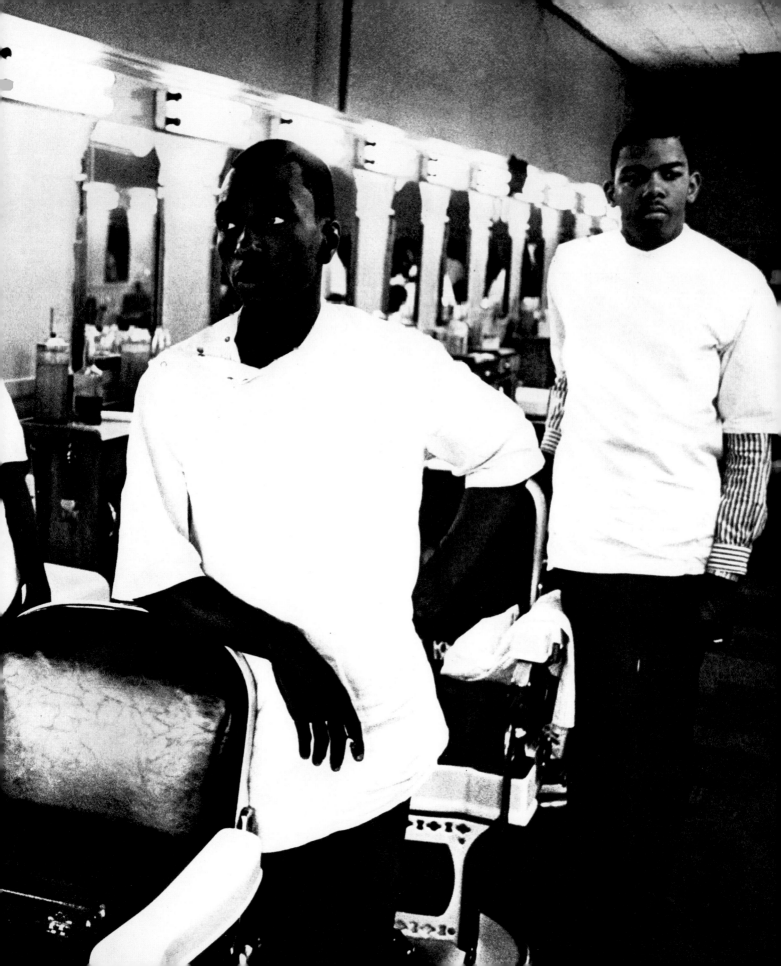

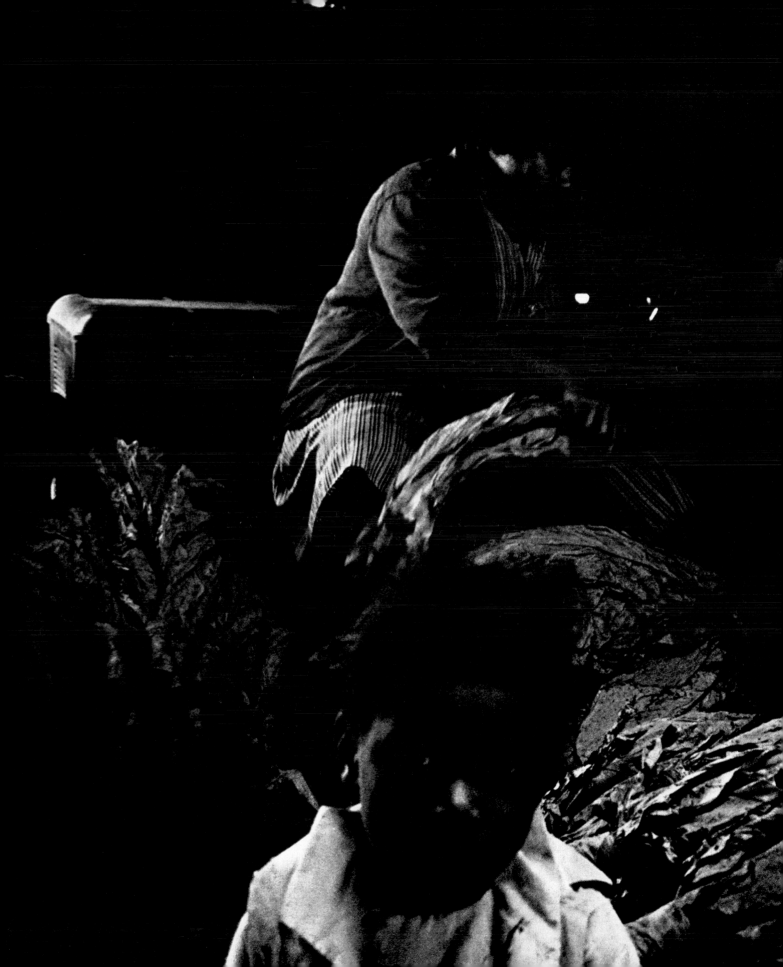

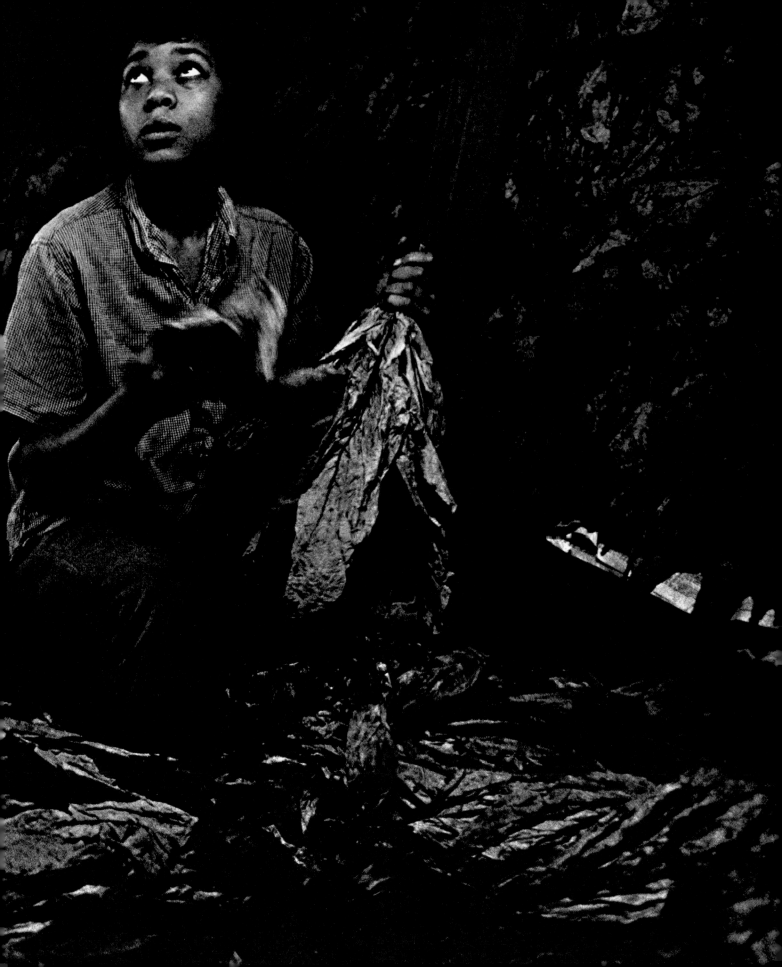

Mount Vernon, Virginia

In the home of George Washington there is a stone model of the Bastille prison (the stone had been taken from the original Bastille during the French revolution and carved into its present form) given to Washington by the Marquis de Lafayette, perhaps to represent the new-found love of both countries for the civil liberties man had now attained.
I was pushed through Washington's home . . . bus loads of school children forced me on . . . and seeing all the fathers with crying babies, one felt as if he were in a giant doll house. A young couple asked the guard: 'Where are the slave quarters?' And the school children asked one another: 'How many slaves did he have?' It seemed to be always the same, it was the slave cottages they came to study. To satisfy their wishes the slave quarters at this national shrine were being restored.

p. 87:
Georgia, cotton fields

In the distance, the parents of the child at work.

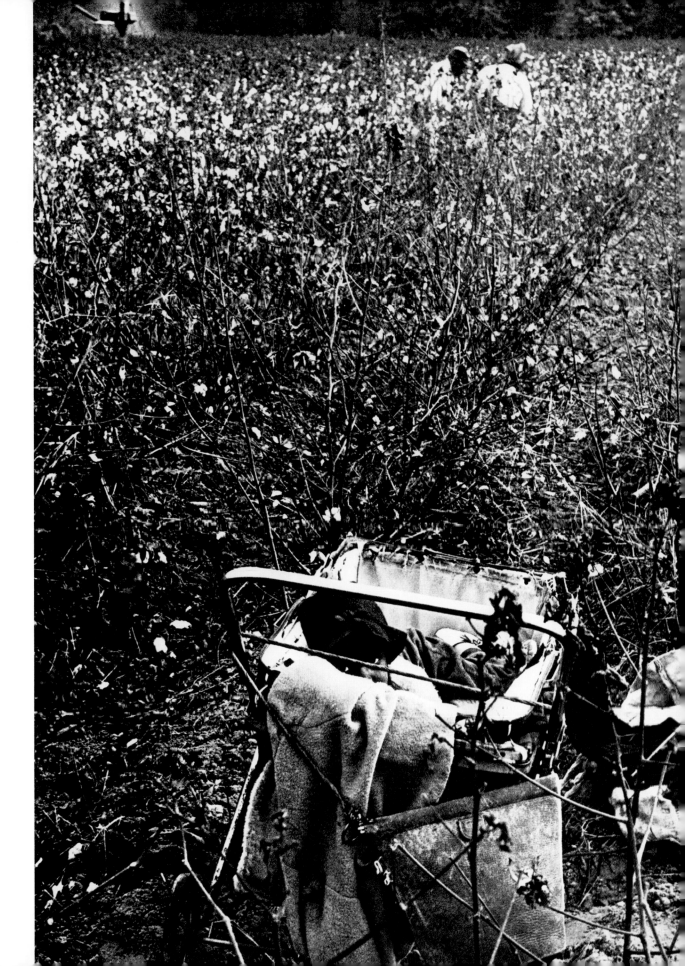

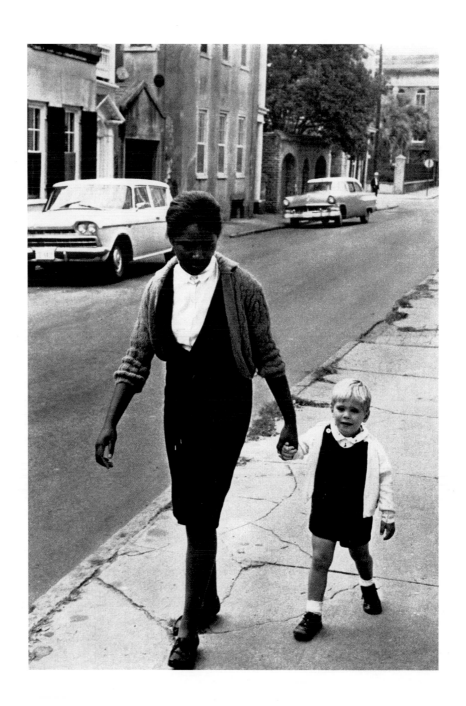

p. 91:

'Every wire has its function,' he said, opening
the door and getting in. 'I like things to run
perfectly. Look at this, without my turning
I can get any view I want. These antennas
are set up for HiFi; the wife thinks it's loud
but I like it that way when I'm driving. I'm an
amateur Ham operator, got the license
and all. Picked up all these little tricks in
the army. Even got a telephone in here but
keep it disconnected; all my friends used
to call their girl-friends. Unbelievable,
ain't it? Did it all myself. Had a portable
T.V. set in it but the police made me take
it out, got me while I stopped for a red light,
saw me watching it.'

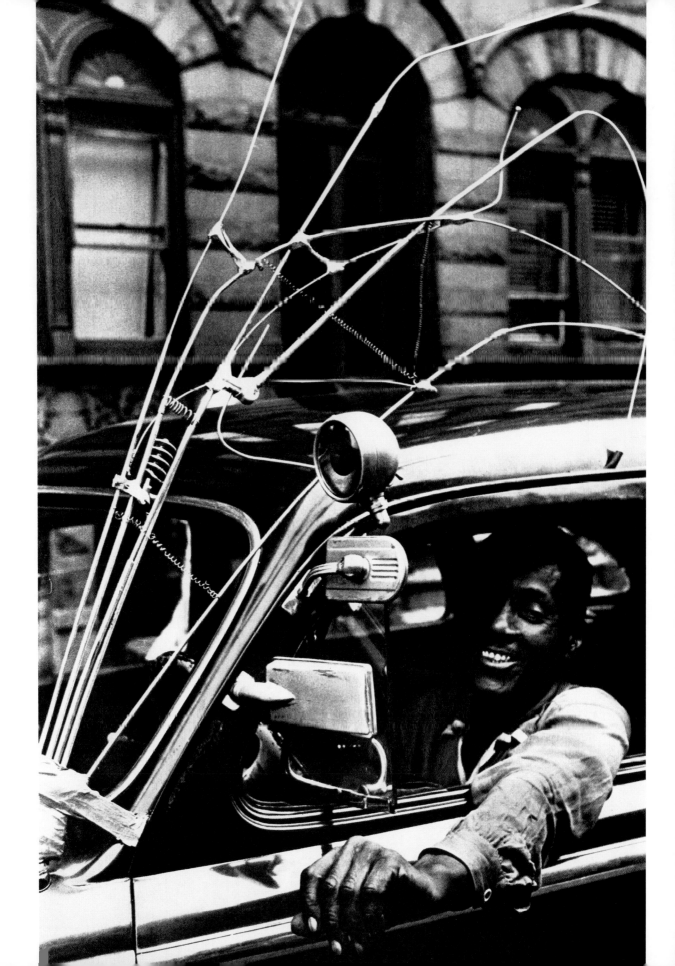

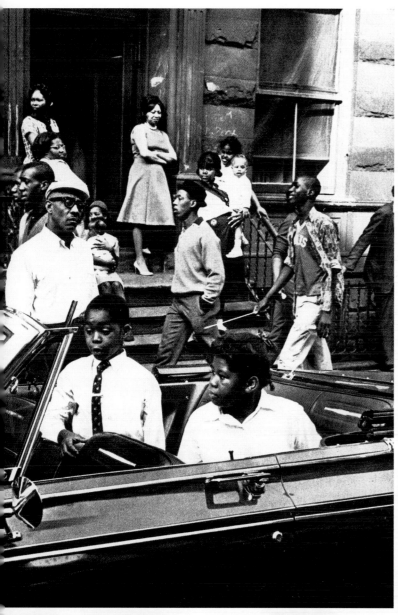

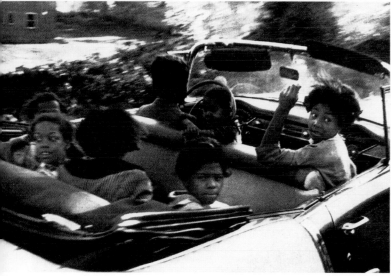

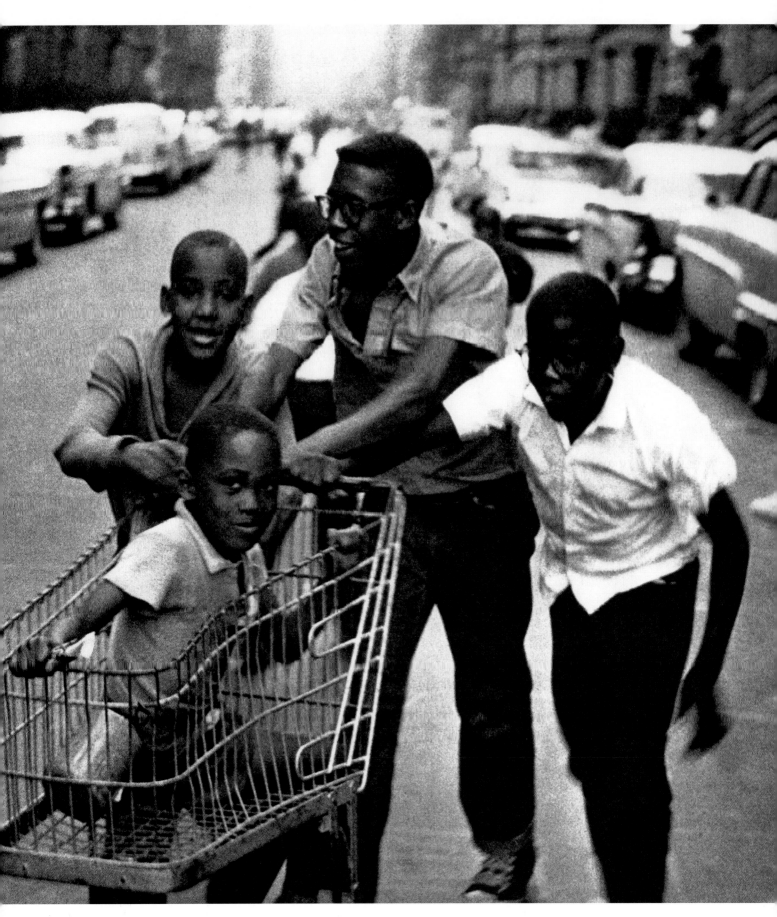

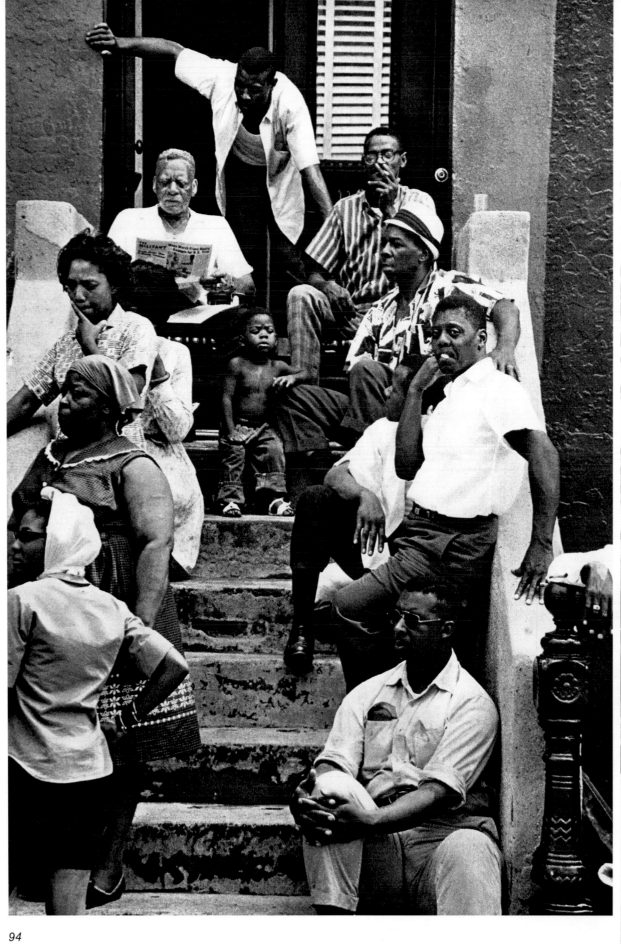

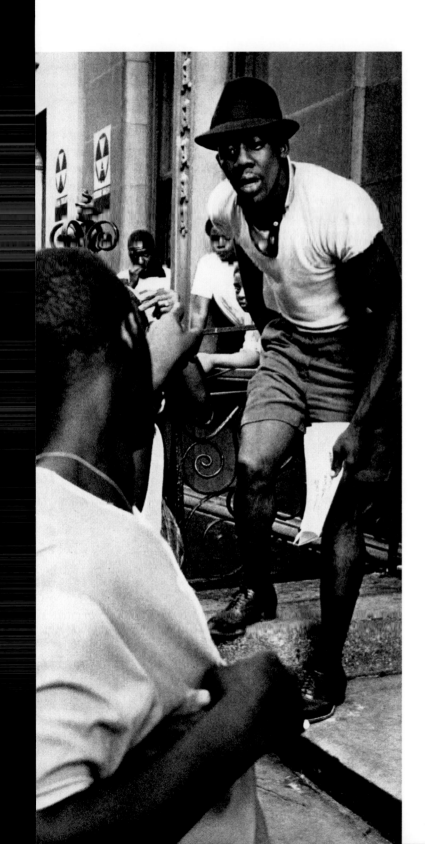
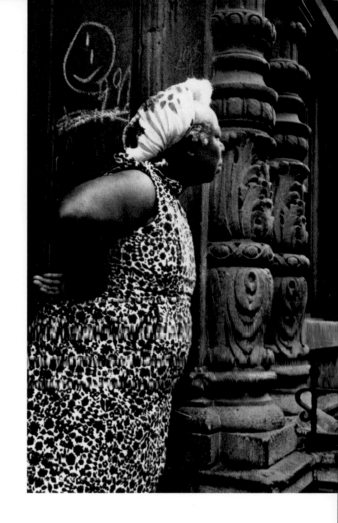

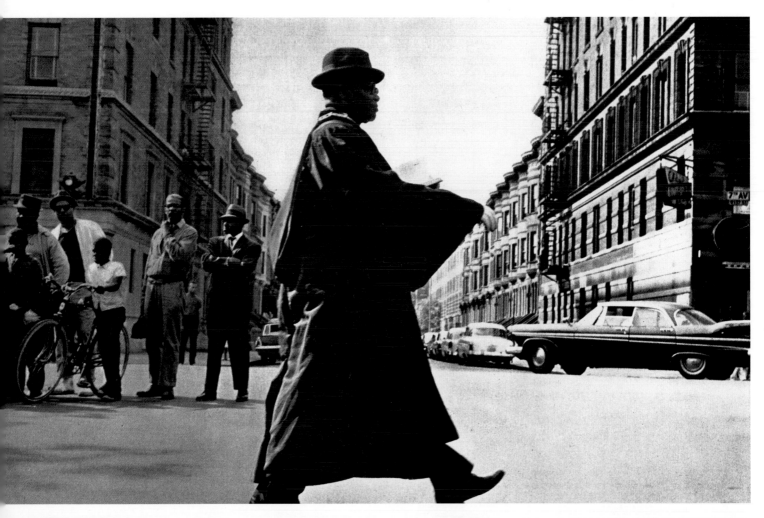

The Negro-white conflict is becoming greatest in the giant Negro ghettos of the cities, from which the whites are fleeing, creating rings of white suburbs around the cities, strangling the Negro within. The difference between a ghetto and a neighborhood is that a man can always choose to leave his neighborhood. But in a ghetto he is locked in, and for most . . . especially the sensitive and the aspiring . . . it becomes a prison.

Unless it is to sell something, white people don't go into Negro neighborhoods. In some neighborhoods the conditions are so bad Negroes are either ashamed, frightened or unwilling to come out; we then have almost complete isolation between the races.

'That's right, yes sir,' the crowd responded. The speaker's voice flowed above the glowing eyes and filled the darkening street. Pressed up behind me a burly working man seemed to be devouring the speaker's words. I could feel the Amens as they came up from under his guts, 'That's right, yes sir.' 'Jesus Christ was a black man,' the speaker went on, an open Bible in his hand. 'Black like all of us here and don't let any white man or black preacher tell you differently. Jesus Christ was a black man, it's written right here in the Bible.' and pointed a finger to a passage in the Bible, 'having kinky hair is how they described him. Well, look about you, who got the kinky hair? The whities down town? Red spots in the eyes fit that description? Hannibal was a black man, do the whities tell you that?
No!
Man it's time
we found out who the black man is.'

The reactions of the crowd varied, according to the moods of the individuals who joined it. The man beside me grew restless, and to no one in particular said his supper was waiting on the table. Then his eye caught mine and he said with a twinkle, 'Don't mean much, they're always talking that way.'

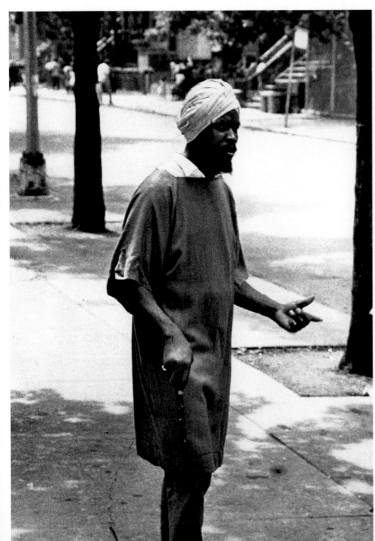
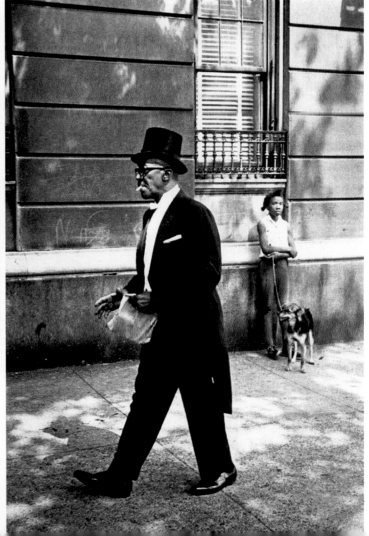

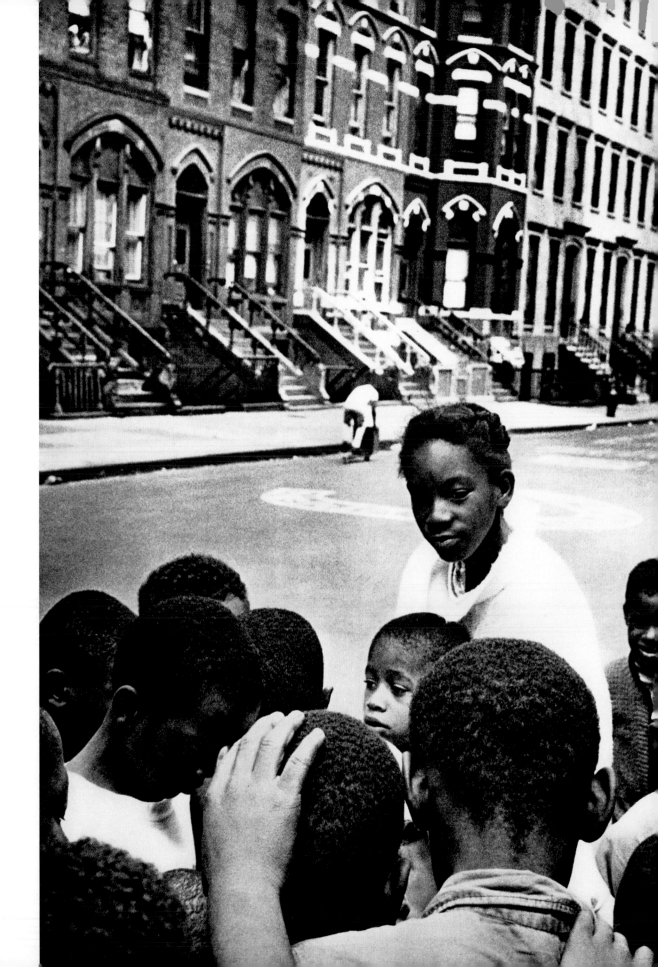

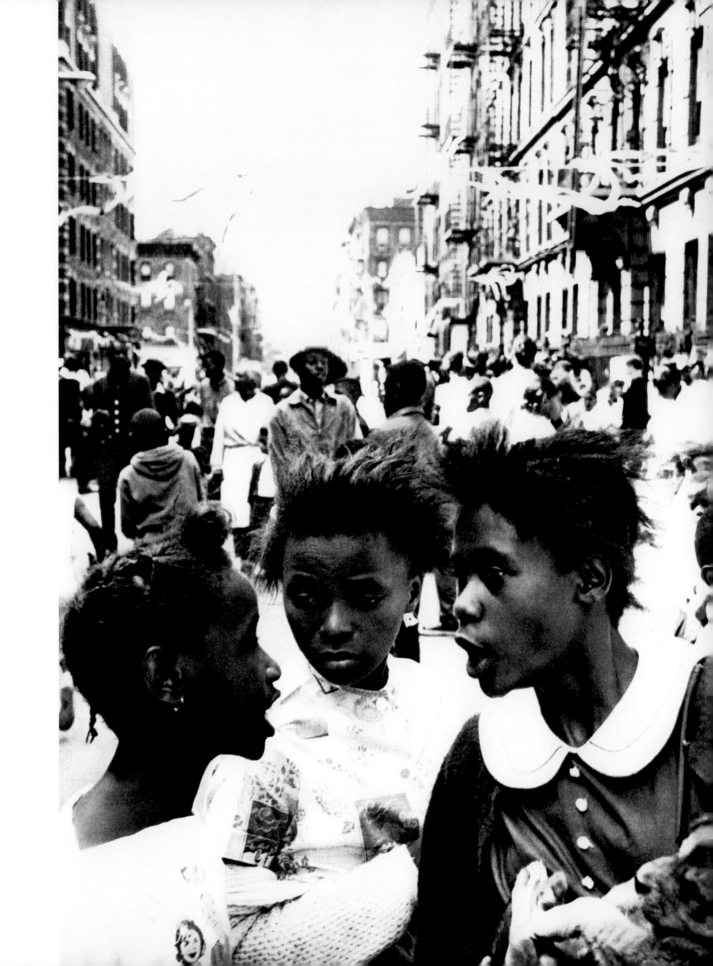

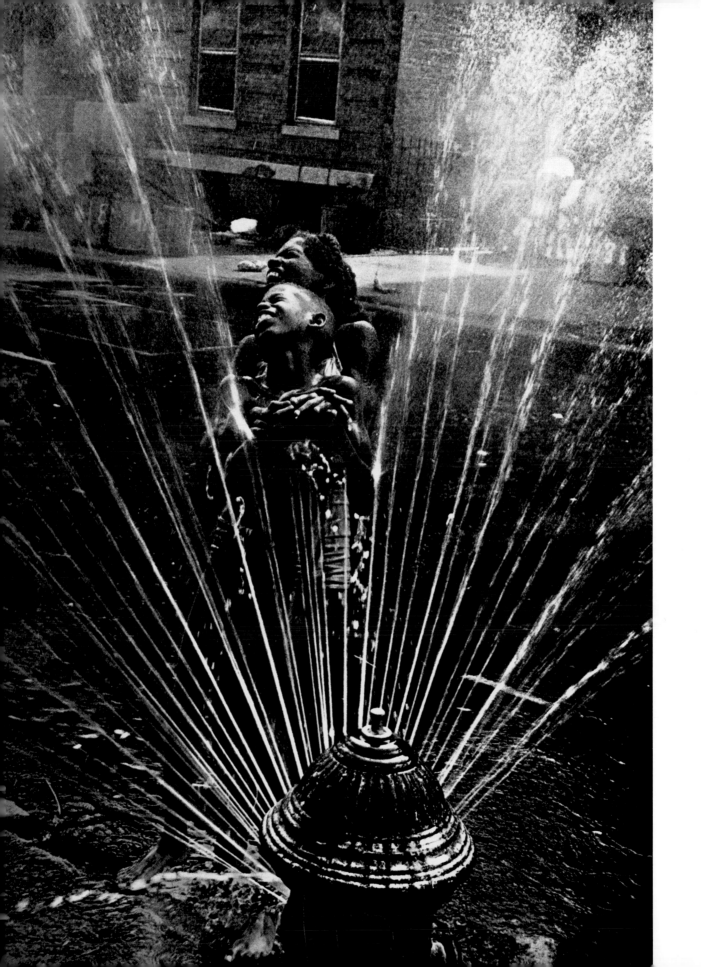

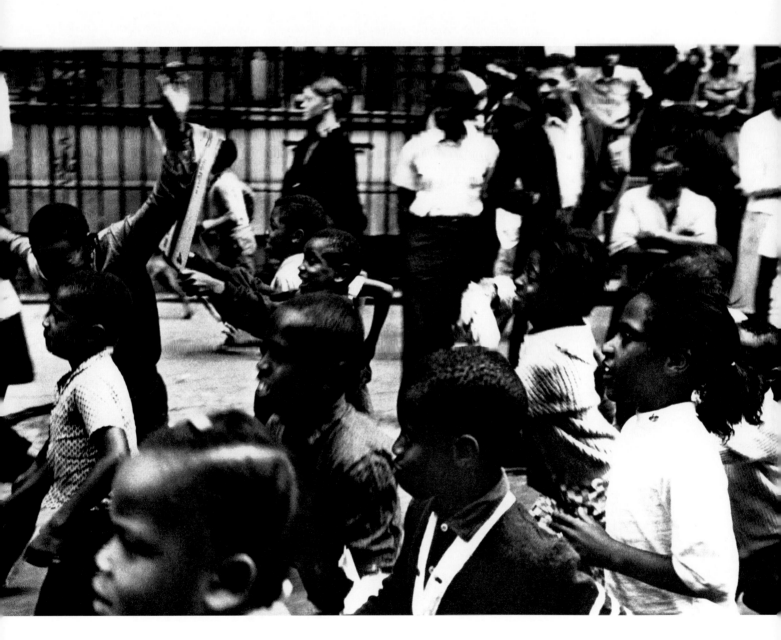

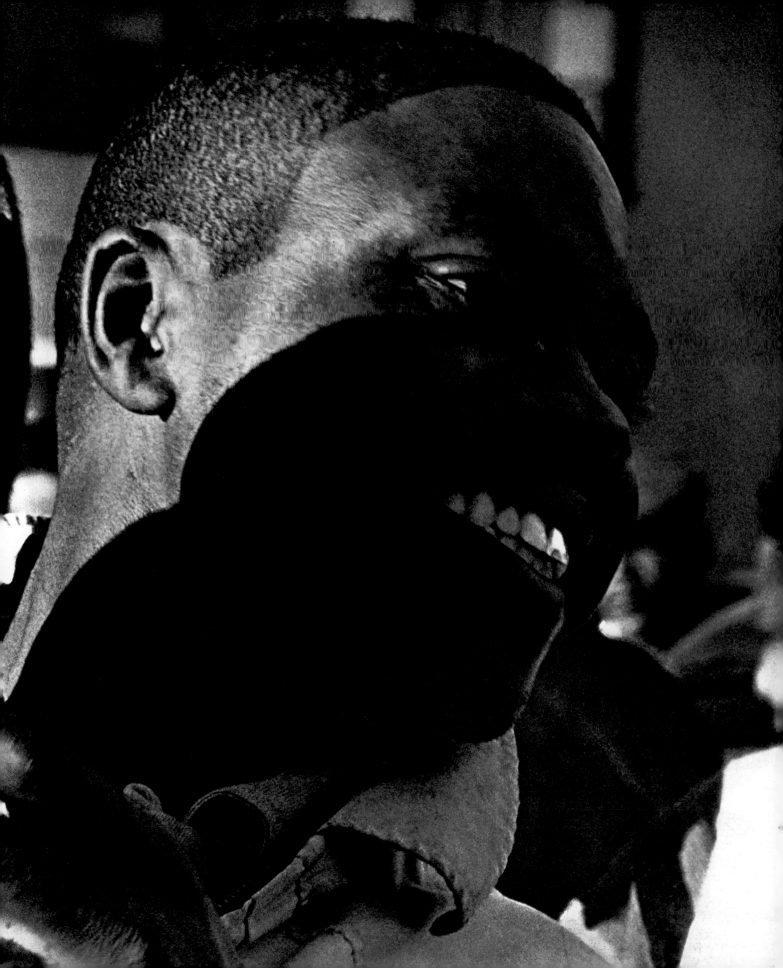

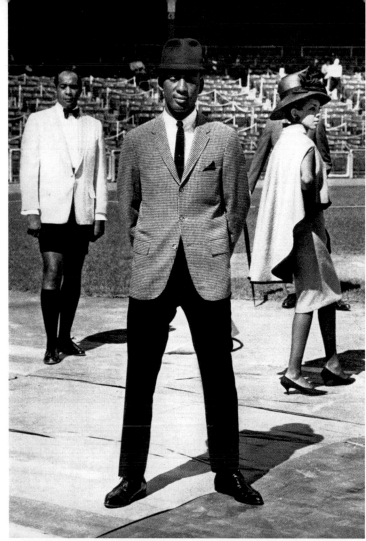
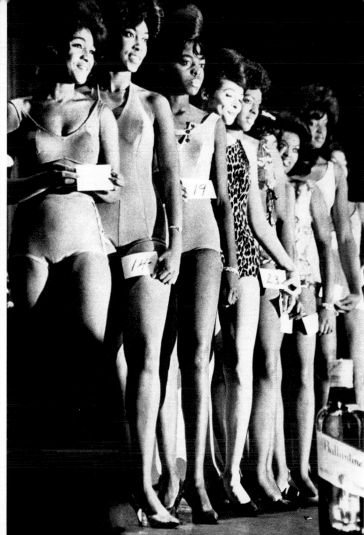
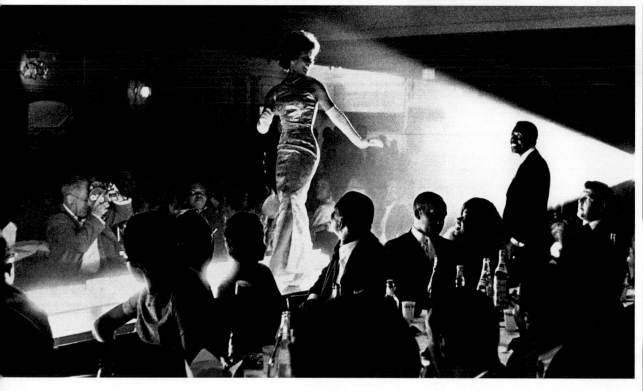

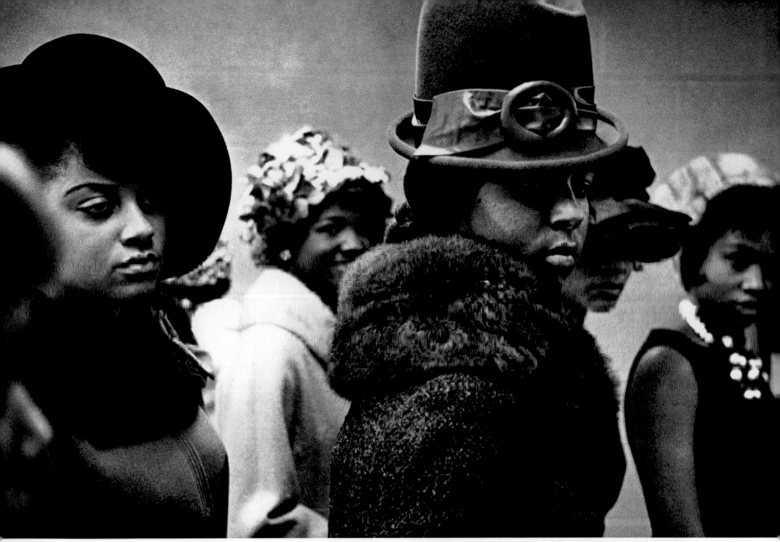

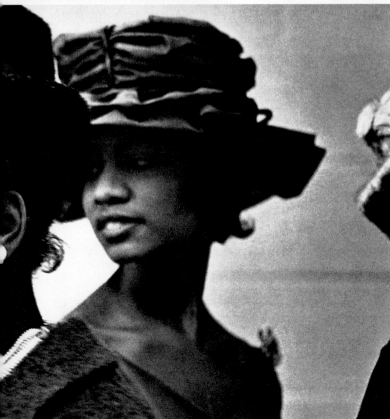

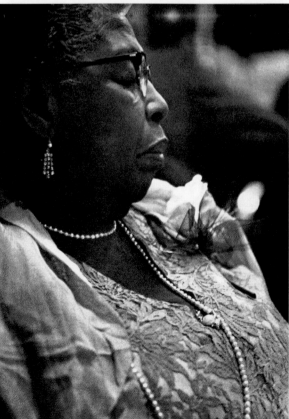

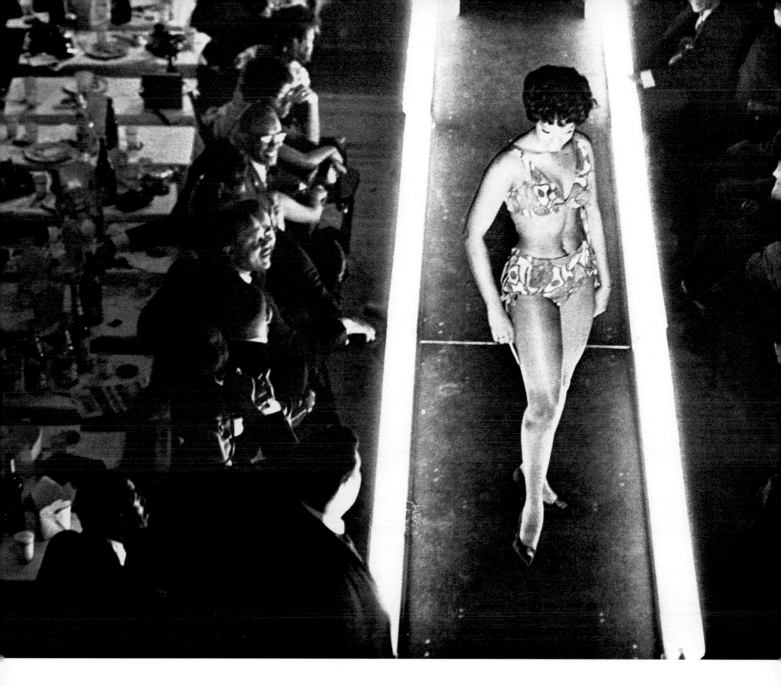

p. 105:

The annual amateur church fashion shows are occasions for inviting members of the mother church from down South. Often, as the Negroes flocked North, the elderly minister would send his son or a younger minister along to establish a branch church. Gathered together occasionally on the same city street are members of a particular Southern church, using a local Southern dialect, while on the next street another dialect is spoken.
This communication with the folks back home constitutes a valuable asset. It makes for a line of tradition in which newcomers to the big cities can establish themselves in a familiar and friendly atmosphere, instead of sinking and drowning in lonely despair within the city's complex structure.

p. 104 and 106:

Doing the cake walk at a beauty contest.

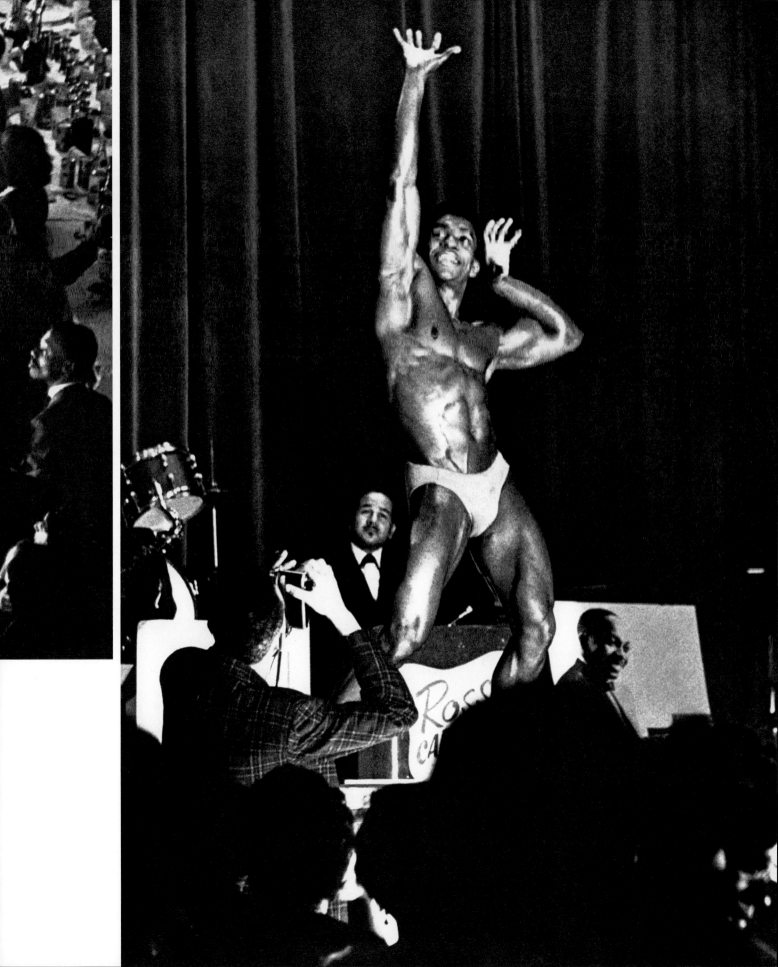

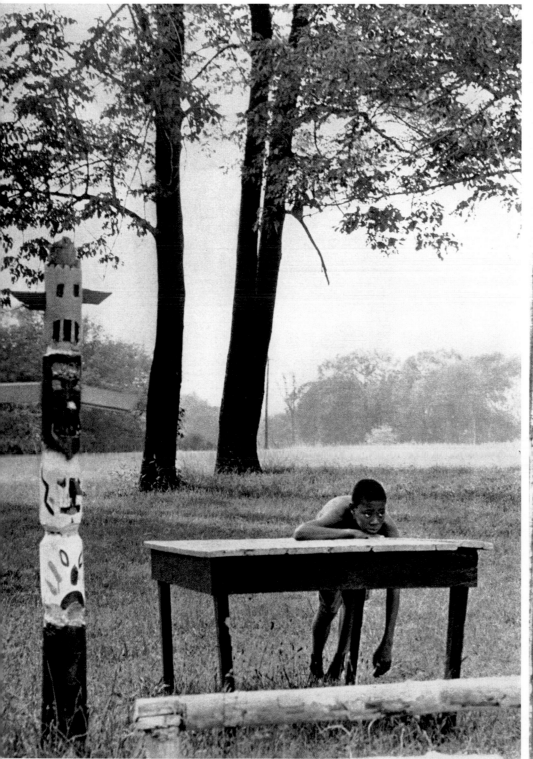
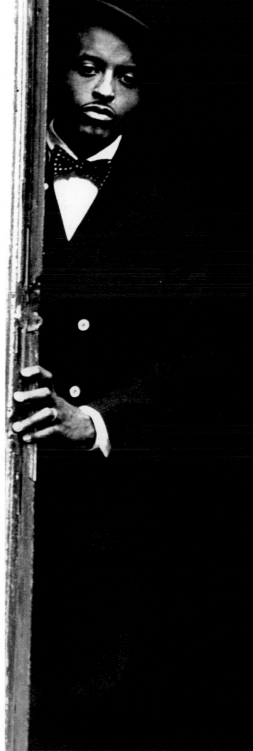

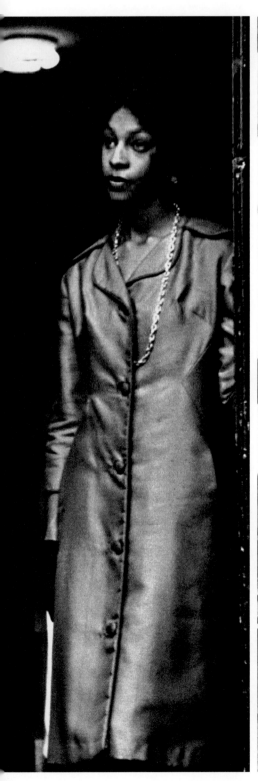
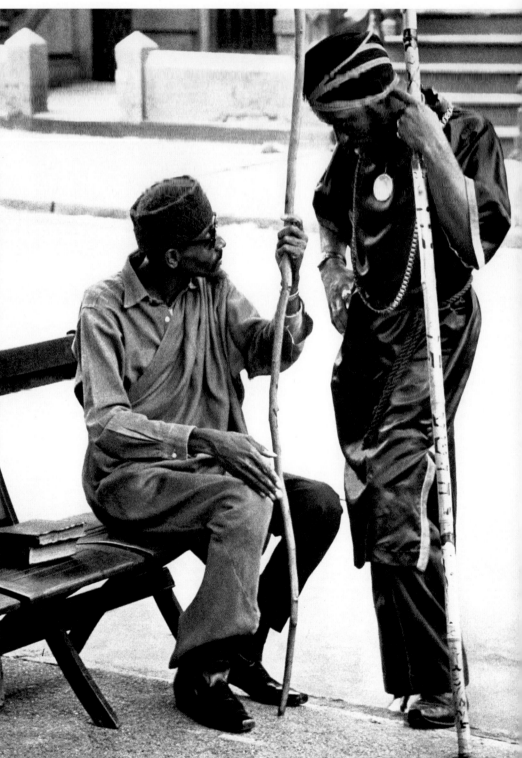

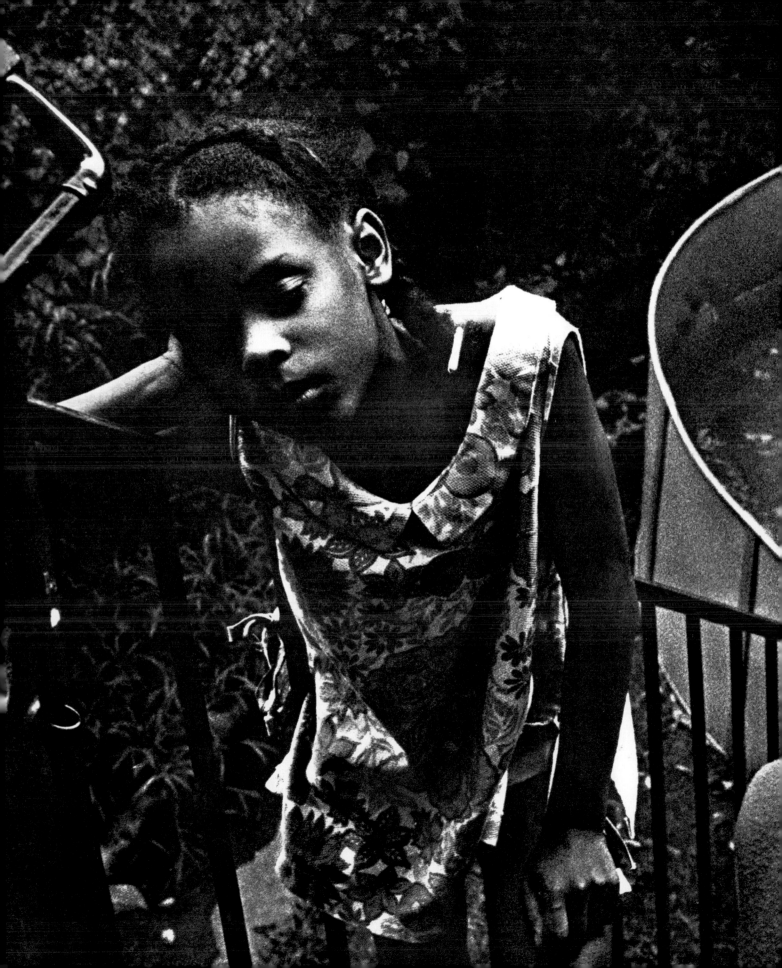

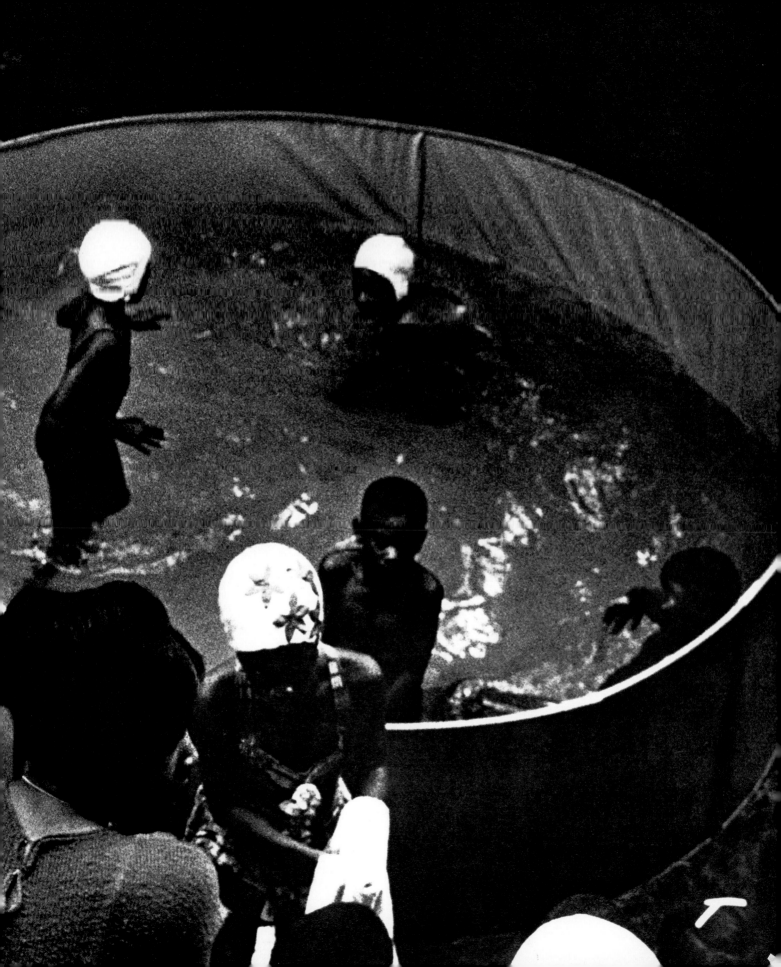

'Let's go out and make a little history,' Emma said. History? How does one make history? 'Watch me,' she said, 'I make history every day, just by being myself, just by being where I am, just by walking down the street, by standing, by talking, by shopping, yes, by walking into a food store and buying a can of beans. When people see me, they drop things, cars bump into each other, shop owners stop selling, policemen get nervous, and the colored sneak away in fear of a riot. It's then that I know I'm making history. It could be dangerous for a boy, but I get along. All I do is obey the law – the new law in this town – I obey it.'

Emma and I were sitting in the apartment of a young Southern white couple. The wife came from a well-to-do family and had spent her school years in Mississippi; while living in New Orleans' old French quarter, she met Negro intellectuals, became interested in civil rights and returned to Mississippi to spend time in its jails. Emma continued, 'The United States Congress passed an anti-discrimination law forbidding discrimination in public places, it's now the law of the land.'

I wondered what made whites and Negroes fear Emma's presence. Other Negroes lived in the French quarter, shopped and spoke with whites. Was it all in her manner? People could see her doing these things, doing them as if it were her right, and she was even enjoying herself. Negroes were supposed to be visible when working, otherwise out of sight. (Here tourists were white only. To see one of America's best tourist attractions, the beautiful old buildings, middle class Negroes chanced it by driving quickly through with closed windows.)

Now a young Negro girl walked about with white friends, dressed unlike a domestic servant, and was to be seen in the streets and shops. In other words, she had made herself visible.

But, she also was taking a psychological beating daily. Having white friends alienated her from her family, and the Negro community rejected her as an undesirable snob. Accepted only within a small circle of whites, she found herself treated as an object, to be dropped as a burden when her presence restricted their movements in the white community. For the whites moving through her life, it was a passing adventure in race relations. For her, life was a never-ending tragedy of disappointments, harassments, and acute self-conciousness. Knowingly, she offered herself at the altar in sacrifice. As she says, 'Someone must break the wall of hate and prejudice between us . . .'

Then, she repeats, 'Come along, I'll show you history, stopping the traffic by just walking down a street.'

p. 113-117:

Weddings, before and after.

112

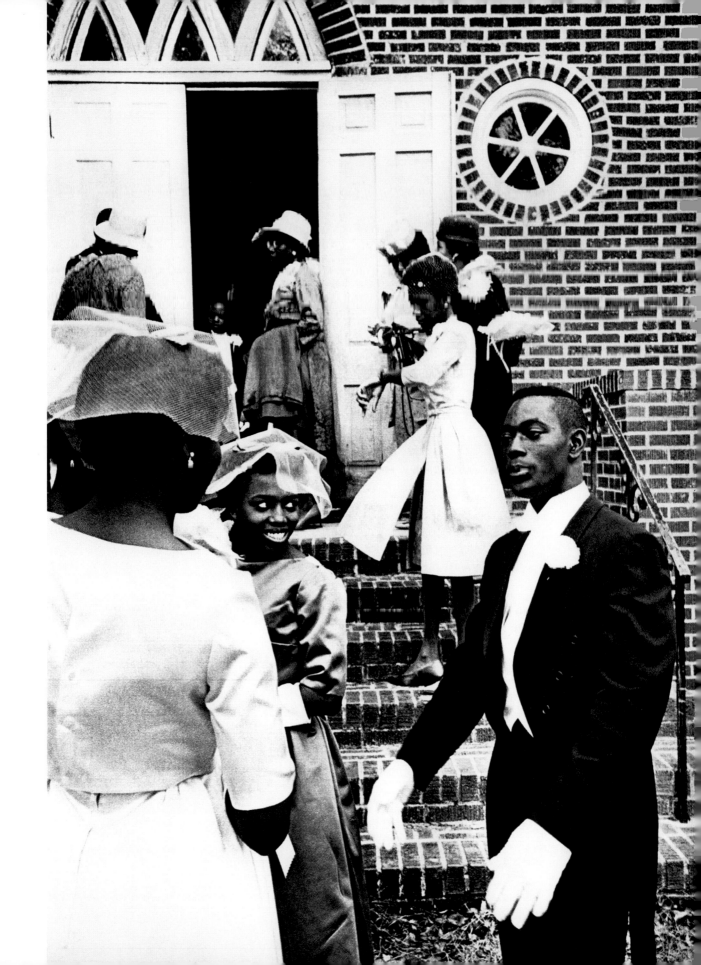

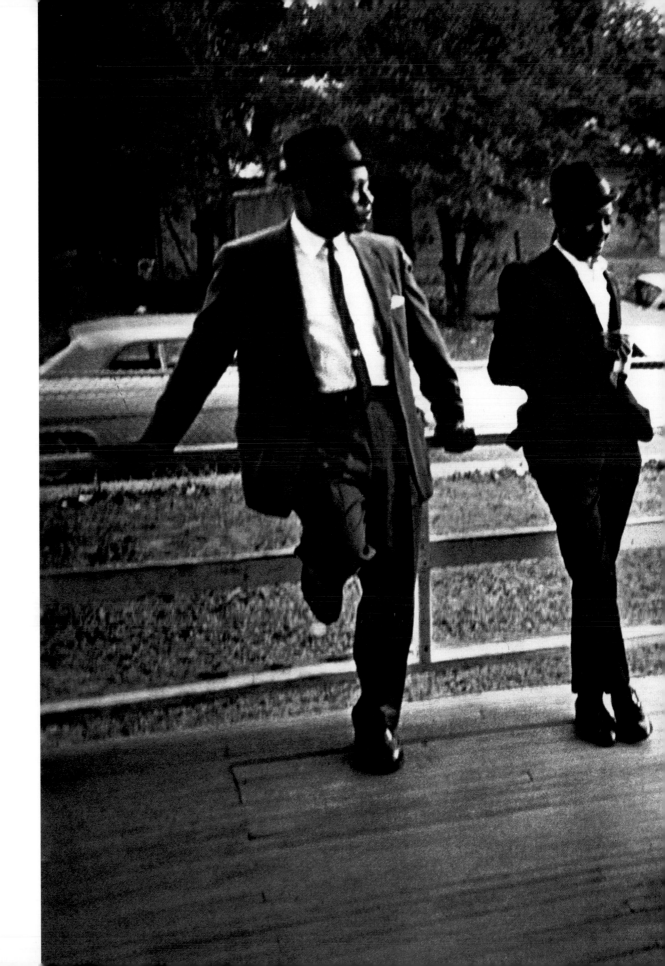

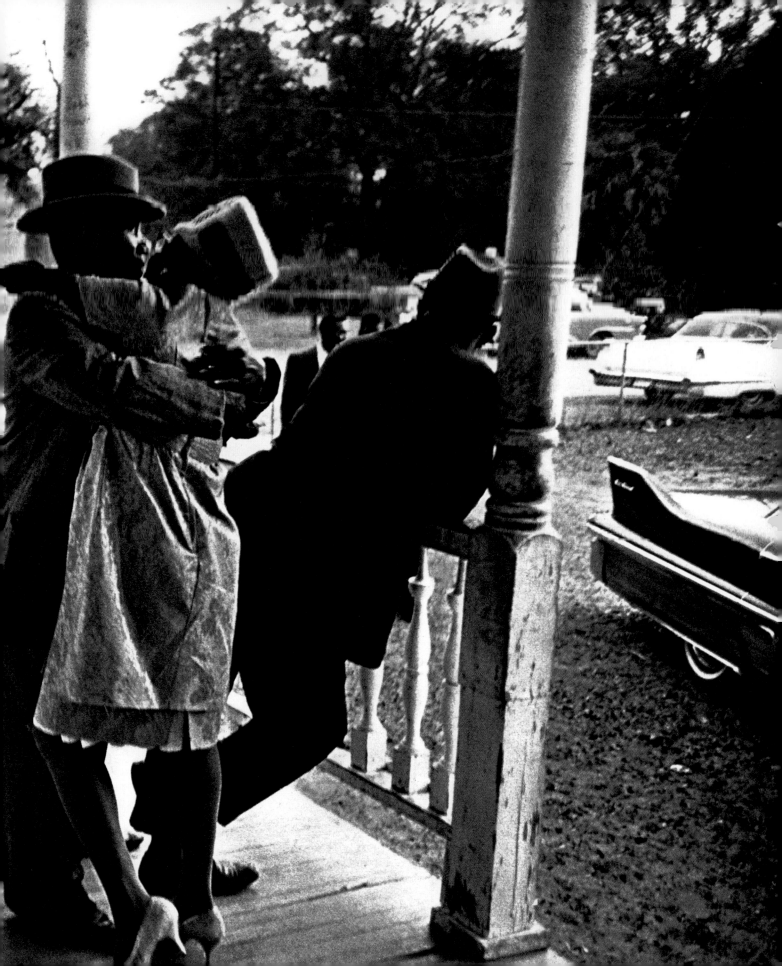

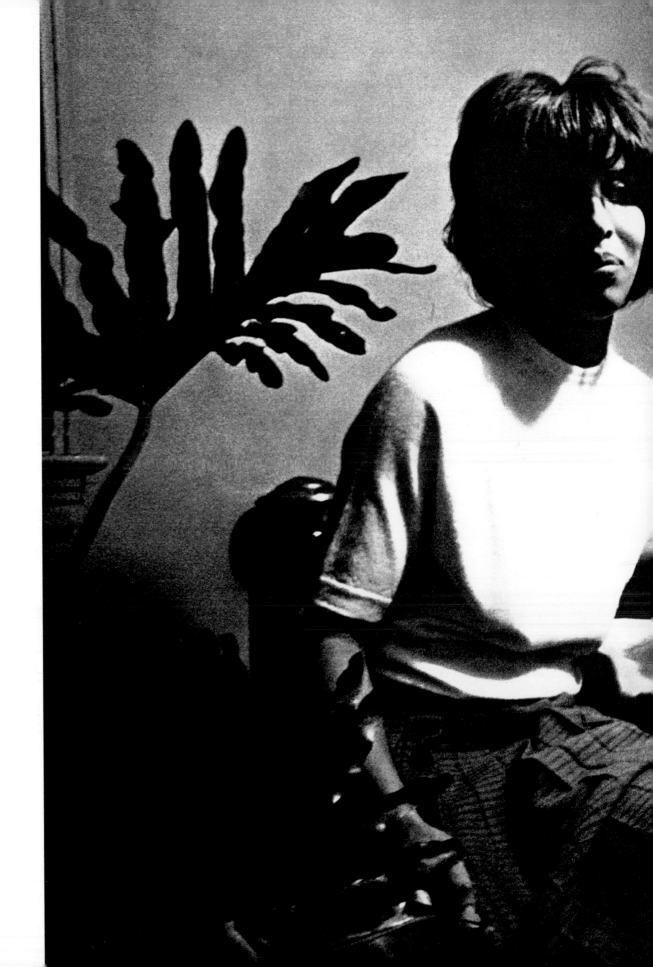

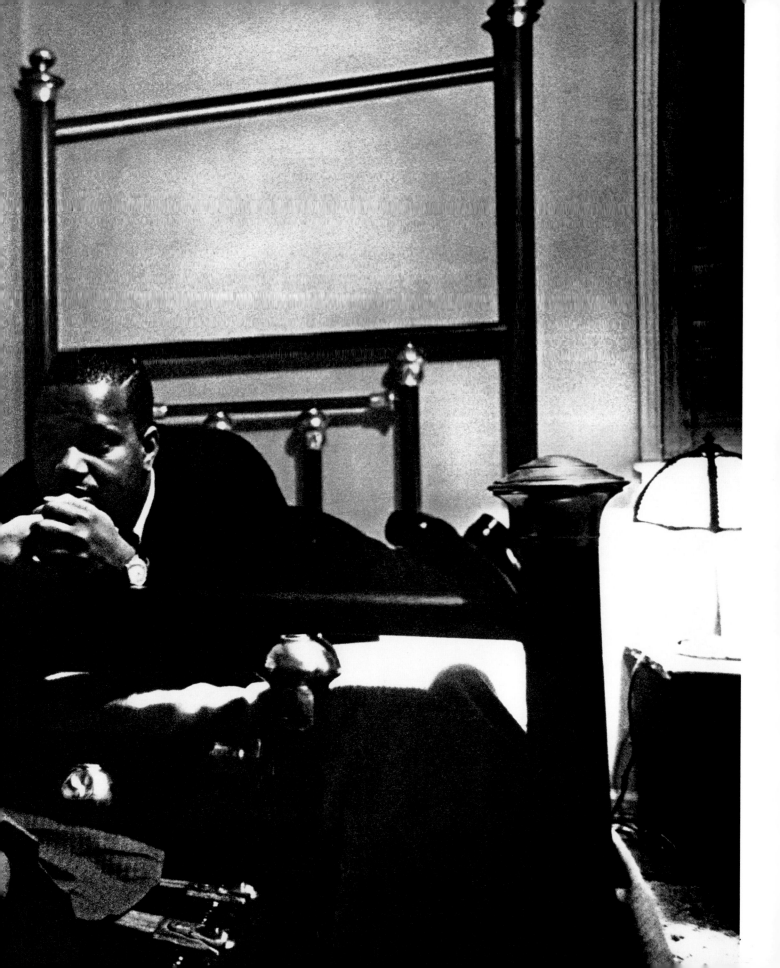

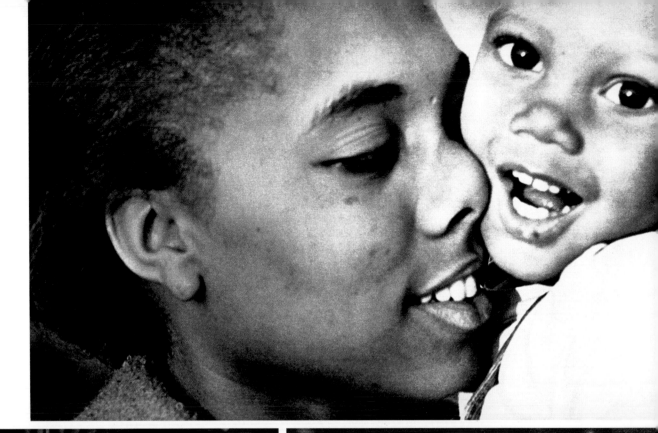
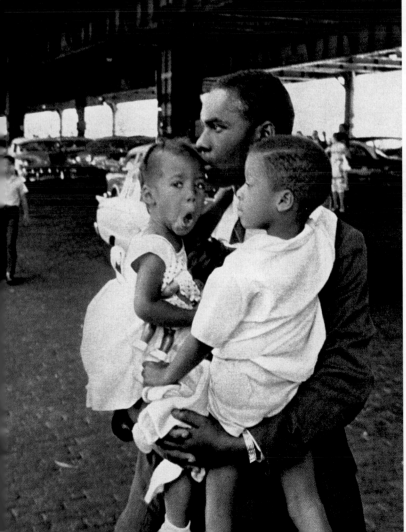
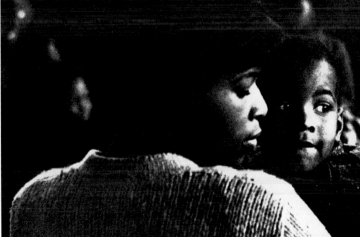
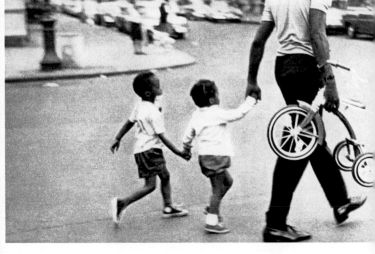

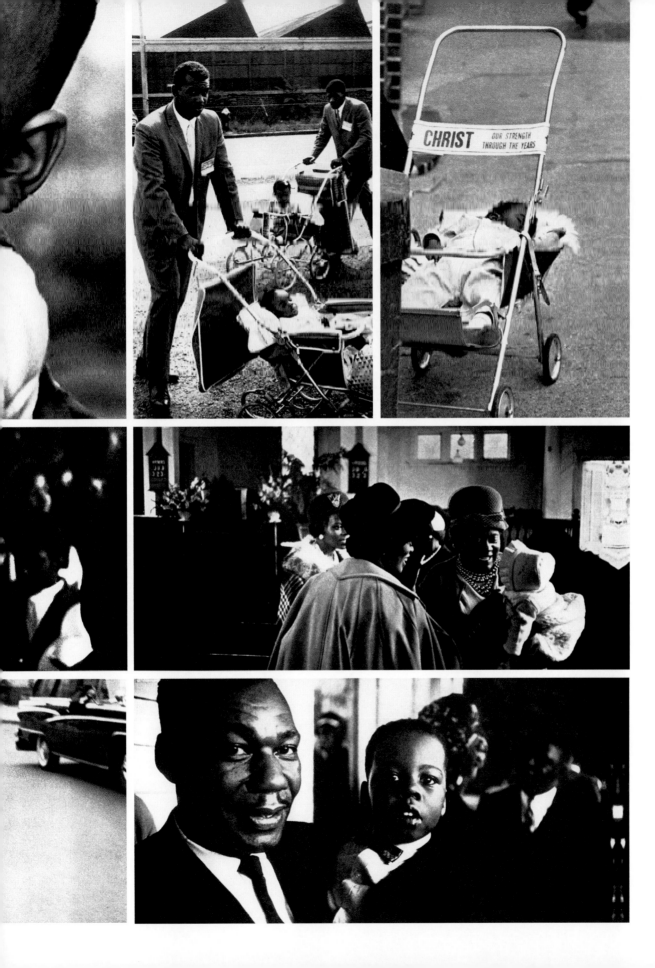

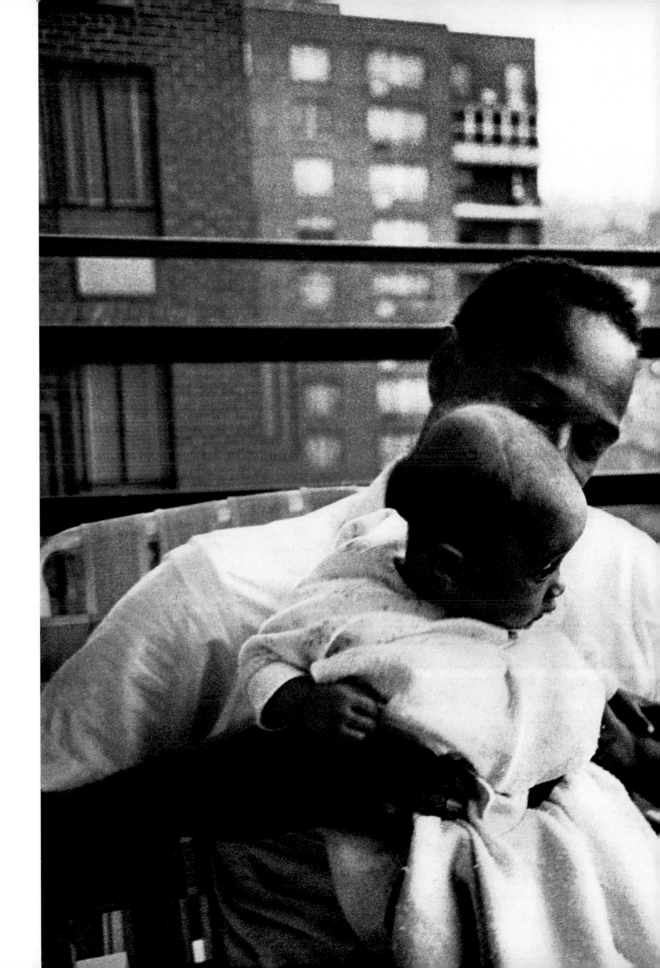

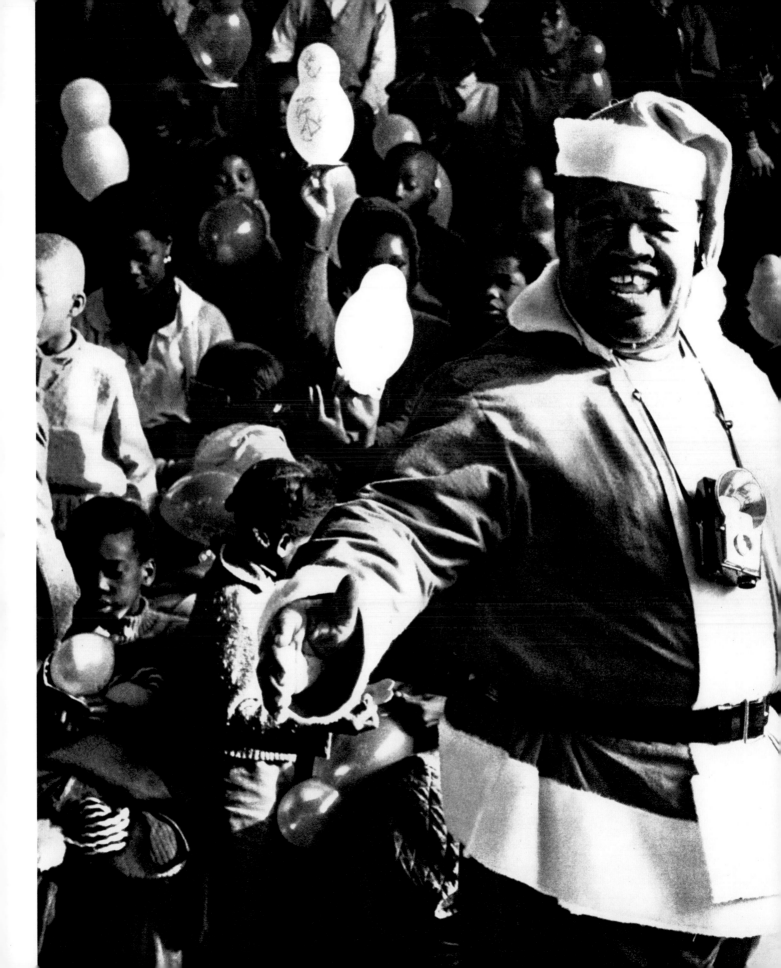

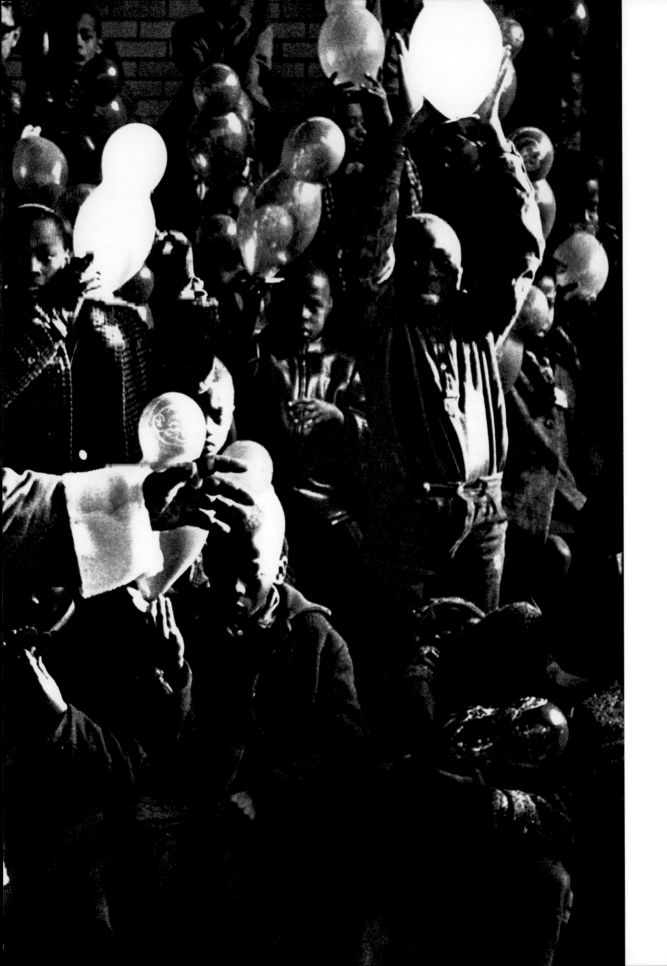

Notes from the 30th of December

The 'Black Belt' of Florida is just over the Georgia line, a few miles from Alabama. It is part of the rich black earth that stretches across Louisiana, Mississippi, Alabama, Florida and Georgia.

Arrived last night at this civil rights outpost, a little wooden frame house just outside the town. They said it would be safer to sleep here with them. They could check me in at night. The night before sixteen shots were fired into the woodwork of the house. Whoever did it must have been in an auto, fired and then sped away. Only afterwards did they realize what happened, thinking at first that the sound came from the Western they were watching on T.V. They often heard shots.

Two weeks ago a fire broke out in their town office (above some Negro bars). Someone broke in, heaped old newspapers on the desks, and set it all afire. It was quickly extinguished when the smoke was seen from the street.

A week ago, Christmas Eve, some whites shot into a Negro road tavern, using an automatic gun. They wounded seven. Everyone here seems fatalistic, resigned to being killed.

There are three white volunteers; each in turn has been beaten and threatened with guns. Having become immune to the violence, they hope none of the Red-necks (poor Southern whites) will pull a trigger in a fit of anger. The police say they better be careful as the guns would not be taken away even if it were forbidden by law to carry one.

The famous man around here is Farmer Jones. A good many of the Negro farm hands work for him. On his land is a sign, 'Posted no peddlers,' meaning, 'No civil rights workers.' It is said that Farmer Jones killed a Negro worker and his daughter when the Negro wanted to leave the farm. The Negro had hired himself out to another farmer in Alabama. When the white man arrived to help in the moving, Farmer Jones got wind of it just in time to beat him up and chase him off the land. Then he finished off the old Negro. Farmer Jones says none of his

people are going to leave him, but it is well known that his wife did. A few weeks ago one of Farmer Jones' field workers was found dead in a ditch. The police reported it as an auto accident but those who saw the body say he was first beaten and then run over. Lynching has become too risky; a problem is now resolved by running over it.

Some months ago a white civil rights worker visited the Jones farm to make contact with the Negro hands when suddenly Jones and some friends caught him. During the beating he escaped into a nearby swamp, but being unfamiliar with swamps, he was eventually retaken. Holding him on the ground, the four discussed what they should do with him. The three friends were for killing him immediately, but eventually, because of differences in opinion, he was brought to Farmer Jones' office where Jones called his cousin, the deputy sheriff. The discussion was resumed on the deputy's arrival. The three were still for the killing, but Farmer Jones was somewhat afraid of an F.B.I. investigation on his land. With the deputy's backing he succeeded in getting the worker off to jail, where he was eventually fined and set free.

The KKK is also having a fine time burning crosses at the homes of Negro civil rights workers.

The telephones are not to be trusted. When one is calling out of town for help after a beating or arrest, the telephone operator usually refuses to make the necessary connection, saying there is no answer. When one asks for the operator's number, to report the problem, she hangs up. It is suspected the KKK and the police are tipped off on all important in and out going calls.

'Nigger, this is white country,' say the Confederate flags seen flying all around here. The whites fly the flag from their autos, and make the Negro hands affix it on the farmtrucks which the Negroes ride in. In another town, I once saw an auto go by with a white person driving and affixed upon it, a United States flag; must have been some kind of radical or something. On another occasion, a Negro had attached the despised Confederate flag to his own

auto; while driving through town a group of Negroes ripped it off.

The little 'Freedom House' where I am staying is a battle station. Spotlights have been set up around the house, a litter of puppies is being trained as watch dogs; unfortunately they are afraid to remain outside alone in the doghouse and sit huddled up under the house. Everyone is expecting the place to be blown up one night.

A full-time civil rights worker formerly received twenty-five dollars a week, but now due to lack of funds this sum must be divided between two. A few days ago a civil rights worker had to pay a $25 auto fine. The police keep checking their autos for defects (here in a region where some whites drive without a license). Also, the police drive behind their autos waiting for them to get nervous and tense and then slip up.

Florida is not Mississippi, but in many ways it is. People think of it as a vacation land. Just give us the sunshine, they say, and don't disturb our beautiful illusions.

Am sitting in the office: A pretty teenage girl comes in saying she just answered the telephone. 'Freedom House,' she answered, and the man at the other end started cursing, 'Now why did I get this shitty wrong number, God damn Nigger bitch this is not the number I wanted to get, you black whoring Nigger bitch,' then hung up. She said, 'I should report him for using profanity over the telephone – yeah, yeah.'

The Christmas decorations are still seen about town. Over the homes of the whites is written, 'Peace on Earth'; the radio and T.V. still speak of 'Peace,' the churches have signs outside, 'Welcome all.' Yet I feel myself being watched suspiciously by the whites, the police, and the Negroes.

A boy is now saying that sometimes a white family can be friendly and without prejudice. But as one says about a farm family, 'Be careful, they haven't invited you to dinner yet.'

Midday: Strolling about town. Noticed that doctors and professionals have two entrances, one for the whites, the other for 'Colored.' A few have taken down the

'Colored' sign, but only one door has a number, the numberless door is for the colored. It all gives the houses a symmetrical, yet unbalanced logic of their own.

Now again in the office: Two teenage girls enter, they want to test a truck terminal about twenty miles from here to see if they will serve food to Negroes. The last time the owner, gun in hand, said he'd kill any Nigger coming near his place. The boys are trying to convince them of the danger. Tomorrow, New Year's day, the girls say they are going to do it. Grim jokes and talk about the preferability of being killed with a gun to being burnt or beaten to death. The talk has now turned to dates, marriage, youth and old age (around 25). In this little town so much energy and emotion is bottled up, especially in the women.

The girls are now asking for two dollars; they already have three and it usually costs five dollars a meal to test a restaurant. A test is often expensive; if they are served they are overcharged, and if they ask for a receipt, the waitress will say it's not her habit to write receipts.

Unable to raise the money, the two girls now want to play the new game called 'Challenge.' They 'Challenge' a hamburger stand to serve them at the 'white' window instead of the dirty back window for the 'Colored.'

Am sitting on the charred office window sill watching them in conference. Suddenly they realize it is dark outside. There is an empty warehouse across the street and there is always the possibility of someone shooting from it. Quickly the blinds are drawn. The discussion is about plans to organize the community; how to create interest in the projects, increase attendance at meetings, and raise money. This planning of the teenagers would do justice to an army staff. A girl tells of a policeman at a picket saying to her, 'You don't know the trouble we've got.' She answered, 'You don't know the trouble we've got.' Blacks and whites in the same auto is looking for trouble. I took some kids home and the police followed. The kids said to go slow, watch the lights, and look out for white

people crossing the street.

To save the whites from paying more taxes, the Negro is taxed indirectly in all conceivable ways. Conveniently, the jail has been built across the street from the Negro bars and businesses. The police need only look out the window to see when duty is calling. The taxes are collected from the Negro in the form of fines.

Once a white woman told me the story of how a farmer wanted his Negro farm hand to save his money. The hand answered, 'No sir, this is Saturday night. I feel sorry for you white people, you don't have such a beautiful night as we colored have. Saturday night is the most beautiful night for the colored; it's when we spend all our money.'

A civil rights worker from a nearby town called tonight, he had been receiving telephone calls with no one responding to his hello. Then, as he prepared for bed, the phone rang again; a woman's voice said she was coming over for him. He had called immediately to say he wanted to sleep here tonight. He was picked up; as he left the town an auto followed.

This morning we awoke to find the F.B.I. at the house to check on the shooting. One F.B.I. man asked who the boy back there was. I was the only one back there, but not knowing who he meant, they asked, 'Who?' 'The white boy,' said the F.B.I. man, meaning me. They thought his calling me a boy was strange as it is not the custom around here to call a white man a 'boy.' It turned out that the F.B.I.'s main interest was not the shooting but me.

Now, in the office: A mother comes in saying she has to live in this town and so couldn't go against the customs. The police had questioned her on the activities of her children and she had replied, 'The children, I can't seem to handle 'em.' Which means only the young, without responsibilities, can be active. The Negro luncheonette owner was saying, 'These kids are the first real Negro leadership this community has ever had.'

New development. They started distributing the civil rights newspaper outside on the street, when a Negro woman came over from the jail house for a copy. The distributor refused her, claiming she was a lackey for the police. Whereupon she went back and said he had threatened to kill her. Within minutes he was sitting in jail. The Negroes from the bars are gathering under my window, looking her way as she sits there outside the jail house with the guards. They say she's a prisoner but does all the pimping for the police. The problem now is getting the money for bail.

An hour later: He is out in custody of his mother. The problem now is getting a lawyer for the trial.

I am sitting alone in the office. A man came in saying he had important information about a shooting but trusted only one worker with the story, would speak with no one else as he lived in this town and didn't want anyone shooting at him.

Evening: Some drinks for the New Year and a civil rights worker opens his heart. He can't stay in the town much longer; his father has lost three jobs this year because of the son's activities. None of the civil rights

workers can find employment. This is how the movement is killed: by the use of economic sanctions against the whole family. The whites say, it's the outsiders who create the problems, but it is only an outsider who is free to agitate.

1 January, New Years Day

No bombs under the 'Freedom House,' everyone relieved. To avoid a tragedy, all stayed away from the house with friends. Today's problem: Getting people out of jail. In a nearby town last week a Negro was sentenced to three months for trying to date a white lady. How, asked some, could a Negro man ask a white lady for a date at that luncheonette, when the Negroes are all afraid to go near the place? The girl in the office asked how I could stand having white skin.

Today's big case is Jake, an epileptic. In the hospital he had had fits and now is locked up in jail. Today an old friend passed by and through the window Jake called to him. The friend stopped to talk and was immediately arrested.

As I am able to gather: Jake, who is twenty and a friend of the civil rights group, worked on a farm near Chattahoochee, where he started having the seizures. His parents took him to a doctor, who sent him to the hospital for treatment. In the hospital, he became violent and was transferred to the county jail (a common procedure here). For two days his family was not allowed to see him. The parents asked here for help, whereupon a white civil rights worker was sent to the jail. He was informed there were to be no visitors. He explained to the jailer that Jake was a sick man, not a real prisoner, and needed his parents' help. The jailer jumped from the chair yelling, 'God damn it, get out of my jail.' Then, grabbing the civil rights worker, he locked him in a cell. At last the jailer got a better grip on himself and let him out. Still wanting to know the charges against Jake, the worker was told, 'He's charged with being crazy.' The father went to see his boy during visiting hours and was told no visitors because of doctor's orders. He then asked those here at the office to call the doctor. The doctor said he would call the jail house. The father then went personally to see the doctor but was refused entry and told that the doctor would again call the jail. When the father returned to the jail, the jailer's face was flushed. 'Did you go see that white son-of-a-bitch?' (civil rights worker).

Now he not only could not see his son but was warned against coming near the jail or he would be keeping his son company. At last a lawyer from Tallahassee, the state capital, was engaged to call the jail. The jailer first wanted to know, 'You representing that damned Nigger-lover?' At this point, I walked over to the jail house. It seemed an extension of the Negro business street. A brick building with lights and barbed wire all around. The Red-necks sat outside watching the doings along the street. I passed and one got up to follow me. I turned the corner and suddenly turned to face him. Surprised by my action, he almost fell over himself in the attempt not to walk into me. He pretended to be scratching his leg. I walked to the corner and on to the next; suddenly a voice called to me. Jake's mother came running to my side, saying that as I walked past the window of her son's cell, the whites had come running up to the corner to see if I had gone on. Seeing that I had, they went back to their lounging chairs. She wanted to know if her son called to me. What does one say to a mother whose son really is calling to her from inside a prison cell? I lied, saying I heard nothing. 'Maybe he's sleeping?' And I said 'Yes.' We looked toward his distant window, I could still hear his cries, just audible, low, down behind brick walls: 'Jail,' then, 'Here,' and a long crying, 'MOM,' then the women from the cells below calling out for him to keep quiet. All the time she kept biting into and twisting her handkerchief. She said she would wait outside until she could see him. Then she asked my opinion, 'Do you think he's crazy, as they say? He knows me, he knows his wife, he even knows the jailer. Does that sound like a crazy man? Do you think my boy could be crazy? If only they would send him to Chattahoochee (the state hospital) he would get well there.'

I am now sitting in my auto parked on the trash lot behind the bars, across the street from the jail and Jake's window: Am watching the Negroes go by, all afraid to look or stop or listen. Some try signaling in such a way that the Red-necks

can't see. They all rush by, and he calls out to old friends by their names; they cross to my side of the street hoping to escape notice.

Now his mother and his wife pass along my side of the street. His mother had told me she was fearful of approaching, knowing the others had been arrested. I hide low within this auto while continuing to watch and write in this little book.

He has seen her coming and calls out, 'MOM? MOM,' she goes past, 'MOM, MOM, MOM.' Trying to look, she bends, hunches her back, her eyes twisted towards him A hand darts out from under the hunched form, winking, the arm held tightly to her side. They hurry and are away. 'MOM, MOM, MOM, MOM, MOM.'

His shrill cry fills the empty street mingling with the noise of blaring jukeboxes from Negro bars around the corners.

Five minutes have now gone by and still the agonizing low, 'MOM, MOM,' like a child at night calling for a glass of water. Now low, long, drawn out, 'MOM, I'm in jail.'

Listening to him, a tear comes. One of the Negro girls had asked me, 'How can they be so mean? I don't mean you personally, I think you're different, but do you like having white skin?'

A half hour has now passed; still he calls out every now and then. People go by; a few stop to listen and then hurry on. The voices of the women prisoners can be heard as they speak to one another. Two Negro women with children stop. He calls out, and I hear, 'Please tell my Mama that . . .' but they grab the children's hands, running off, not wanting to hear more.

Now his father in an old straw hat is coming along on my side of the street with another man. (His father had told me of his fear of being murdered.) Walking fast, looking down, and talking together, almost past . . . 'DAD!' They continue talking and walking – 'DAD, DAD,' they stop. 'Help me, get me out!' His father shouts back, 'I can't do nothing.' Now they are shouting at each other. (I hide in the auto waiting for the police to arrest the father.) I hear the father saying, 'I can't do nothing, I was in jail for two years: I know what it's like in there.

Son, I can't do nothing.' He rushes off. I feel brutish and numb, could I watch anything now? Is this how the whites in this town feel? Brutish and numb. Having lost all feeling from overdoses and constant exposure to this way of life? They must know what is going on before their eyes!

The jailer's pretty little brick house is next to the jail; a path leads from one building to the other. Still up are the Christmas decorations.

The mother had said to me, 'There is one that I could trust and he's up there.'
'Up where?' I asked stupidly. She pointed a black finger towards a blue sky.

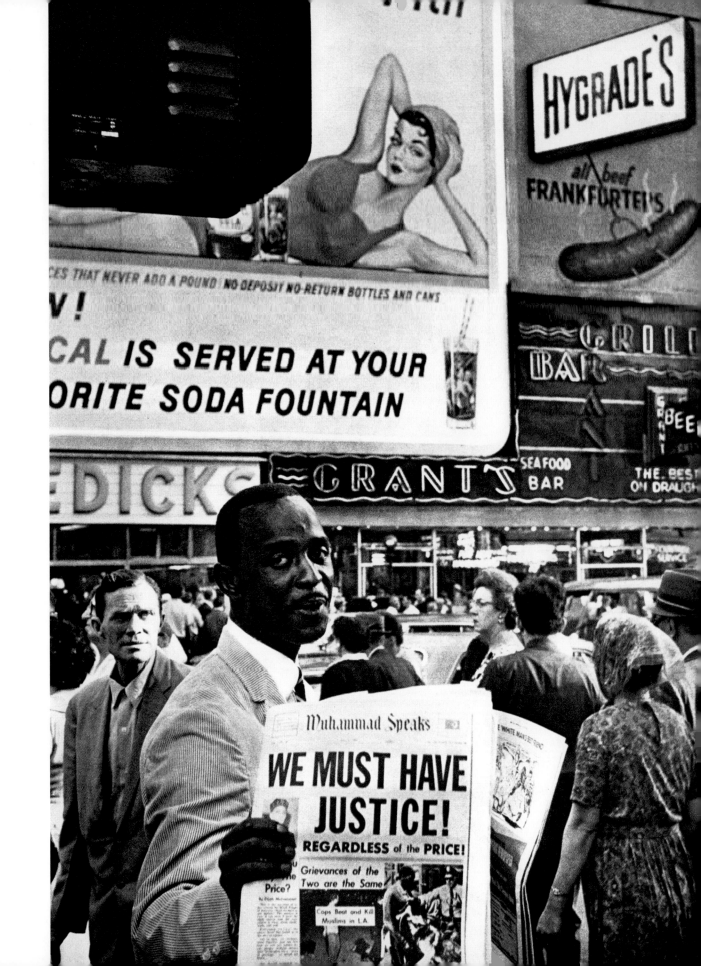

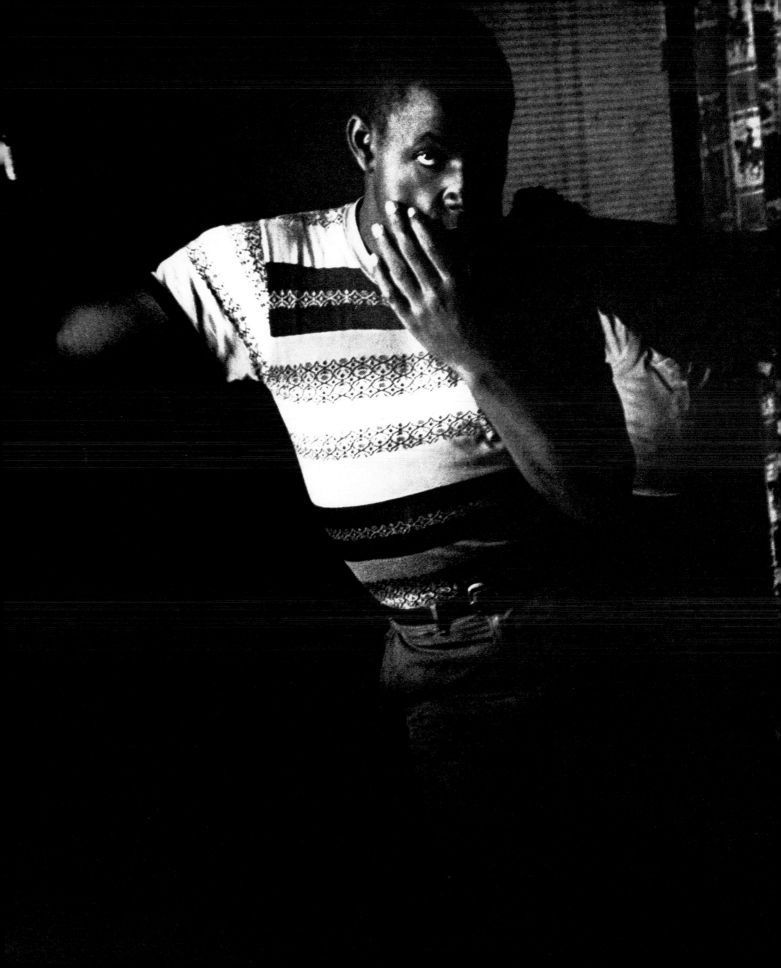

p. 128:
New York

Book stand placard at a Black Muslim bazaar.

p. 129:
New York

A member of the Black Muslim sect, one of many black nationalist organizations, selling the sect's newspaper on a street corner.

p. 130-131:
South Carolina

In a poor cotton picker's cabin, far from the towns and cities where the civil rights agitation is taking place, a new force has entered the lives of the isolated Negro

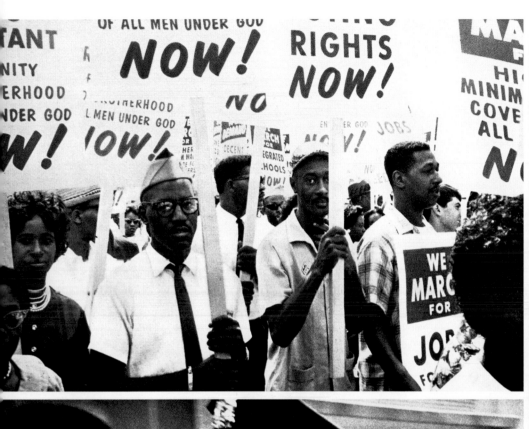

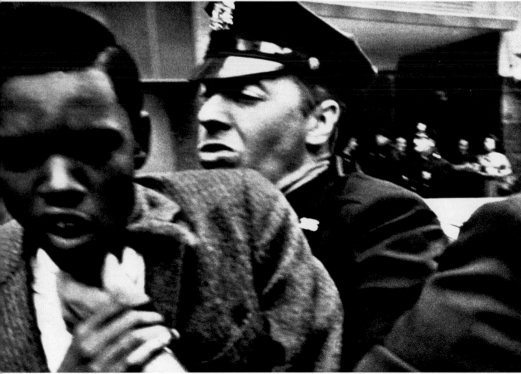

youths. Television, with its instant communication, direct to the living rooms of the poorest, has created a revolution the likes of which the world has not seen before. Television confronts today's Negro youth with a way of life completely at odds with his own experience. The richness advertised makes him acutely aware of the gulf separating his physical and moral condition from that of the whites. The faces he sees are those of whites speaking to whites and now white society has reached him in the depths of his innermost being. For the Negro youth there is now no flight; he is being forced to acknowledge his condition, to take note that he lives as a black in a white America. And he is in revolt.

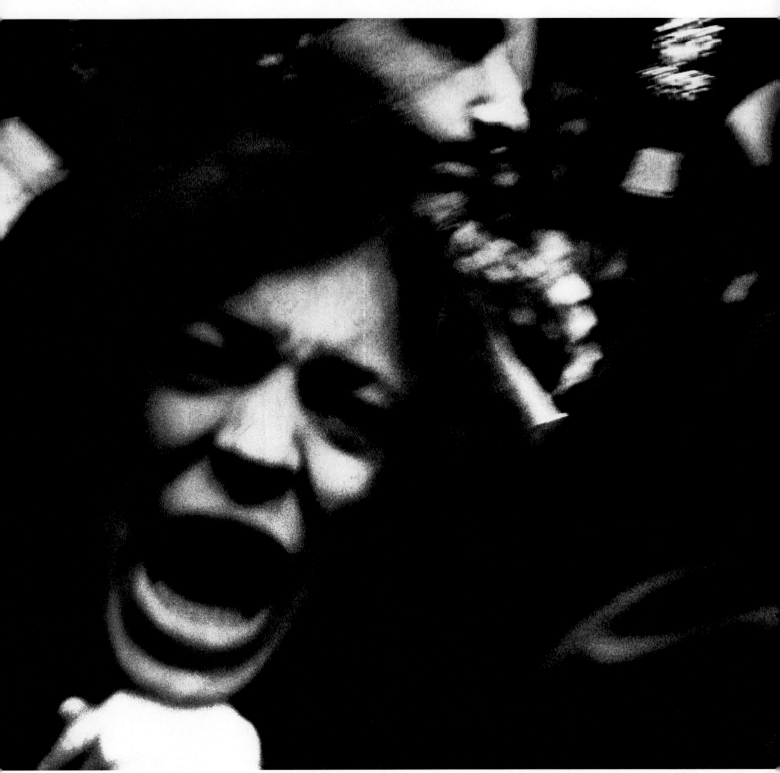

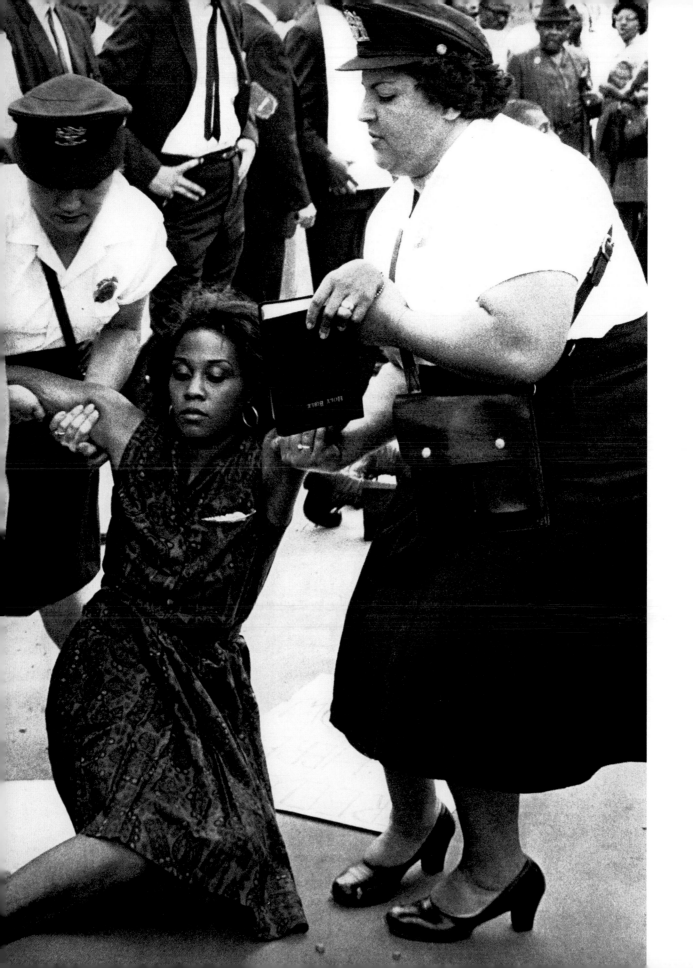

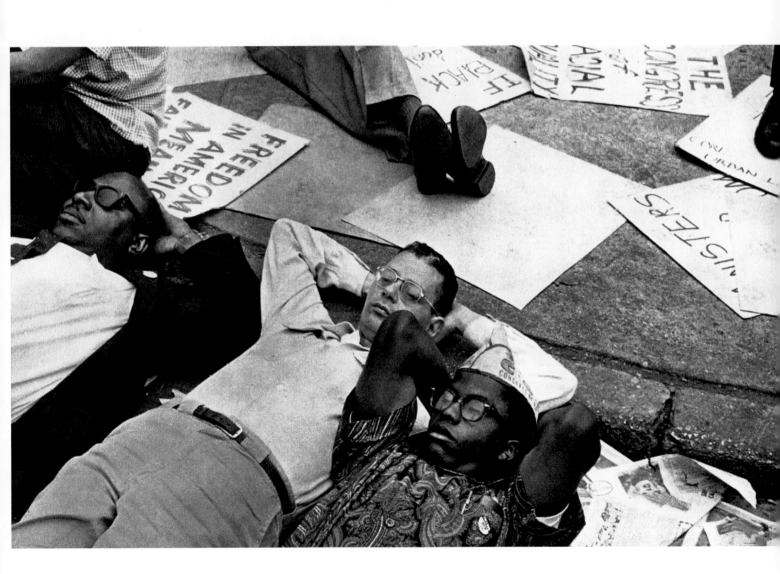

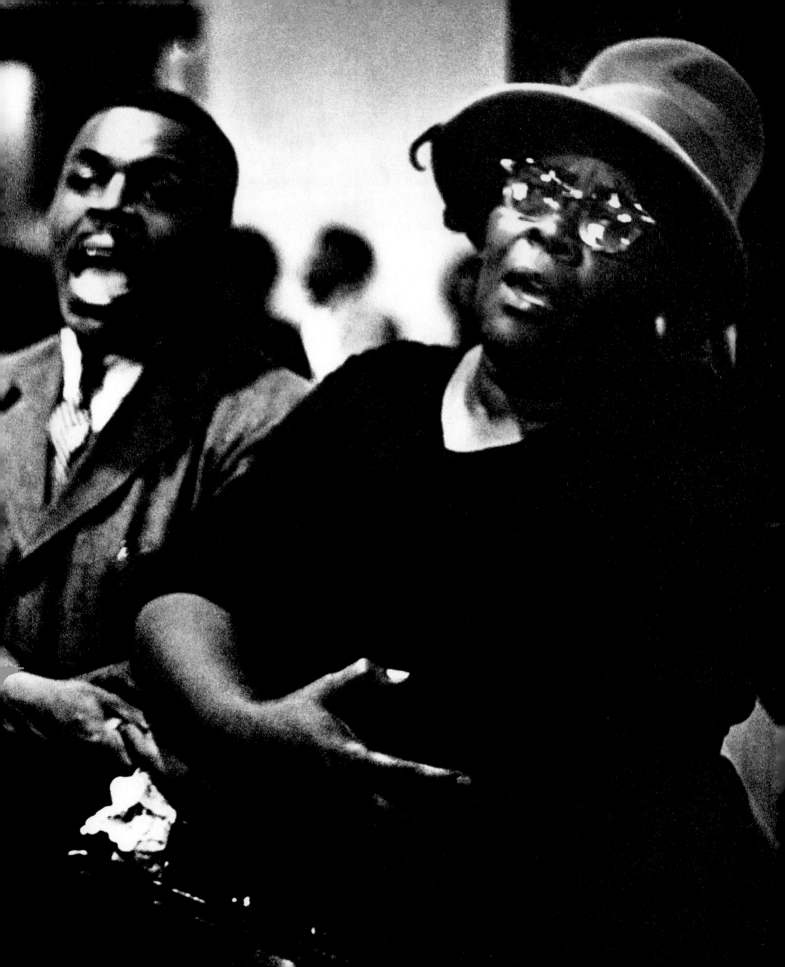

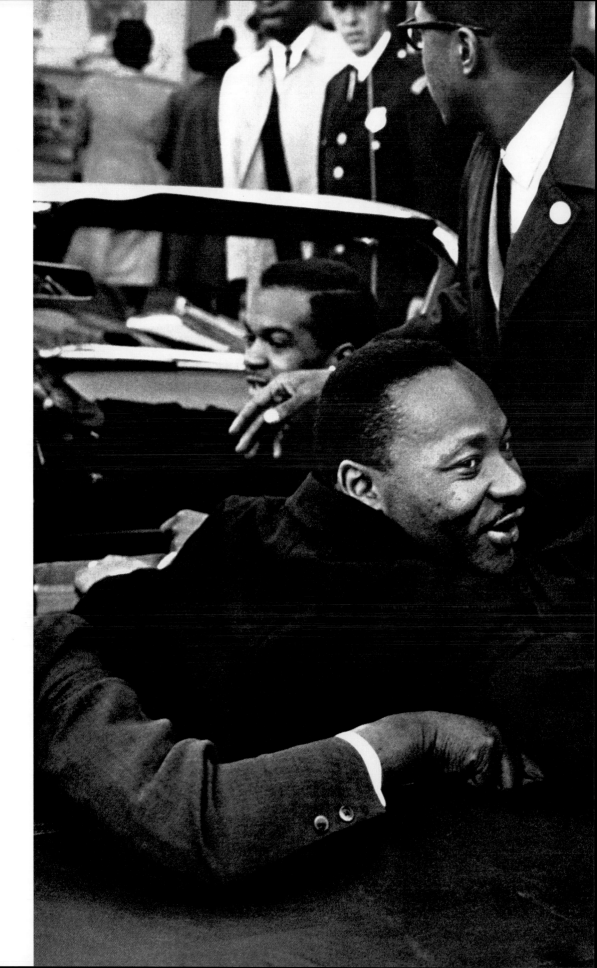

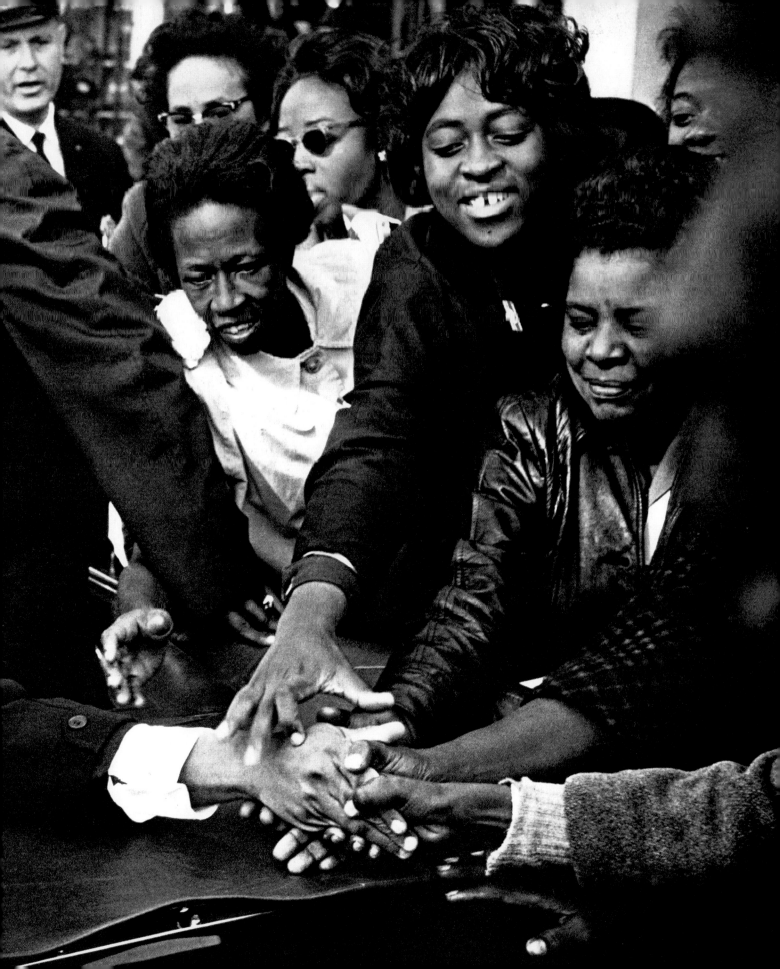

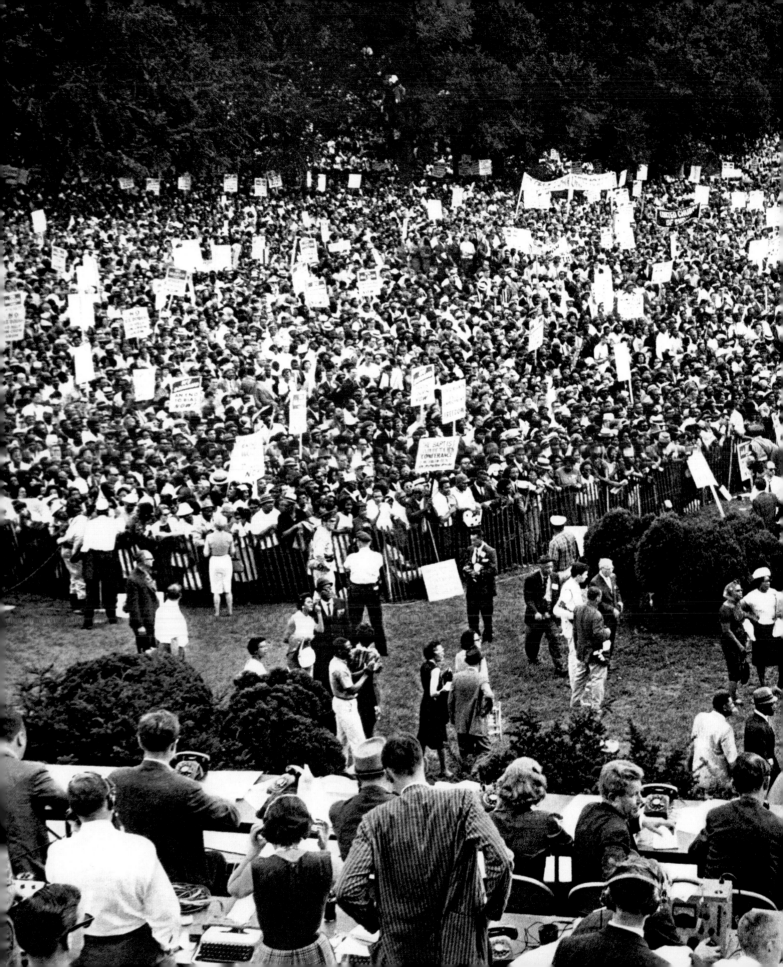

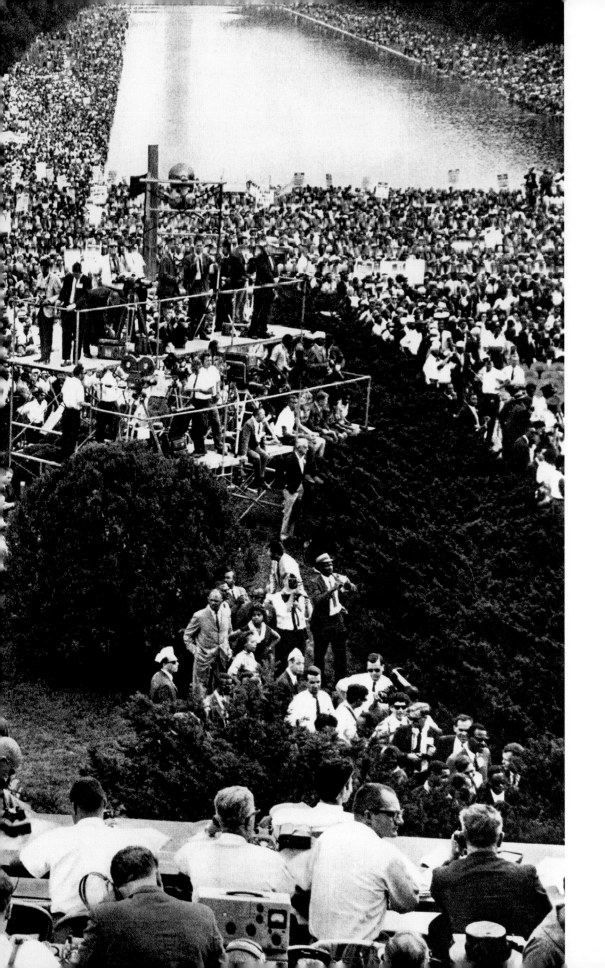

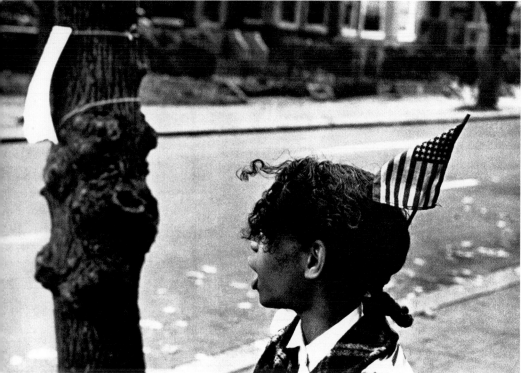

Virginia

In the political contest between the two whites, one was openly seeking the Negro vote while the other campaigned on a platform of white supremacy. Supporting their candidate, some young teenage Negroes set up a street corner campaign stand. They would collar a prospective voter, and while giving him information and collecting his contribution, pin a campaign button bearing the candidate's name on his lapel.

Even the poorest of the poor knew this was their cause and gave gladly. The button was a badge of honor: it told neighbors they were committed to the fight. Tears came to the eyes of older folks as they watched the young ones in action, and some held forth with street corner orations.

A poor but proud elderly couple came by. The girls ran up handing them the literature. The couple were pleased to see the youth of their race being so active politically. They contributed generously and the girls pinned the campaign buttons on while cheerfully reminding them to vote. The elderly lady smilingly looked down her bosom to the button; a frown then covered her face and in an enraged voice said, 'I'm voting for the other man.' She pulled the button off and walked away.

While watching this a teenage girl turned to me, shrugged her shoulders, pointed a thumb back to the couple and said, 'Yeah, some people never will learn!'

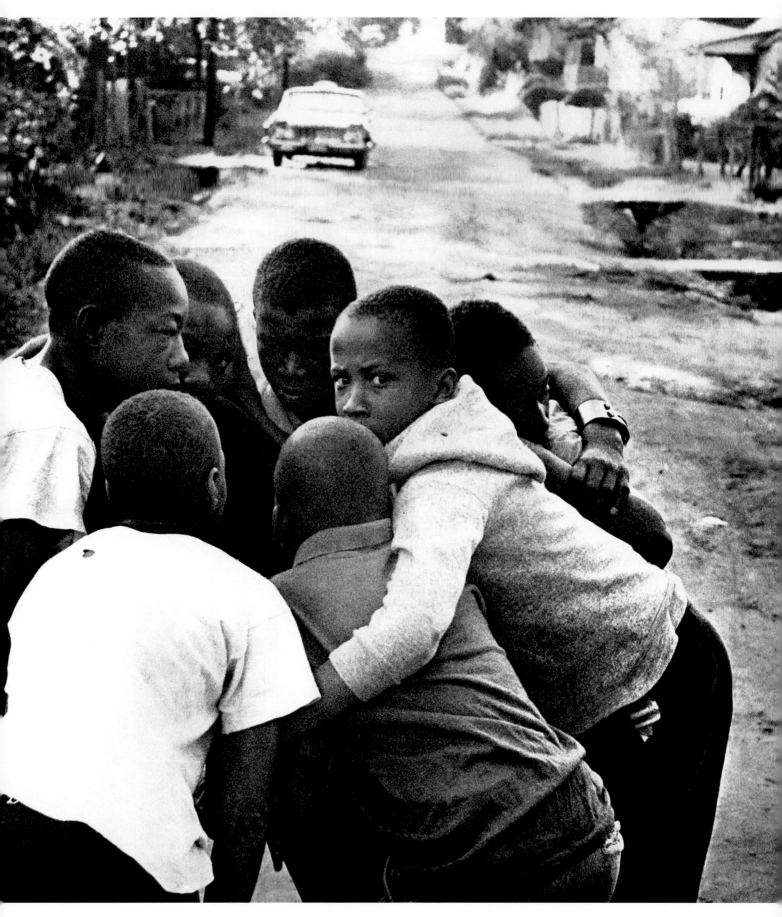

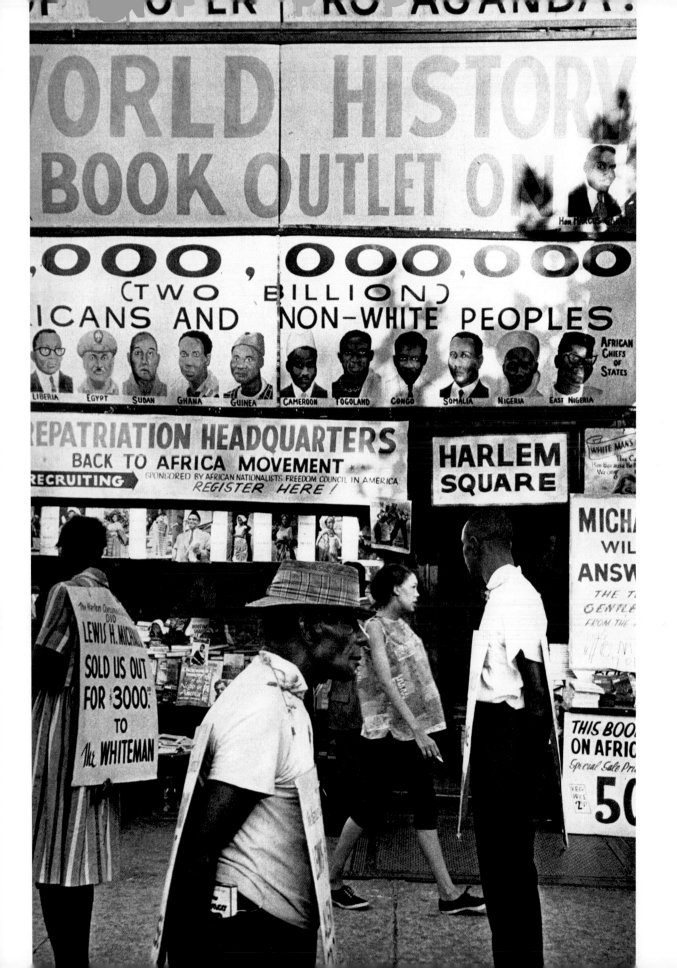

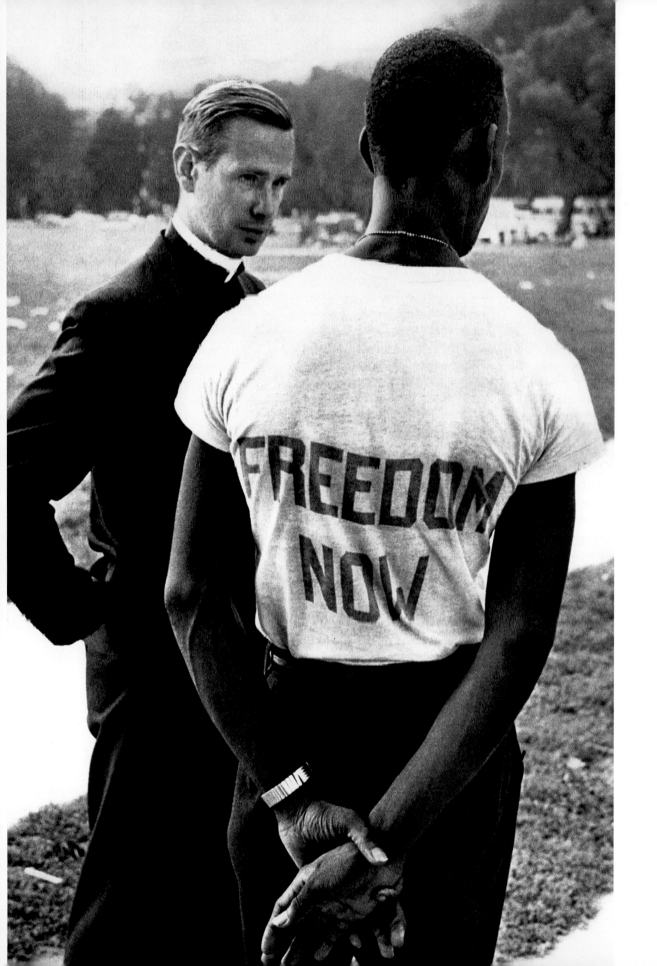

Baltimore, Maryland

A large golden cross now covered the cubicle for the Torah but the Stars of David could still be seen in what were now church windows. Each time I moved to photograph, a series of greetings and smiles met me; the air was warm and the crowd filled with joy. The doors were open so those outside could hear the speakers.

Up front, the speaker was calling for God and the prophets to hear of the new day coming. Today we were all seeing this new day, it had arrived and all could be joyful. He spoke as a fiery preacher while the neighborhood people clapped and shouted until the tears rolled over their cheeks and down. Coming to the end of his long emotional talk, he stopped to look out over the faces of this Negro community and then said, 'There are times when as your mayor I make official visits to other cities and they tell me of their minority problems. It is at times like that when I say they have no idea what it's like to be a member of a city's ethnic minority. In this town it's the Italian, Jewish and Irish who make up the majorities, but the biggest majority group is right here in this neighborhood, in this church. The Negro in this town can out-vote any racial group and it's up to the Negro to vote in the man they want. But I tell you, some of you out there have no idea what it's like to be in the minority, you have no first-hand experience. But if you want to know, ask me, I come from the one group in this town that really experiences it every day, me, who comes from the old Anglo-Saxon stock.'

With that, the political get-out-the-vote meeting came to a joyous ending.

North Carolina

A local news announcement just came over the radio. In a small nearby town, an Indian (many Indians live in this area of the state) was killed in a fight when three Indians tried to integrate a Negro pool-room. The Indians were now agitating for integration into the Negro community.

North Carolina

For the students of this discreet university town, the shops along the main street showed clothing of impeccable taste. There were book stores, hi-fi shops, foreign and U.S. newspapers and lots of good student eating places. At the Negro college in Greensboro, fifty miles away, it all began – the Negro sit-in movement. On February 1, 1960, four students from the Negro college sat down at the 'white only' lunch counter of the Greensboro Woolworth store, igniting a fire that is tempering this nation's character. A flame of indignation had blown among the nation's Negro youth but it had blown at random, flairing up uncontrolledly, across the South.

When the sit-in movement hit this town, it came like a New England snow storm: hundreds of students from the Negro high school and whites from the university sat down to block the main street, demanding the desegregation of lunch counters. A simple solution to alleviate a complex situation was chosen by the town officials: jail, beating and high bail soon discouraged further activities. The whites went back to their school studies and those Negro students who persisted in picketing were now in jail.

'And what did the town's white people have to say?' I questioned a white professor's wife. 'It was repugnant,' she said. 'While these children were being mishandled by the police, an elderly woman came forward from the crowd of white spectators, stood astride a Negro boy laying on the ground . . . and urinated on his head and face.'

p. 144:
New York

Before a Harlem black nationalist bookstore, other black nationalists picket the store, claiming it has sold out to the white man for 3000 dollars.

p. 147:
New York

Black nationalist sect holding a street corner meeting.

p. 148-149:
Alabama

Police watch pickets before the court house demanding the right to vote. Shortly after, pickets were beaten and jailed.

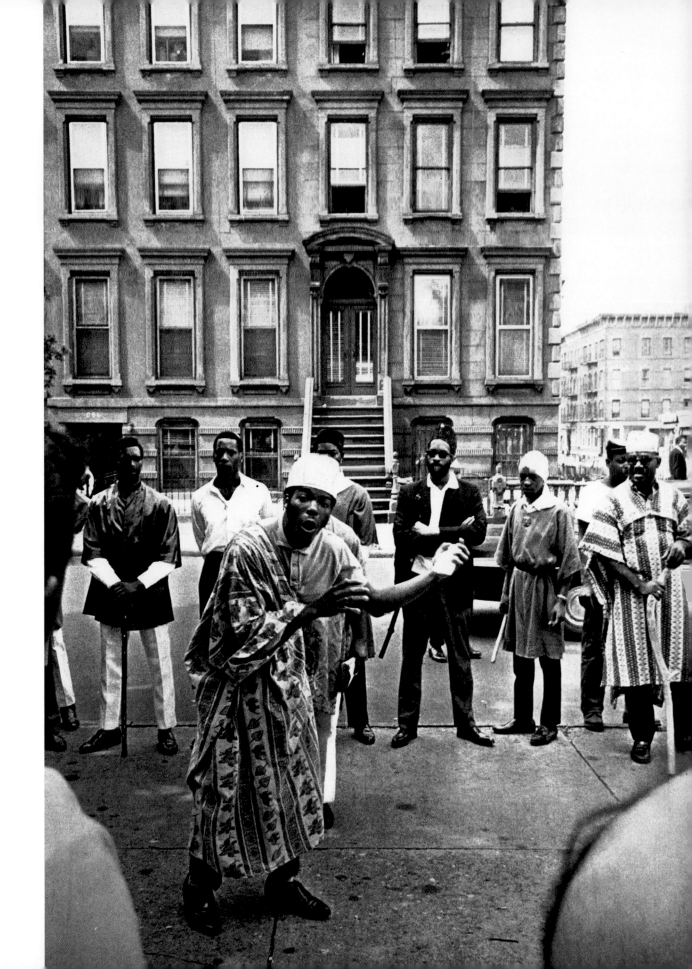

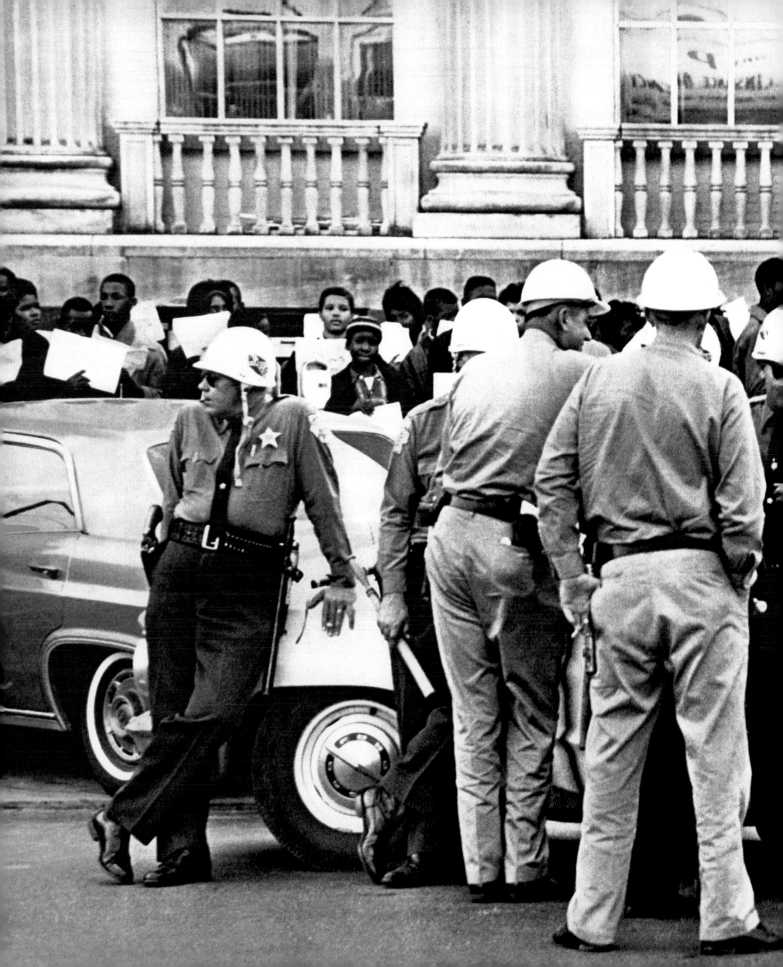

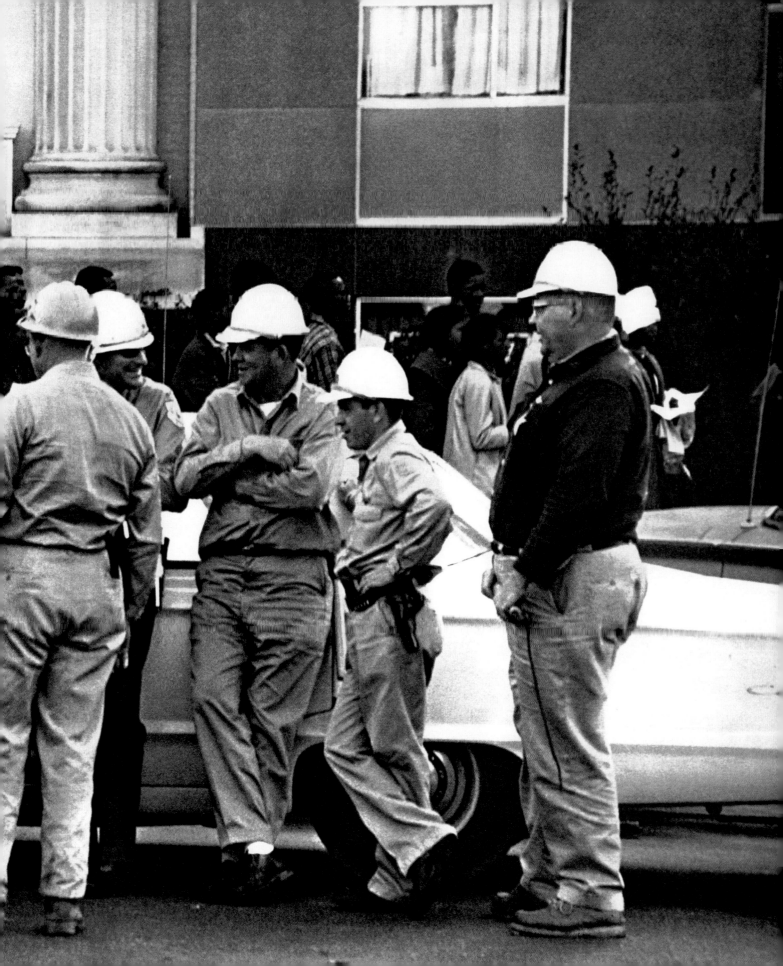

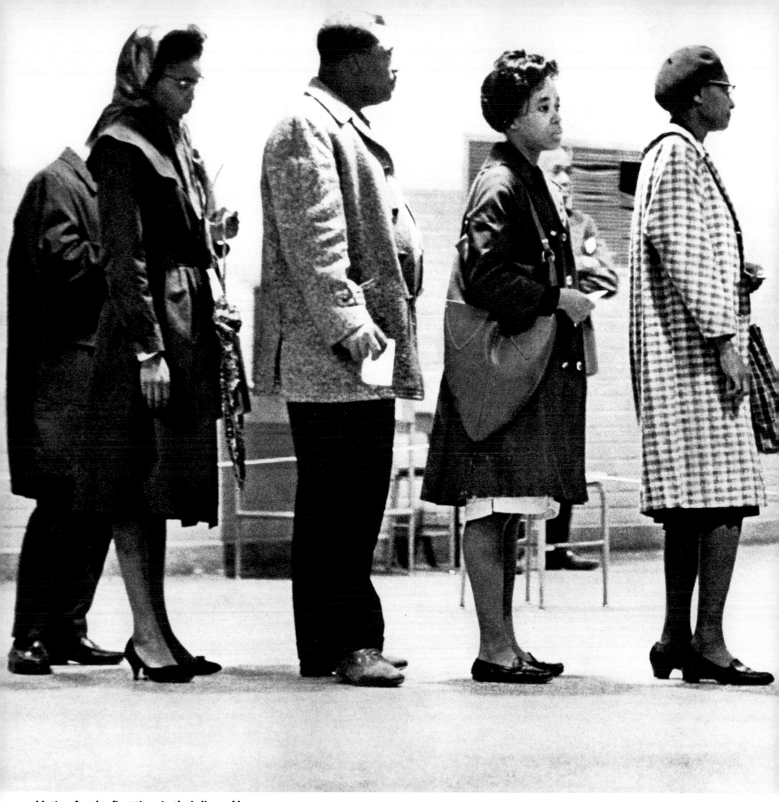

Voting for the first time in their lives, Negro residents of Washington, D.C. line up at the polling place.

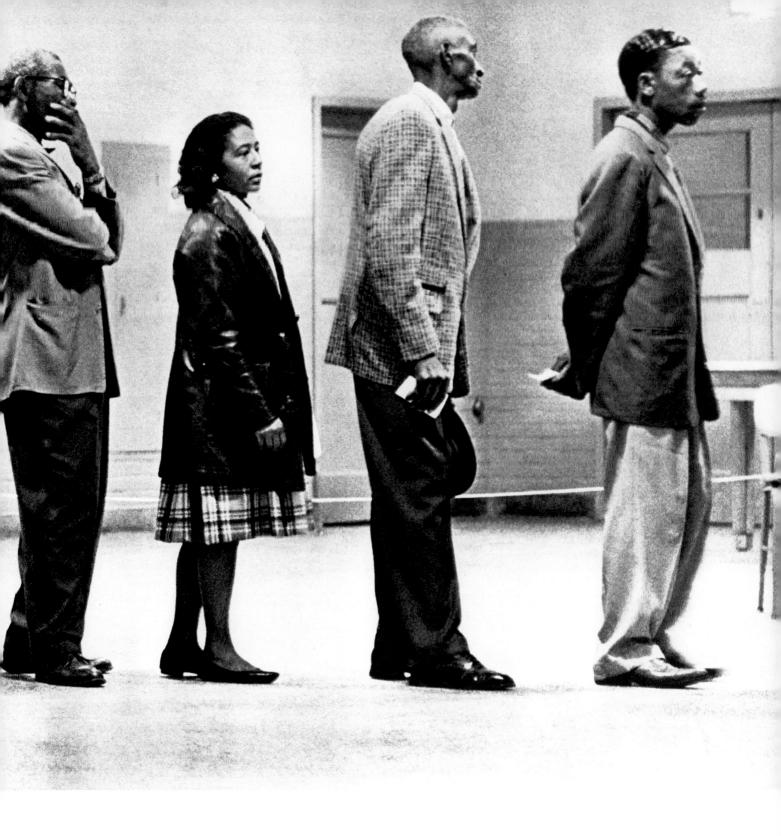

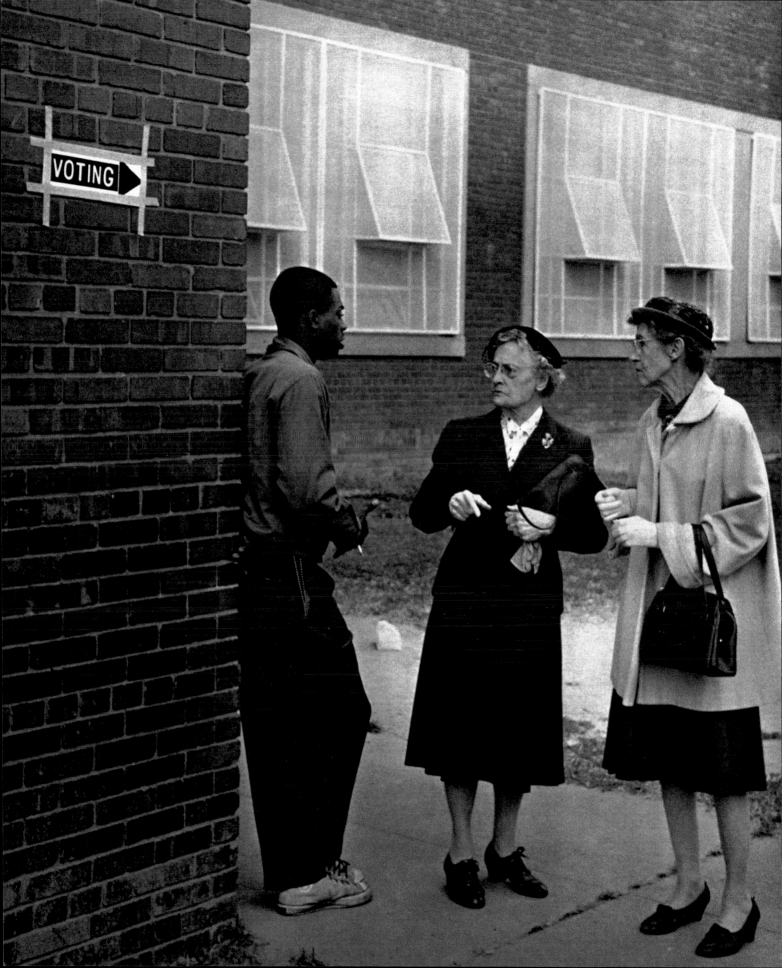

North Carolina

'Impressions are everything, so don't get the wrong ones of me, and don't laugh. Really it's a bit silly but despite my education and all this organizational work I'm doing, I'm really only a housewife: a mother of three children, the wife of a man who happens to teach at the local college, a woman who happily sits and makes her own dresses.' She handed me a wet plate to dry, and I tried to find its place in her kitchen. Outside the last rays of warm, Southern light shone through the virginal forest that reached the screens of the house. The street to the house ran past neat rows of newly built, middle class, one family homes. This was the last house; it pushed into the forest, a forest that extended over thirty miles. Her hands dripped soap bubbles on the kitchen floor, and, as if I were an imaginary audience of public officials, psychologists and journalists, she said, 'Look. I'm not a leader or organizer. Yet, suddenly everything has been thrust upon my shoulders, all because I'm the only one free and with the time to do what needs being done. At the start of the sit-ins everyone seemed to be filled with enthusiasm for making this a better place to live. The white students and the Negro community worked together, contributing their time and energy. At the first lunch counter protests there were hundreds sitting out on the sidewalks demanding they serve Negroes, that Negroes be treated with respect. And for a time we were fool enough to really think things were going to change around here.'

'Then that bastard of a judge murdered the movement. Those so called city fathers have shown us in no uncertain terms who bosses this town. Anyone who took an active role in the demonstrations is in jail, out on bond, or had to flee the state. I got involved when a friend of the family landed in jail and I paid the bond money for him. I went down to the jail house and saw all those colored kids sitting there because the families were just too poor to help. I could have wept at the sight of it all. The first thing I knew, I was raising bond money for one, then another, and I'm now carrying the burden of the whole organization. They have murdered any good feelings in this community by strangling us with thousands of dollars in court fines, court costs, lawyers' fees, and jail bonds until we're all in hock and the poor people's lifetime savings are all gone, gone into the pockets of this town's rich city fathers – for more police. We can't even get to speak with the kids in jail.'

The summer soldiers have gone home, and what remains of the civil rights movement in this town is strife and discontent. Time after time we see individuals who have suffered, have fought for months, suddenly turning against us. Most of the Negro families are now frightened, with their kids locked up, thrown out of school, and the whites retaliating by firing the fathers from their jobs; they want nothing more to do with sit-ins or protests.'

From the living room her husband called out, 'Just say it's all very discouraging. Basically it's the age old problem of the poor. The color of anyone's skin has nothing to do with the summer soldiers' attitude. It's just that the vision and objectives of people living in poverty are limited; the first reverses they suffer, they turn and flee. And then of course some are just dumb.'

What he meant by dumb was 'Jone,' a pretty eighteen year old. Having repeatedly been in jail for participating in sit-ins, she was released after the civil rights group had put up a heavy court bond for her. 'But then she meets a strip tease dancer, joins her group, and skips across the state line to Virginia. The state officials trick her into returning, and she is brought before the judge. Now that she has lost the court bond we put up, she turns on us and becomes state evidence. Standing trial with her were other kids who had been in the sit-ins. The judge, a crafty old bastard, started interrogating her. With the whole court watching, she just kept repeating how sorry she was for having participated in any civil rights demonstration. Like a daudy bitch, her eyes kept fluttering for that old crock of a judge. When he asks her why she joined the sit-ins, she turns to a white girl standing near by – and she and this white girl had been in jail together, lived together, worked together – and then says,

"I didn't want to do it but she made me." Christ how stupid can you get,' groaned the husband and then described the court scene. 'Hundreds of these kids were standing up to that judge, taking their punishment. She wasn't the only one being stuffed into the jail. These kids were under no illusion that this town was going to handle them as prima donnas. No one forced them to sit in; plenty of kids never did. Those who did know they would be beaten and put in jail. They did it because they wanted to, not because we made them. Then she comes, first having jumped bond, and tells the judge exactly what he wants to hear: "White outsiders are creating problems in this town." It makes no difference that a hundred kids before her stated that they would not accept the existing status quo. The white newspapers, T.V. and radio now had it in black and white: it was all the work of agitators from outside. Outsiders could be anyone who had lived in the town for generations but who now chose to think a bit differently from their acceptable norm.'

'Why did she do it?' I asked. 'Some of them are real nincompoops! Just try talking to an oaf!'

Aroused, his wife broke in, 'That's not true! These girls are not stupid! They may say things to white people that sound stupid, but it's a primitive self-protection that's involved. Jone is a smart girl. How should she act after three white college boys rape her, give her a baby, and the white courts and police do nothing. She's afraid. If she were white, she'd have justice.'

Her husband in his most learned voice shouted back, 'Color, bullshit! It's the ignorance of the poor. Her girl friends don't believe she was raped. She has no class consciousness.'

The next day I chanced to speak with the white girl from the trial: 'I can't understand it, we were great friends. I guess it was friendship only from one side.' (A Negro girl with her said, 'Do you believe a girl could do it with a boy and still say she's been raped?')

But, I wondered, did these Negro girls accept this double standard? Here the environmental pressures were such that it

was no uncommon experience for a Negro girl to finish high school while the family tended her illegitimate child. Public, private and official morality has a double standard here, one for blacks and one for whites. Being raped was an official honor reserved for white girls only. Now the civil rights movement is demanding equal judgement and protection under the law, yet this girl's claim of violation was ridiculed even by her Negro girl friends. Here there is no equality before the law, and the Negro is living under no illusions as to whom the laws were made to protect.

A few days later I was in my auto with Jone and her girl friend when she abruptly turned to me saying, 'Do you like me?' I wondered what she meant and looked at her, then out the window. We were parked on a dirt road. All about were wild bushes and the wooden, Negro homes from which she came. It seemed like months but it was only this morning that her girl friend had arranged for us to meet at the Negro high school and after classes she came out of the crowd to meet us.

I had come to talk and they were giddy and giggling between themselves. At last, I asked if she were embarrassed and if I should leave. 'No please stay,' she said in a low tone. I suggested we all go and have an ice cream somewhere, but where could we sit in this town and be served? Nowhere, so we remained in the auto.

She was now finished with all civil rights activities and against anyone else being involved. 'Just makes things worse.' She had been in jail sixteen times, almost a year in all, the longest period being thirty days. She had started at the age of sixteen. She had had four trials with four more to go, which she hoped would be suspended. At her last trial the judge pronounced a six month prison sentence, but she was out now after her family and neighbors contributed to a $2000 court bond. (Lies, said the civil rights people later protesting the statement. They said that the neighbors had laughed when her mother turned to them for help, saying there was no money left in the Negro community and, anyway, she deserved jail for jumping bond the first time. Moreover

she was an arrogant, pompous ass, who strutted among them as a white. The civil rights members said it was they who had raised the bond money, each of them contributing from ten to twenty dollars.) 'When you're young,' she said, 'you're looking for excitement, for a chance to get away from school, to do what all the other kids are doing. Joining the sit-ins was it. I'm older now, I don't want any more troubles. I only want to finish my schooling.' She was grateful to the school director for permitting her to re-enter. Saying that there was little interest in civil rights at the Negro school, she now agreed with the teachers that it was best to follow the lead of the respectable and responsible in both black and white communities who had spoken out against racial desegregation. Segregation is the only method for maintaining a peaceful community. What is important is self-respect and respect for others; racial respect can only be developed through segregation. The civil rights people she found lacking in appreciation and respect for others and wanted nothing more to do with them. They should stop the sit-ins as these only created troubles for the Negro. The Negroes were led astray. She knew a boy now in jail for tearing up his probation slip in front of the police. No one knew where they were keeping him now. While some white store owners now serve Negroes, those who had demonstrated were denied service. 'They have a right to serve who they please. It's their store and they must consider what is good for their business,' she said. She would do as the judge advised: act grown-up and lady-like, avoid civil rights organizations, be helpful and show appreciation to the family and neighbors for their support. 'I wear more feminine clothes now, I don't want to look like a boy any more.' In the Negro community when a girl married she usually left school to set up house. The unmarried mothers continued schooling while the family cared for the child – the family is in no way stigmatized. Generations of Negro girls have had no defense against sexual domination by whites, so that it has become the accepted norm to see various shades of skin color

within a given Negro family.

A Negro woman in this town learned life 'as it was' and overcame it by accepting. Jone was now pleased to have more time for her own sixteen month old son. The father of the son was white, Jone's father was white, her mother's father was white, her grandmother's father was white; she thinks her great-grandmother's father was also white. Whether her great, great-grandmother's father was also white she has no idea; but that her great, great-grandmother was a slave, she does know. (The woman would then marry a Negro man and the other children would be more negroid. A noticeable diminishing in inter-racial sex in the last years has developed as the South industrialized and as the Negro has become more vocal.)

Quietly she told me of her rape. 'Yes, raped,' she said, 'though some refuse to believe it.' While working in town she had often come in contact with the white college students. One beautiful spring day she was standing at a street corner with some friends when an auto with three white students pulled up beside them. The girls knew the boys and they chatted awhile; suddenly the students said they were on their way to a fraternity party and asked if she would like to come along? She and the other girls had never been to a fraternity party, but they had heard much talk of such parties, which sounded magnificent, delightful and glamorous. Now here were these handsome, wealthy and intelligent students asking her while the other girls watched in envy. She decided to go, if only to sit in a corner to watch and learn from such society people. At the fraternity house the other girls and couples would soon arrive. In the meantime they put on some jazz records, had a few drinks and turned the lamps down low. Not wanting to appear provincial, she waited for the others to come. They complimented and charmed her, drinking and dancing with her, and she could hardly consider the situation while the flattering handsome voices performed so masterfully, and when she arrived home, she realized she had been raped.

'Would you like to see my baby?' she asked.

I drove her home and was greeted by the family. The children went out to play; her mother's husband went to work; and, alone with her mother, I looked through the family's photo album. As we closed the book she said, 'She's just a child; school is the best place for children.'

When it was time to go, I drove Jone to her girl friend's.

'Thanks for your offer of ice cream,' she said, as we were almost there.

'Yes,' I said, 'it would have been nice.' We both smiled at the idea. Becoming serious, she asked if there were anything else I wanted to know about her life. 'No,' I said, I didn't want to bother her anymore.

'No! Ask whatever you want to know,' she said.

I parked the car and asked why she laid the blame on the white girl? She looked at me, struggled to hold back her tears, and after a time said, 'Have you ever been in jail? Can you imagine what it's like?' She turned and stared out the window. 'It was terrible, it was inhuman, I don't want them ever putting me in jail again. No, never! I never want to be put in jail again!'

'But,' I asked, 'did the civil rights people make you do it?' 'I told the judge I was sorry,' she went on, not seeming to hear the question. 'I said I was sorry, but nothing helped. I didn't want to go to jail again – not again – not again. I said I was sorry I had done it. It was the truth, but nothing helped. He gave me six months in jail, eight months suspended sentence. This white girl, she kept following me, I couldn't get rid of her. What did she want from me? Why couldn't she leave me alone? The judge was watching me – he could see me always with this white girl – that's why he was so hard on me. I humbled myself, I said what he wanted to hear but this white girl, she I couldn't get rid of – couldn't she understand I had to humble myself! But, I never said I wouldn't do it again, I could never say that.'

'Would you do it again?'

'No, no one should go to jail or break the law. The civil rights people should stop the sit-ins.'

'Do you blame them for breaking the law?'

'Yes, I hate them. I only want to be free. In prison, no one came to see me or thank me for what I was doing! I was so alone, I almost went out of my mind. Just once if they had shown they were grateful, but they never came – no, I hate them.

'The whites are all alike, there is no difference. I was engaged to a white boy from the civil rights group. Then he became afraid of what his family would think if we married – and that was the end of that. She was grateful to one visitor, a white doctor who afterwards spoke with the director of the Negro high school about her readmission.

'It all started when I was very young,' she said. 'Summers at the beach I'd watch how the white people treated my mother; they wouldn't leave her alone. We'd be on a lonely part of the beach, and the men would always be trying to make her, then they would become nasty. They would curse her for her color, they'd kick and punch her, then they would call the police. And she would then be fined for entering a place reserved for whites. I would lay awake nights wondering what it was about my skin that made whites so mean acting.'

'Would you help the civil rights people again?' I asked.

'Yes,' she said, but first they would have to ask her personally and show some appreciation for her sacrifices, and stop activities leading to violence and jail.

And now she was saying, 'Do you like me?'

'What do you mean?'

'Someone like me, could you like such a person?'

Did she mean as an individual, or what she had done, or was it her beauty? 'Yes, yes, surely, why not . . .' She was now questioning me, forcing me to deal with her reality, twisting me from objectivity; to respond to her immediate presence, to treat her as a living person – alive with blood flowing in her veins – not to be contained on the page of a note book. Her voice and expression seemed to say, Has God not made me? Should I not be proud if He has chosen to grant me beauty? It was He who willed me to be born with an unblemished and resplendent complexion, fit for an Aphrodite, a Goddess. And I am indebted to Him. I am as I am: a creation of two human beings that chance brought together, the same chance that made one a so-called Negro and the other a so-called Caucasian. I am the fusion of their genes. Age old traditions and characteristics formed me and flow through me. Do I not belong to the ancestors of my father as well as those of my mother? Am I not privileged to admire the beautiful? If God has bestowed me with it, should I not be worshiped for my beauty? Society seeks to accept the beautiful; why not me? I am suspected by the Negro and completely disinherited by the Caucasian. Who am I and what am I, if not myself? If not Negro and Caucasian together?

Did the civil rights people – the Negroes, the whites – expect her to grope with these questions and to have the strength, alone, to solve such problems of identity? Her tragedy, if one may call it that, was in seeing the immediate advantages of identifying with her white half (more than half) and then being completely rejected by the white community. For the whites, she is born and dies a Nigger. She may feel her white heritage but it is no passport. Illusions die hard: the courts are there to protect, to bring law and order. She has been raped both mentally and physically. Returning to the Negro community for acceptance, she suffered in her efforts to identify completely with her struggles. She was a rebel, but slowly the weight of white power and domination forced her into accepting second class status, as have past generations of Negroes.

What will become of her? Will she, like others in the past, hide and suppress her emotions, become the white man's mistress, while he sleeps beside her in secure contentment?

All this time, her girl friend having performed the formal function of introduction, had remained passive, listening intently from the back seat of the auto. She seemed, like me, to be seeking the answer Jone was waiting for.

Jone became quiet and said no more, but retreating, withdrew into hostile servility.

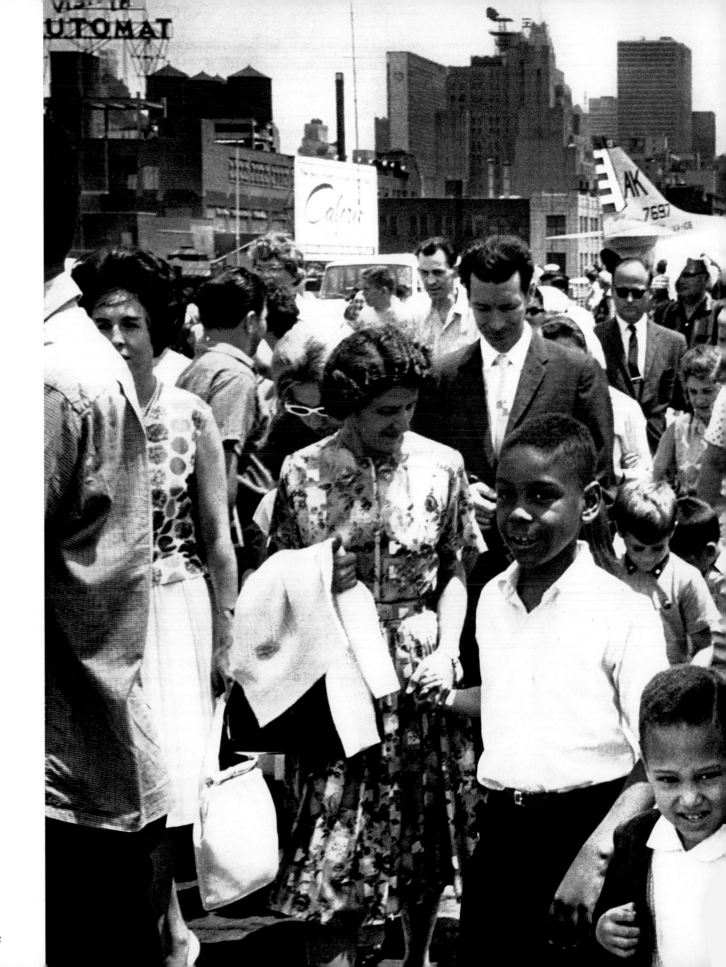

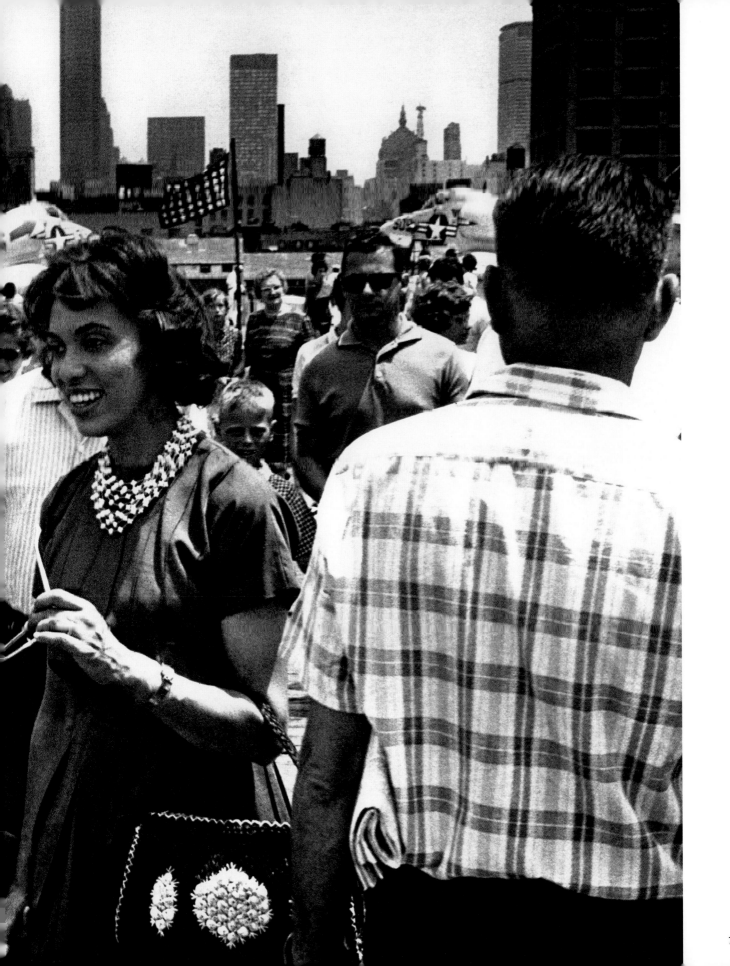

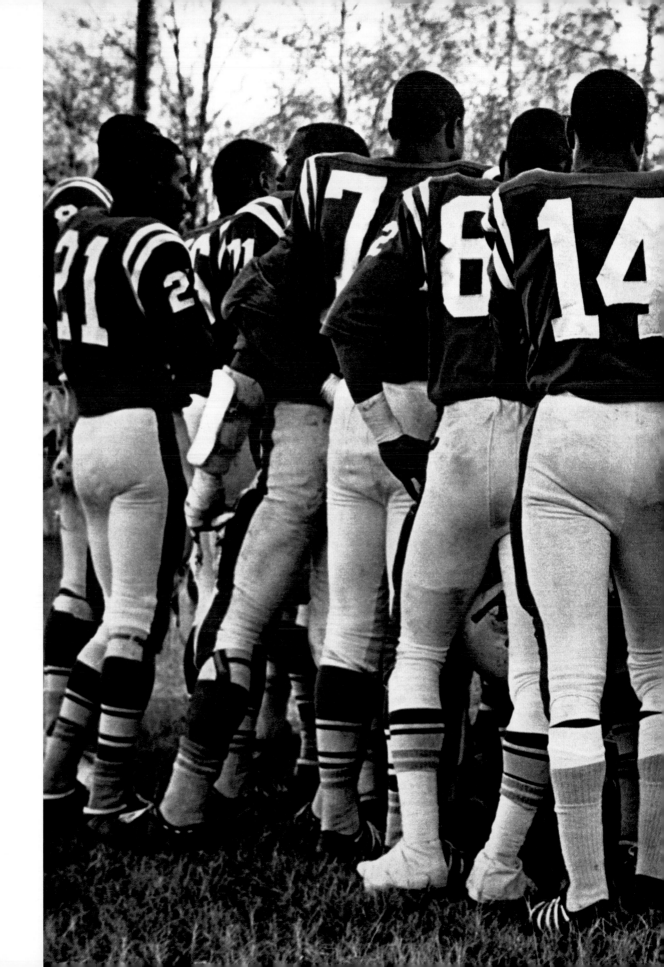

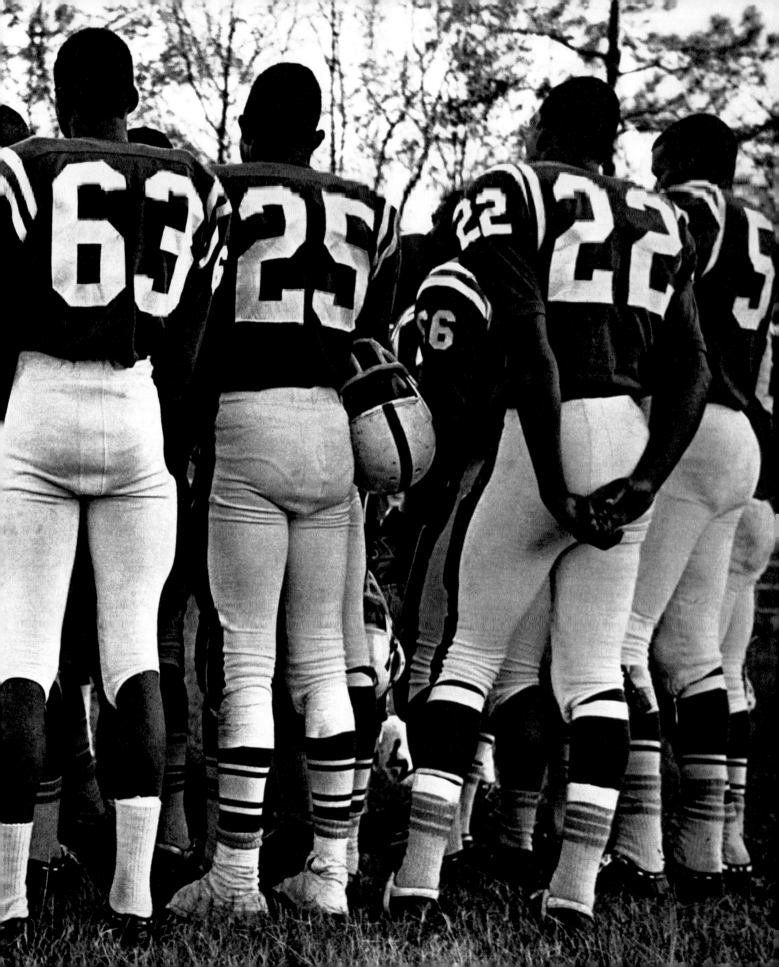

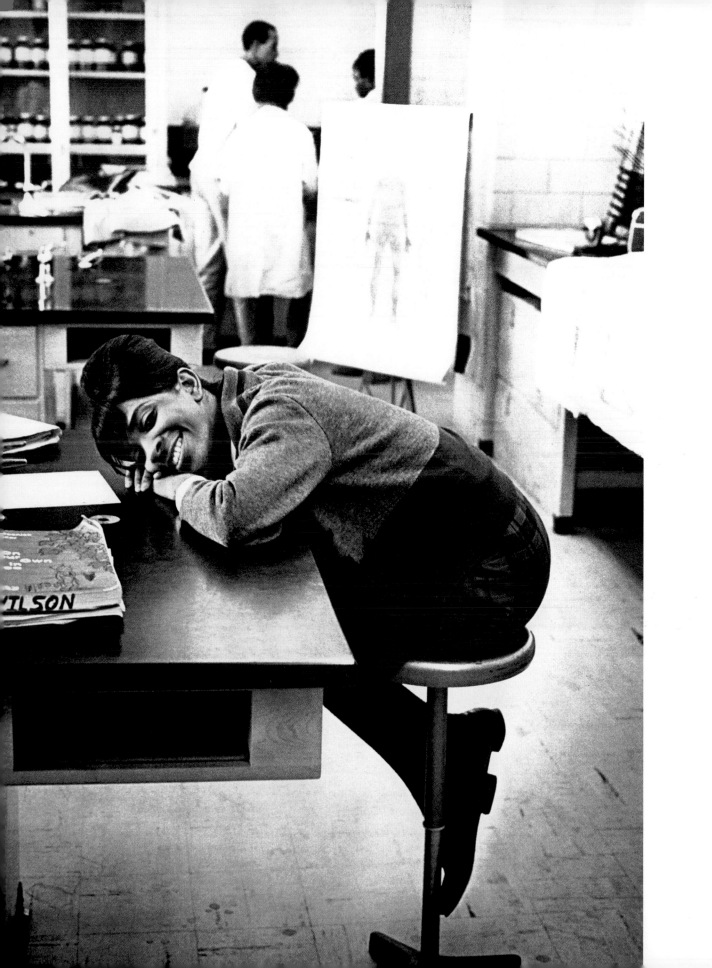

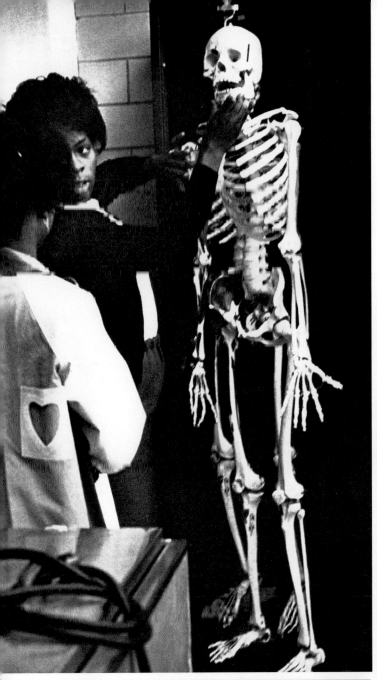

While the majority of Negroes remain outside the main stream of American life, slowly, ever-greater numbers are beginning to enter into it. A new generation of educated Negroes is taking over the leadership in the Negro communities.

Professions once closed to all Negroes are being forced to accept the competent university-educated Negro. Middle class America and the middle class neighborhood are no longer a white reserve.

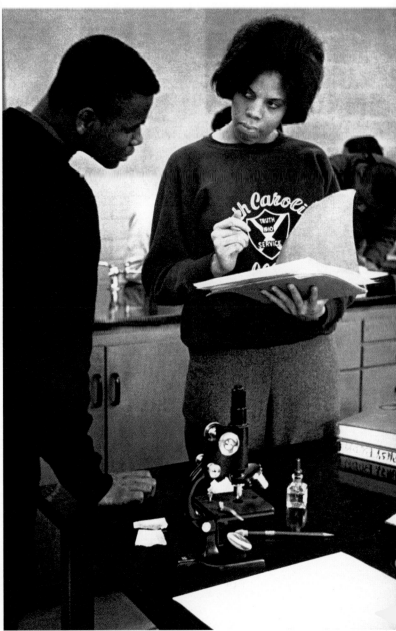

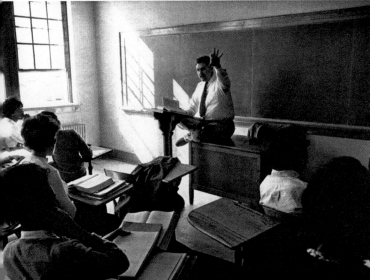

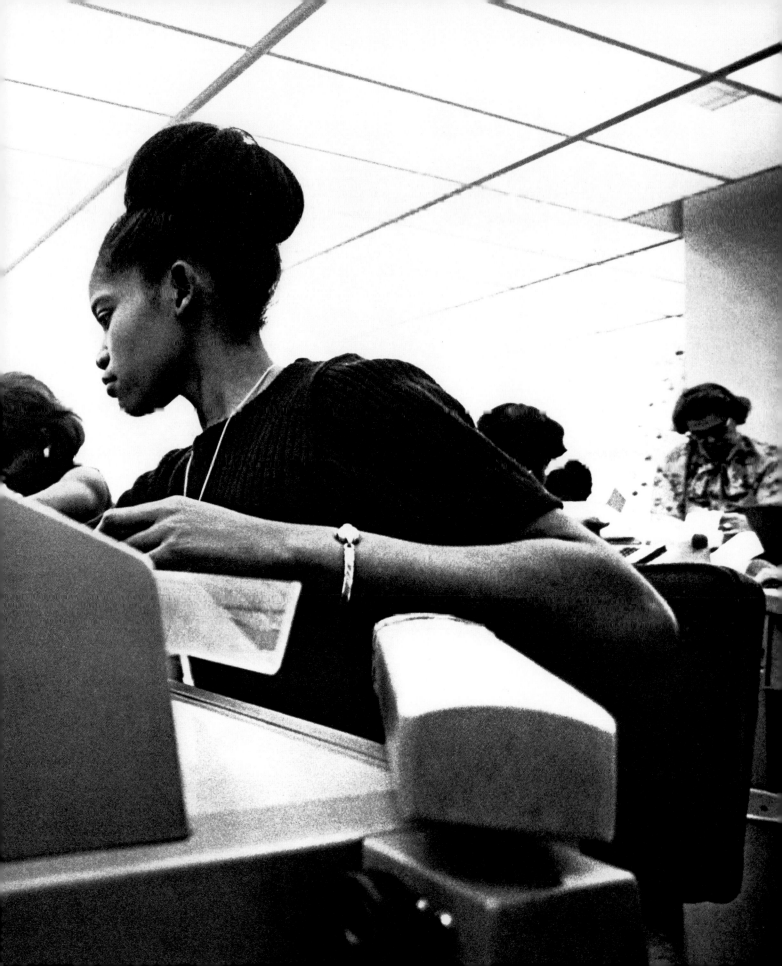

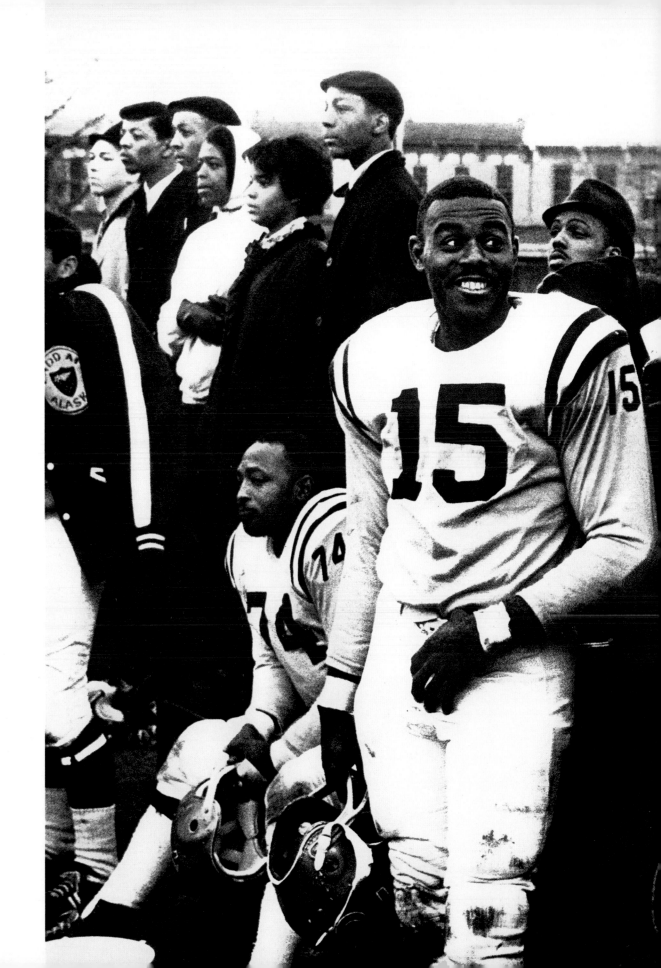

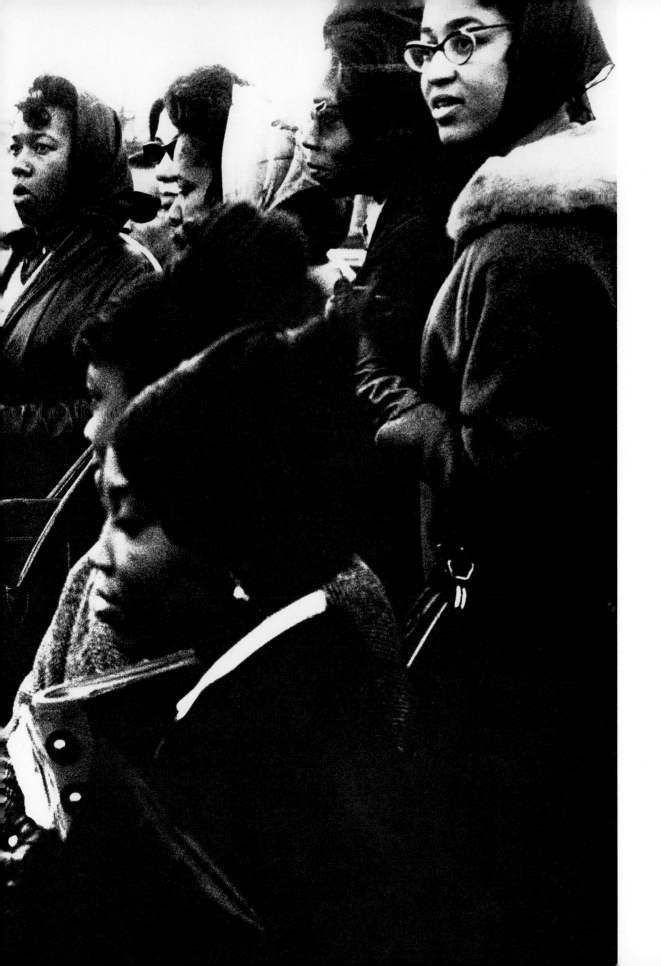

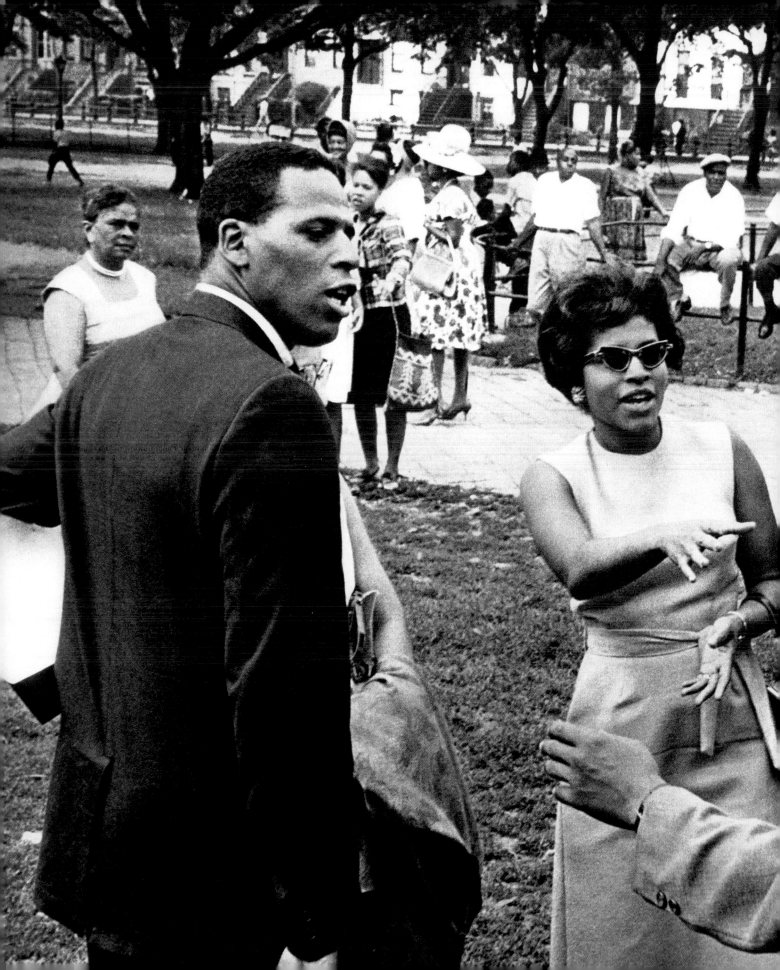

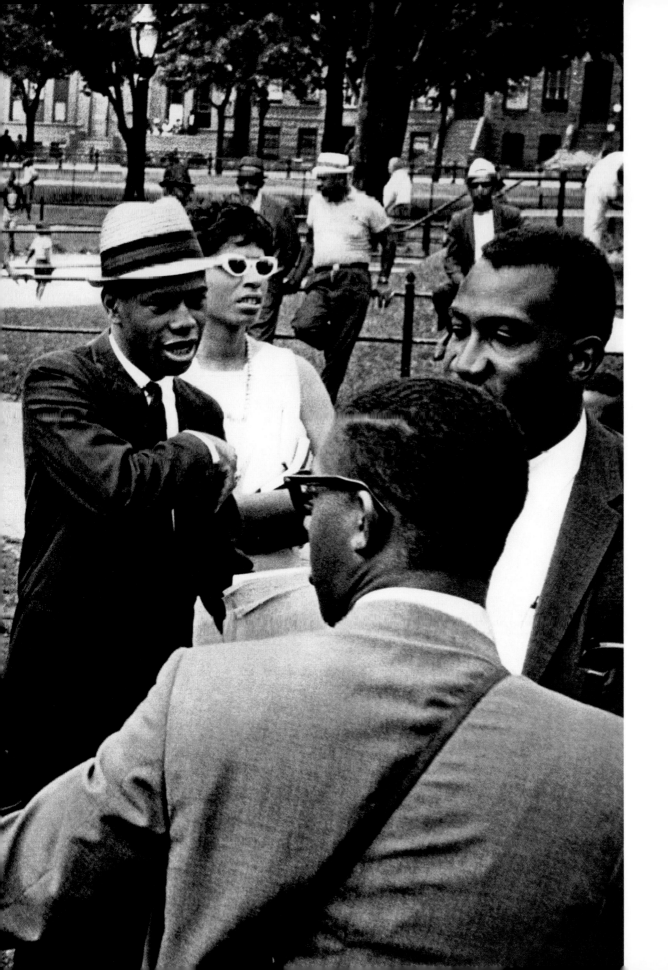

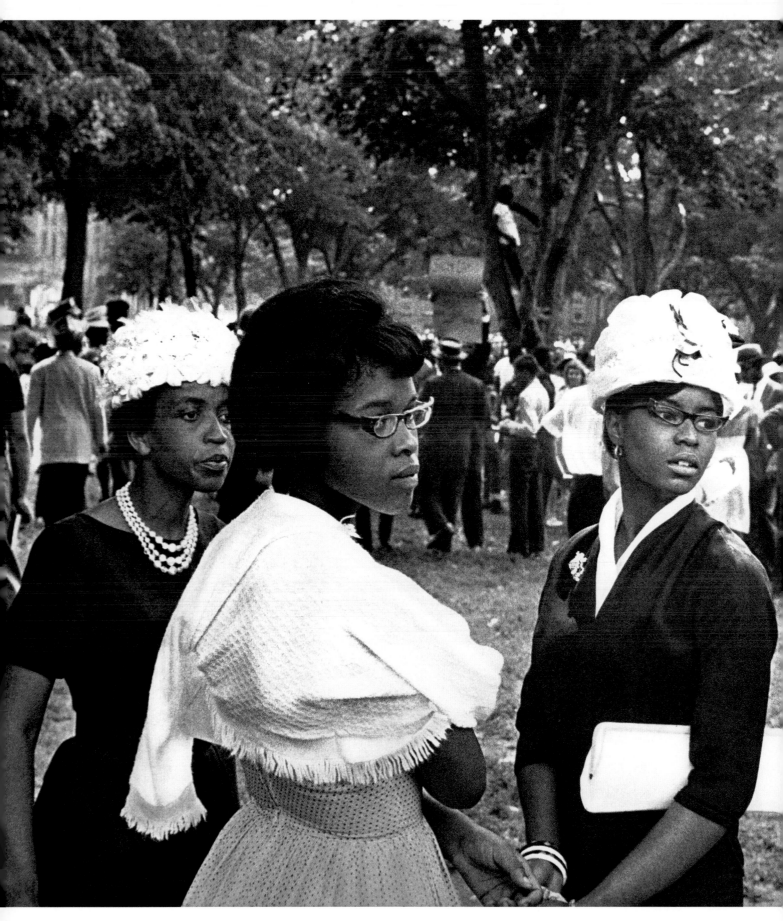

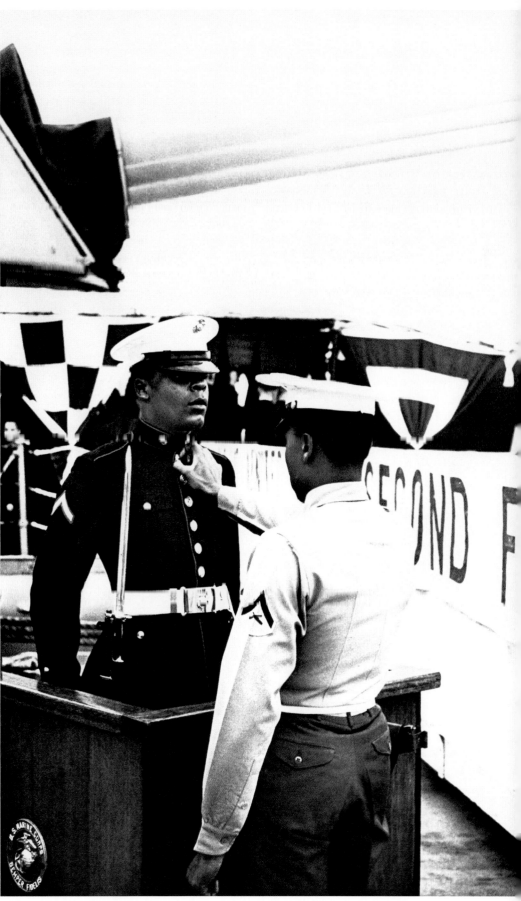

Charleston, South Carolina

'You're next, if you want your hair cut,' the barber said. He was getting excited and speaking fast and loud; his shop was full and the Negro situation was being discussed. A strong-willed man, the barber maintained his position. 'The Negro must show the white man he's not afraid and will fight back.' I had come in with a local Negro, this being where he usually came for talk and hair cuts. 'Do you want to go in?' he had asked. 'The whites have their own shop down the street.' I mumbled something like 'a barber is a barber' and followed him in.

Five years ago, they said, I'd be risking my life being in a Negro shop. The police used to raid Negro bars, hotels and businesses looking for whites; the whites were then usually jailed and beaten. If there was anything the police hated more than a 'Nigger' it was a 'Nigger lover,' as they called any whites they found.

'Here, in the larger Southern towns, a Negro could now live a self-respecting life as a human being, the problems are in the small towns,' continued the barber. He then went on to tell how he always filled up his auto in the city, never buying gas in the small towns. He found it the best way to avoid trouble. Laughing, he said he had read that in Russia things were bad because the gas stations were so far apart. 'Well,' he said, 'it's like that for the colored here.' Whenever he makes a trip, he plans it in advance so as not to refill along the way. Figuring out how much extra gas will be needed, he carries it in cans. A Negro never knows if they will serve him or insult him in the small towns.

The barber told of a hunting trip he took a while back. It was some kind of national holiday, and he was returning home. Low on gas, he stopped in a small town. Knowing that some stations didn't operate the gas pumps on holidays, he asked, when the white man finally came out, 'Are you selling gas today?' The attendant looked at him and said, 'Oh, one of these smart Niggers.' He said he only wanted to know if they were selling gas today. One word led to another;

the attendant said, that he didn't need to sell any gas to smart Niggers and could damn well live without their money. The barber then drove off until he was just about out of rifle range and stopped his auto. He could still see the white man standing there watching him. Then, taking his hunting gun, he shot a few holes into the gas station sign just behind the man. The barber looked at me squarely in the eyes and said, 'I could have hit that white man easily but just wanted to leave something the guy would remember.' Taking my place in the barber chair, I told him to forget about the shaving. He looked down at me and with a broad grin said, 'You'll just have to take your chances with me because I sure can get mad at white folks at times.'

South Carolina

During the day I had passed it, a lonely old broken down country store with a second hand gas pump out front, lost among the wild moss trees, swamps and cotton fields. Now a fairy queen had touched it with her magic wand. Hundreds of autos were parked along the road and the place was a beehive of young lovers and potential ones. From behind the store, in a newly built hall put up by the community, canned amplified music blared out hot. Packed together in subdued light, six or seven hundred country kids and a few from the nearby town, were dancing. It was a new thing for these parts, a Saturday night dance.

'I named the hall the "Progressive Club,"' said the elderly organizer. 'The people have got to get used to the word progressive. The whites don't like it much, they're mad about the whole thing. The whites around here have no place to go Saturday nights, no hall of their own. They can't figure out how we colored could build without their help. They come and look in from the outside, see us having a good time and their faces just curl up in rage. Won't come in though, won't humble themselves.'

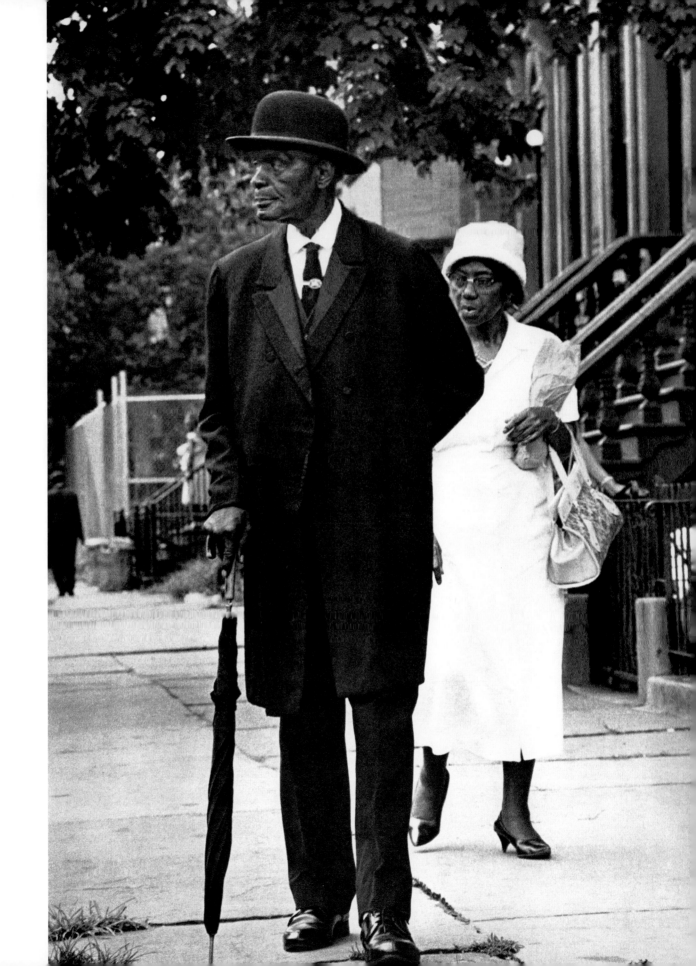

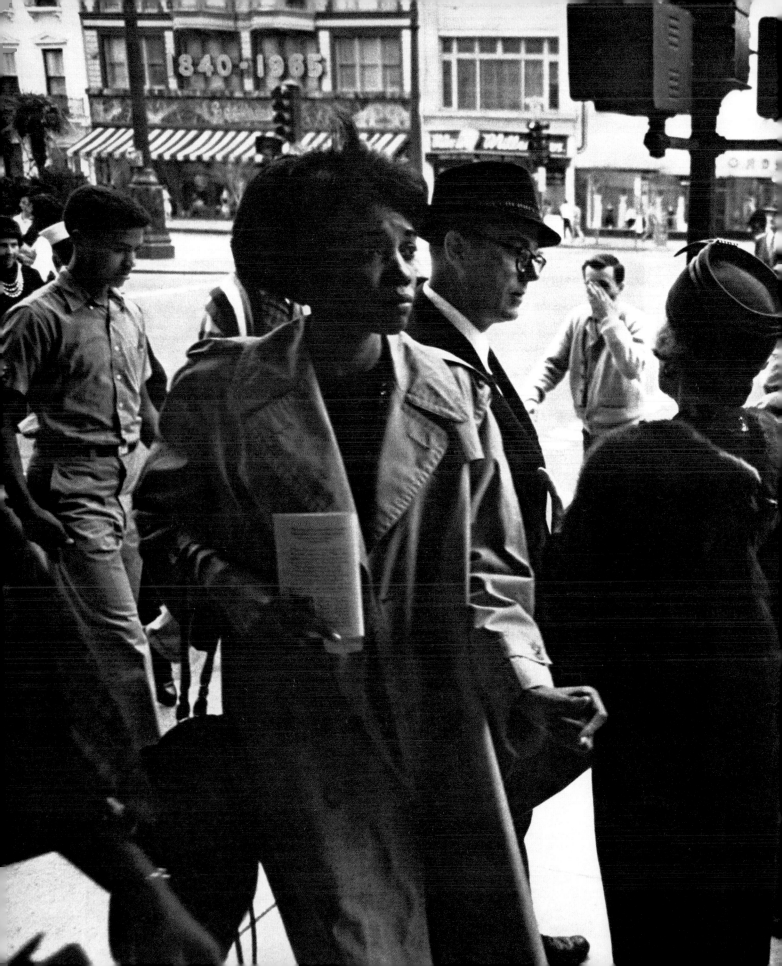

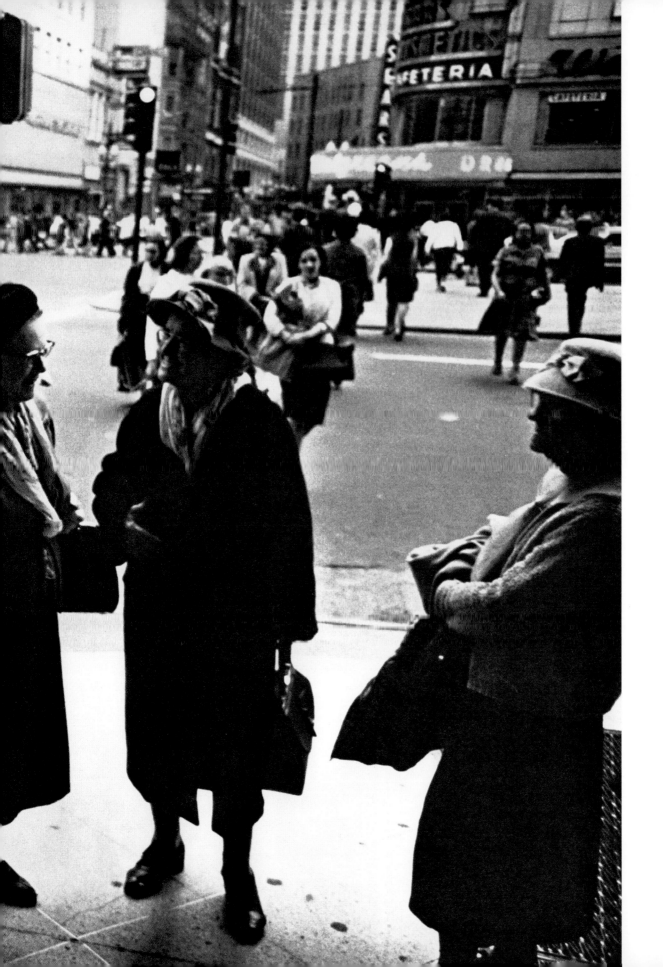

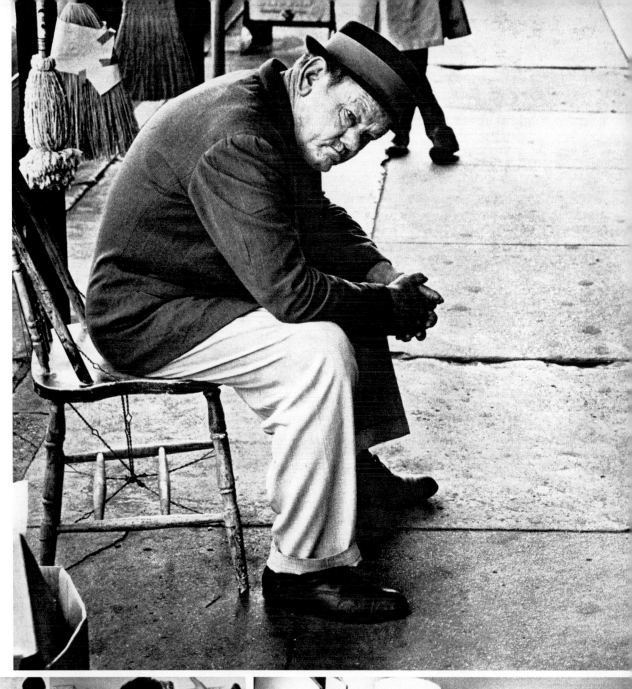

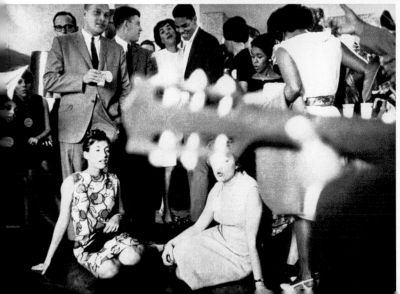

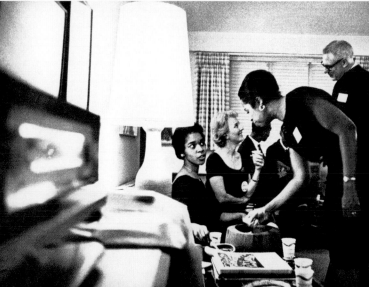

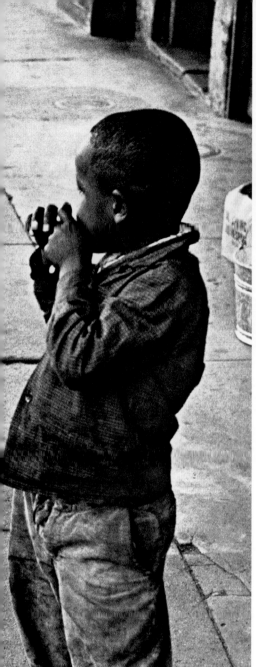

Rows of neat little houses, inside and out each was like all the others, the dream homes of Americans across the country. Only in this community, one saw more African wood carvings than among the white suburbanites.

'These are my husband's books; he still does some reading. Let him show you his carpentry work,' she said. I tried to keep in mind all that she had been saying. 'I hated white people but my husband has gotten me around to viewing the whites a bit differently. Still, at times, when I find myself alone in a shop with them, I feel sick and want to leave because watching them, I start hating.'

She had recently received her master's degree and was now teaching in a Negro school. They would have to wait to have children because her husband, a college graduate, had been refused a position in the Post Office, having been arrested during a civil rights demonstration.

'We need more policemen at the school, the conditions are terrible in the slum schools. I don't know if I can take it much longer. I don't want to transfer to the suburbs because of the great needs of these children, but some of the younger teachers are afraid of being raped in the halls. The worst is seeing thirteen year old girls becoming lesbian for fear of having babies. You look at our home, at how we live and think it's all going fine but it's hell, it's just hell all the time.'

Recently she realized to what extent Negro children were being retarded educationally. With the threat of school integration and white children being taught by Negro teachers, the school authorities had suddenly begun giving preparatory courses in mathematics to the Negro teachers. Also, new advanced text books were distributed to Negro children, the ones that the white children had been using for years.

'Let me tell you, Negroes are not interested in having whites in their homes. What interests them is having a good job.'

'What gets me,' she said finally, 'is going shopping downtown and being treated contemptuously by the white shop girls, as though I just walked in from the back woods. Damn them! Why, just this week I walked into the ladies' restroom in a big department store and all these white women stopped pissing until I left.'

North Carolina

For the last few days I had been watching him, a family man and successful business man, as he talked to groups and individuals on the methods of non-violence in civil rights demonstrations. His audiences were young civil rights leaders from the deep South, who had come together under his leadership to discuss new plans and meet one another. 'You're welcome this evening at my home, we're having a party, just a bit of relaxation,' he said to me. Tomorrow everyone would be on his way, off to do battle again in the small towns throughout the South.
The fact was that this party was a relief from the last six months of tension. At first the party was a little formal with much serious talk, but soon most of the group joined the singing around the piano to sing 'Freedom songs,' improvising on the lyrics. A sadness dampened the thoughts of most; none knew what the next day would bring, and they all seemed to be making the most of this one joyful evening. Then a white fellow sang a sarcastic solo, a joke on white liberals, and the host laid his arm over the white singer's shoulders and carried the melody. Suddenly the host took another drink of whisky and becoming serious, started shouting for all to hear. 'I hate white liberals, you can't trust them!' A shrill stillness pervaded the room. Some discreetly calmed him down while everyone kept their thoughts controlled, avoiding one another's eyes. No one could be quite sure if one of the whites in the room wasn't in reality a 'White Liberal.'

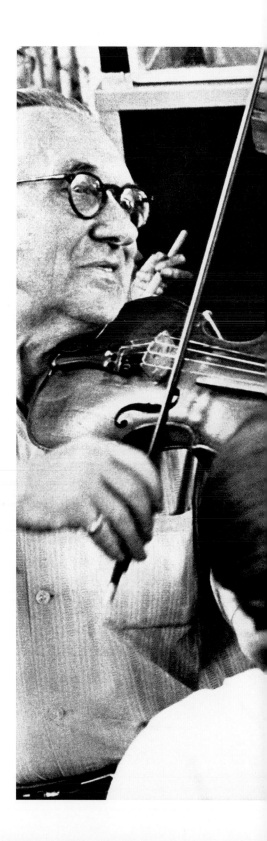

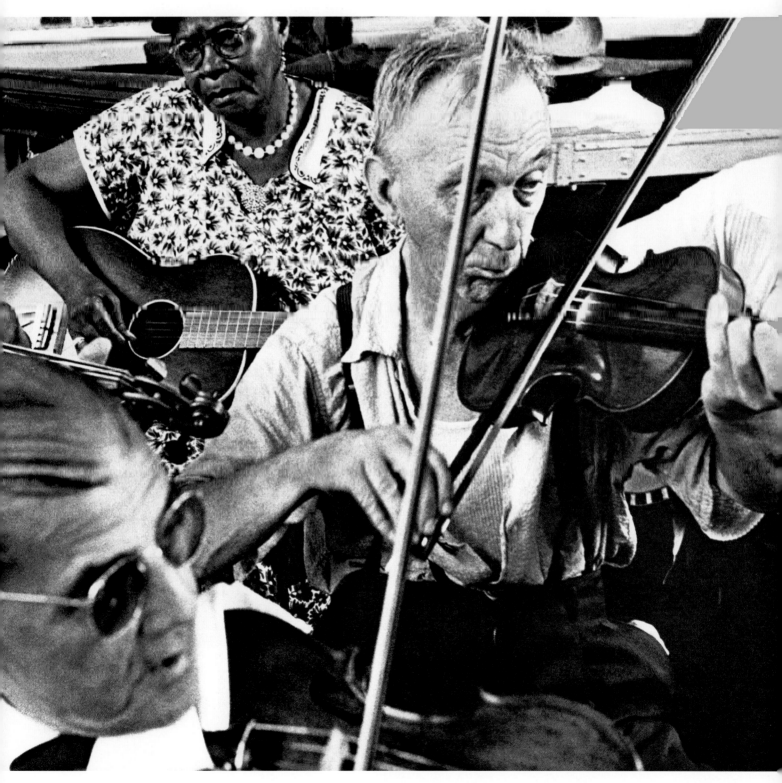

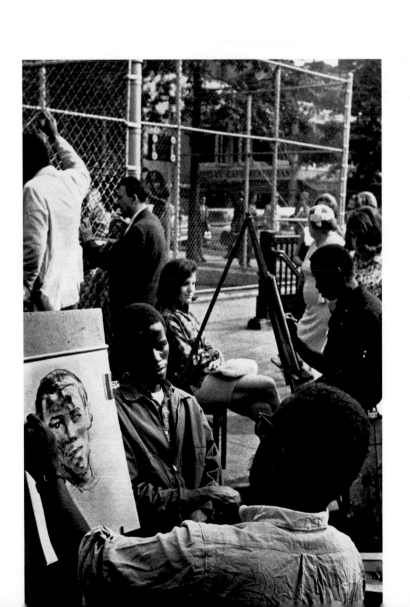

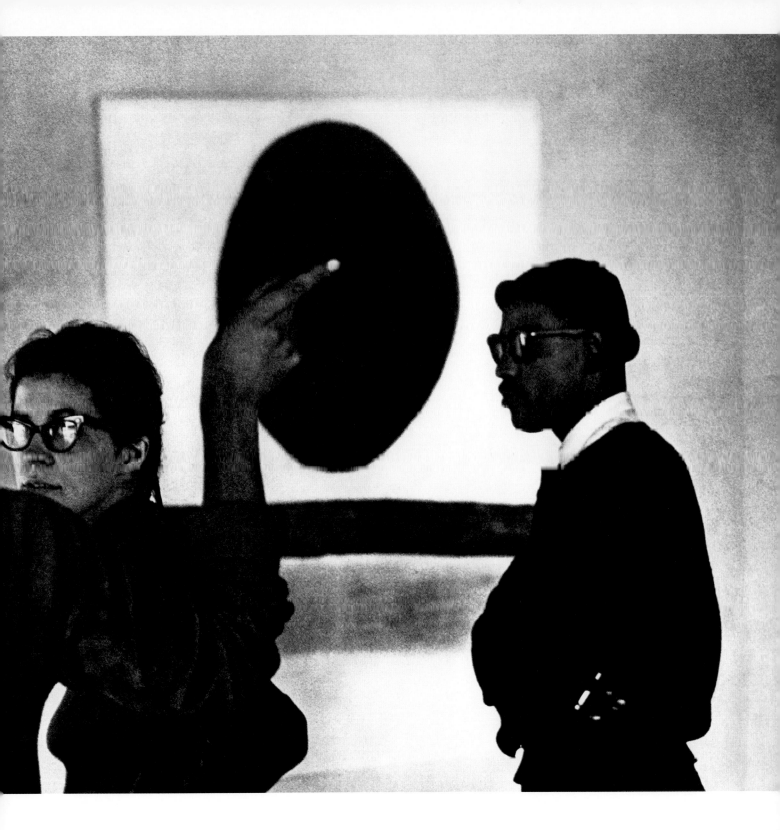

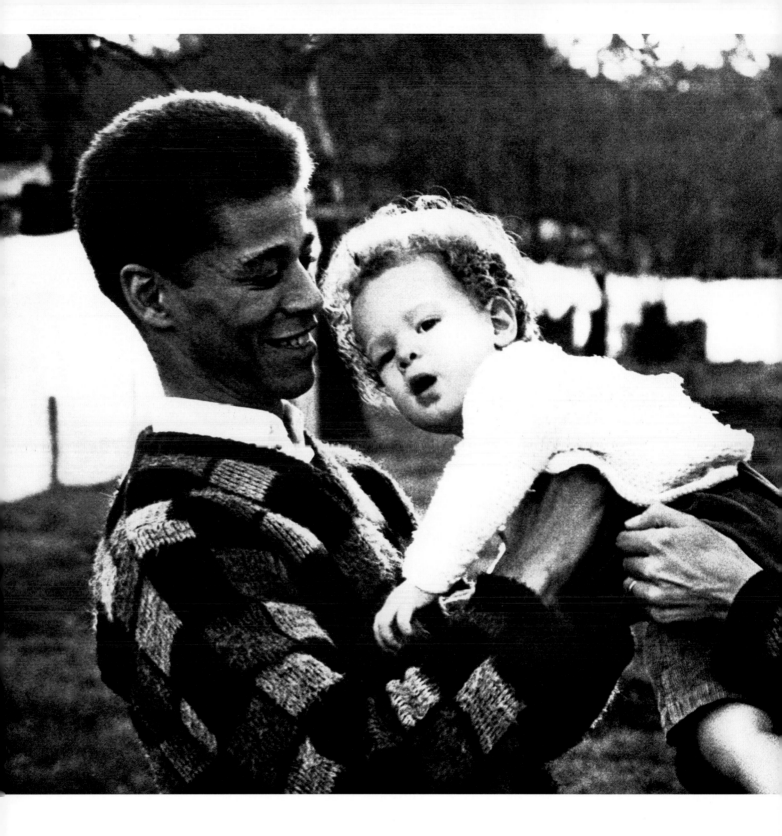

p. 180:
North Carolina

'A few years ago the whites would have lynched me for sure, today they're afraid, afraid of stirring up a hornet's nest. Afraid the Supreme Court might nullify their laws. Afraid of the race riots that might result. Afraid to touch us for fear that others may do as we did. They know I can fight them, so they're afraid to prosecute or draw up a case against us; what they would like best is just forget we ever existed. They're afraid to say we're living in sin and afraid not to, for in this state it's criminal to have inter-racial marriages and we're criminals in their eyes. But the real crime is our having had to marry in Ohio, while my own state would like to lynch me.'

– age 23

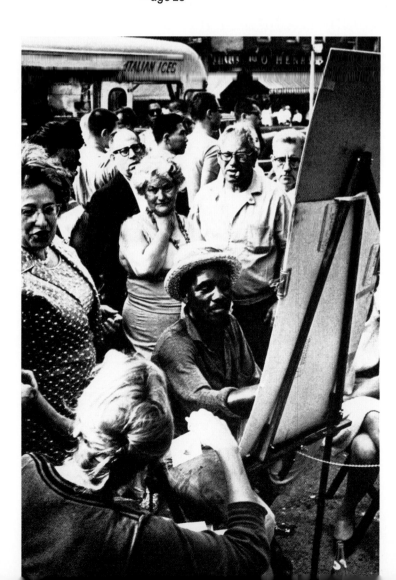

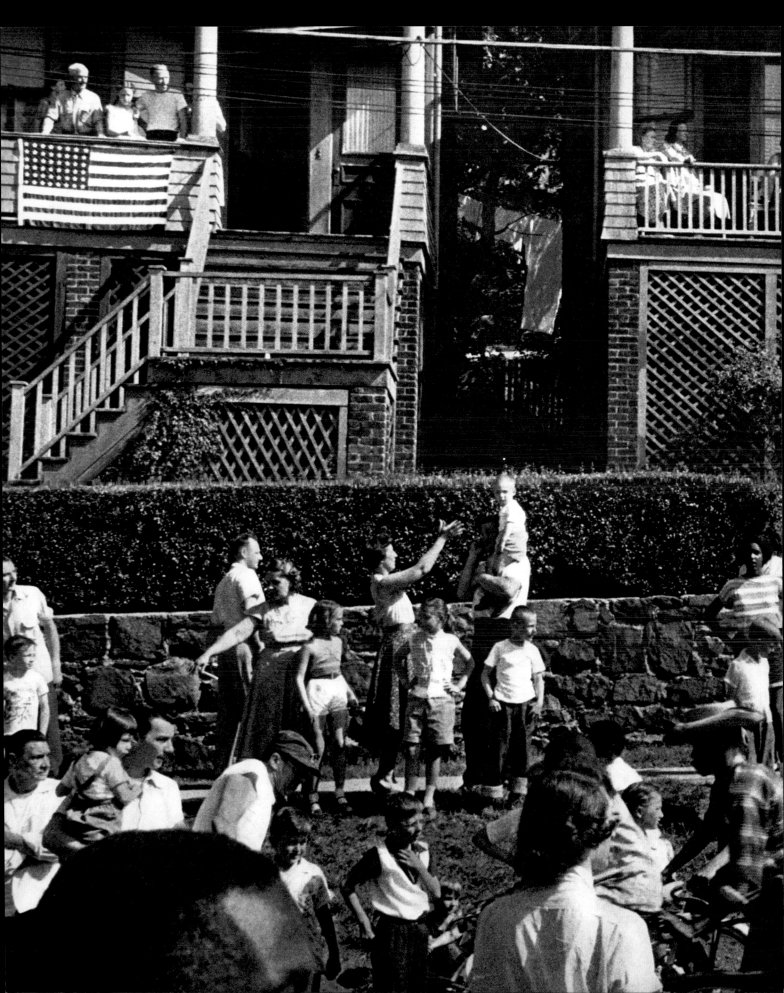

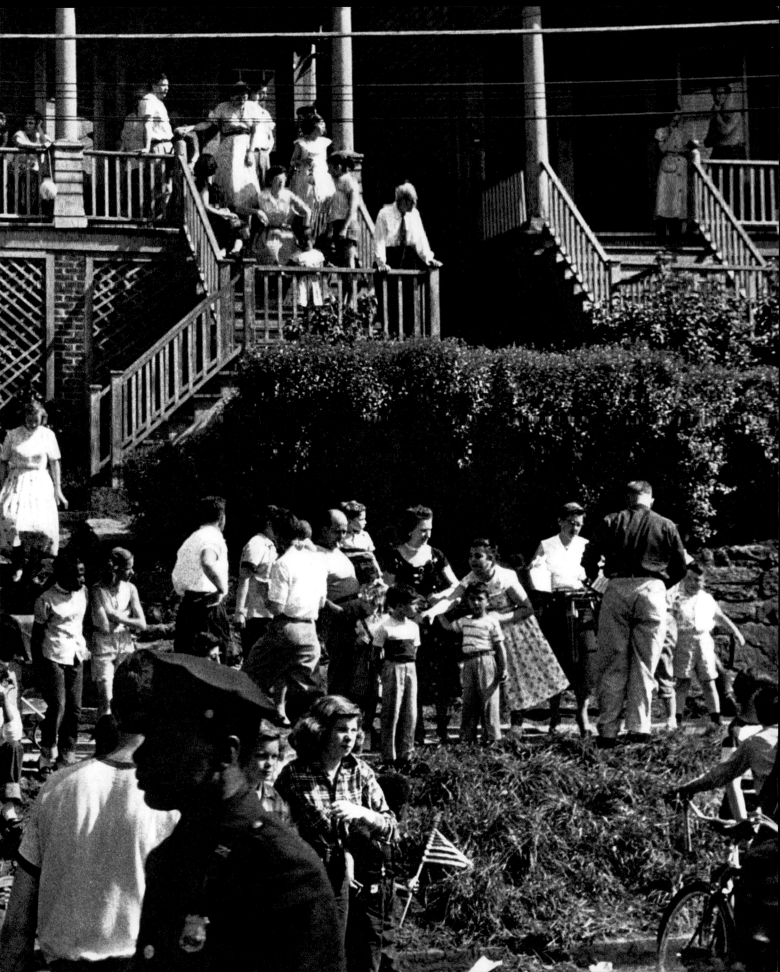

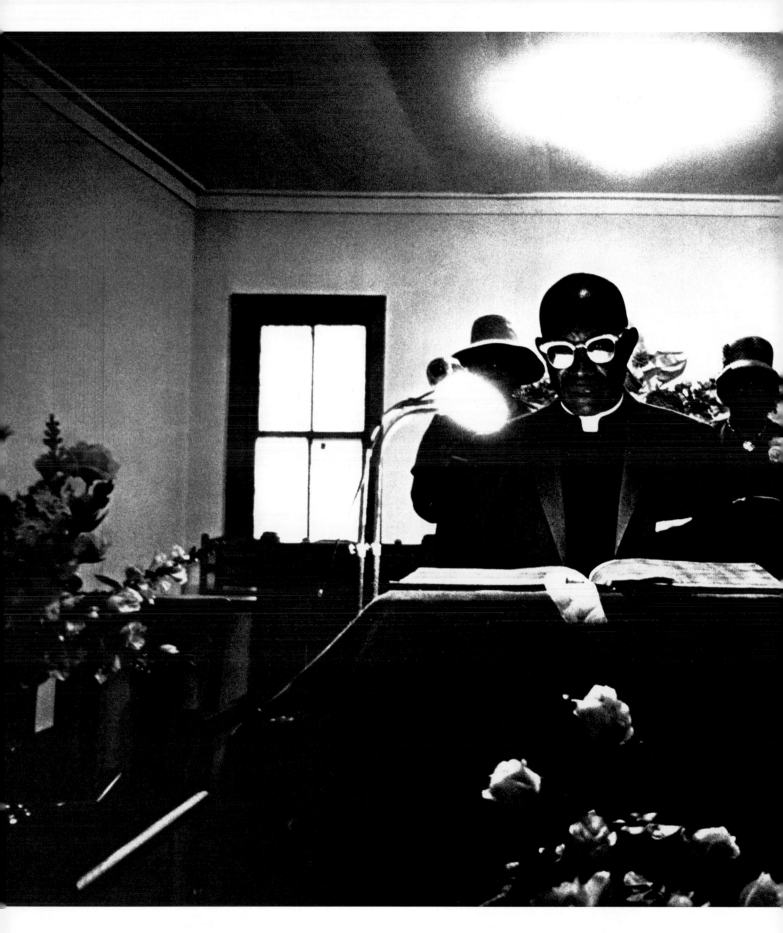

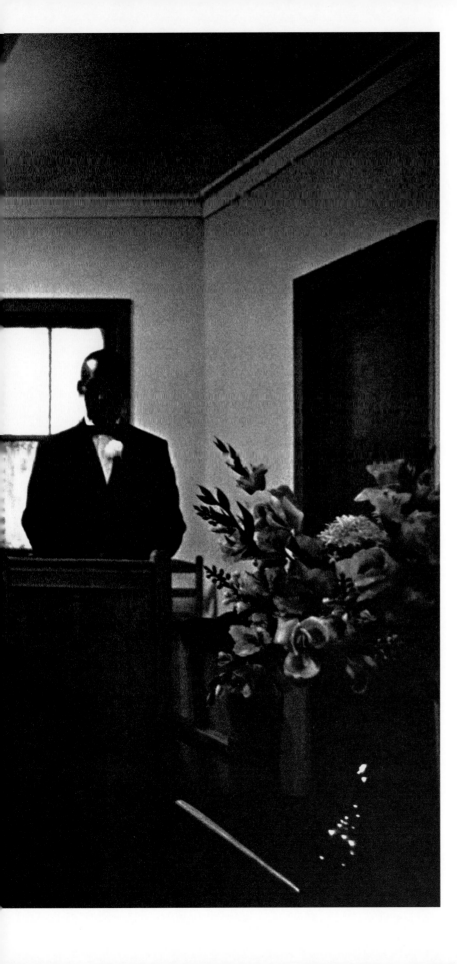

'It's a fine funeral, isn't it?' she said – a wiry jolly grandma dressed in her Sunday best. This morning she had grabbed my arm after church services, saying it was going to be a full day. Everyone was going over, some miles down the road, to Reverend James' church for the funeral. I asked if she knew the person who died. 'No,' she said. It was a young woman who had gone North some years ago, suddenly she became sick and died. Now she had been shipped home to the family. The turnout was good, with people coming from miles around. Some people greeted us, pointed out the family, a quiet group standing to one side. 'Weren't you going to bring a friend?' she asked. 'Yes,' I said, 'but he couldn't come.' I had asked if I could bring a friend, thinking he would be interested, being their neighbor. I especially remembered his saying, 'We folks take care of our people, and the colored and white get along just fine around here.' He had driven me out to the funeral but wouldn't get out. 'Don't think they'll like it,' he said, 'seeing as we're white and that's a colored church.' I told him that she said if anyone's friendly they can come. 'You don't understand the colored like we do; best way to keep the peace is to let them go their way and we ours,' he answered. I left him sitting there; looking back I could see someone was greeting him. The second time I looked, he was gone.

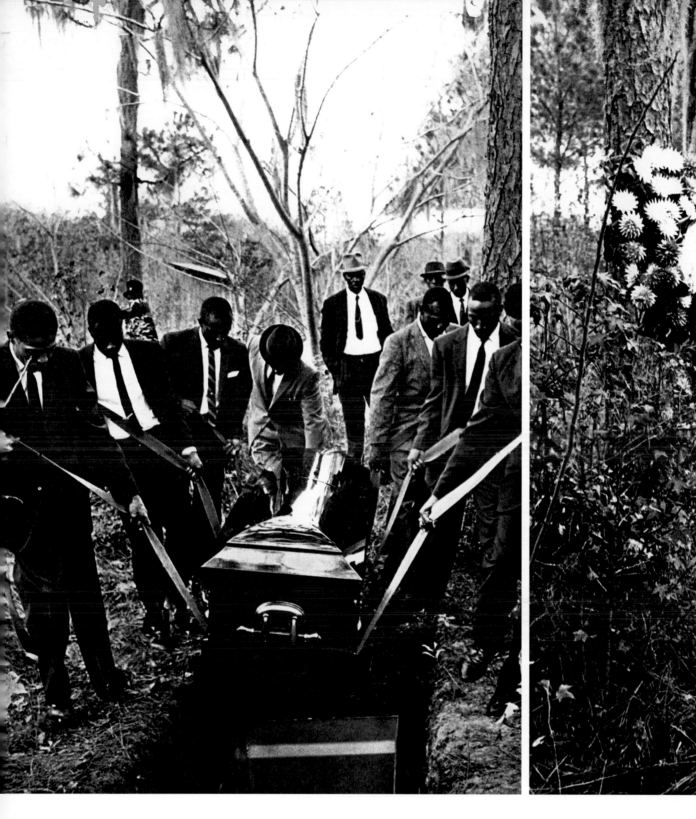

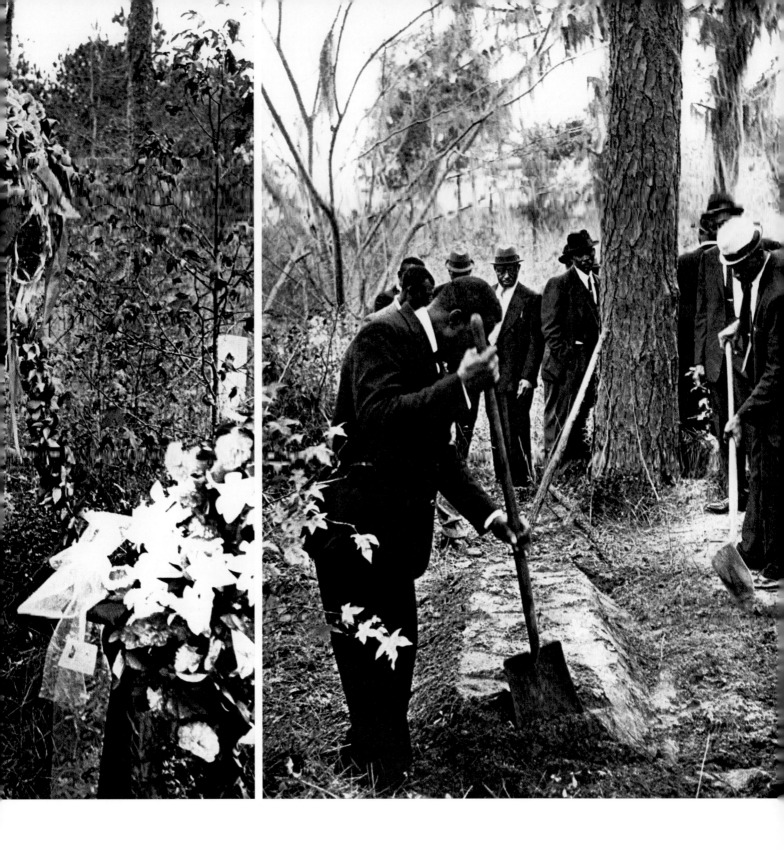

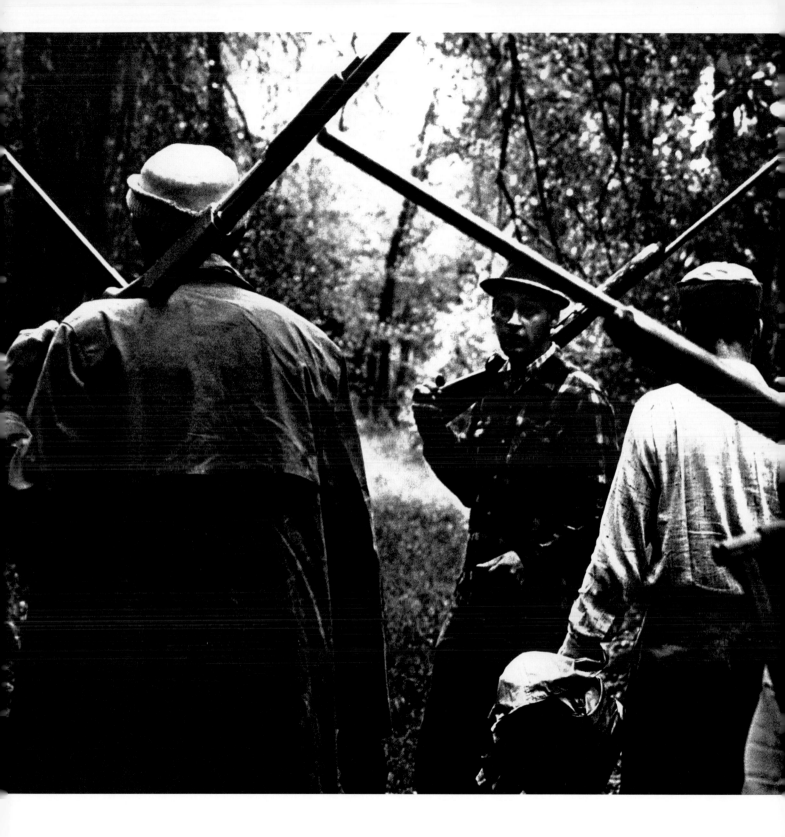

p. 188-191:
South Carolina

**An organized hunting party, the well-to-do
of the community, out for a weekend hunt.**

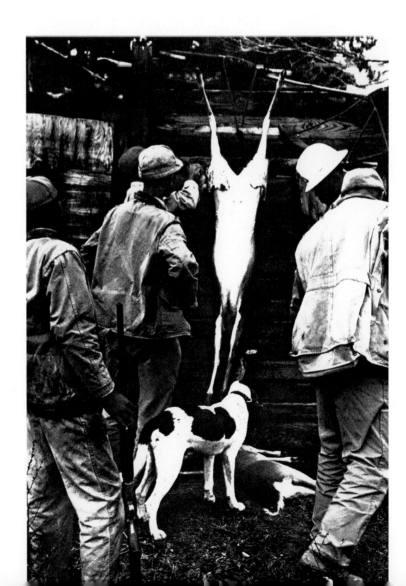

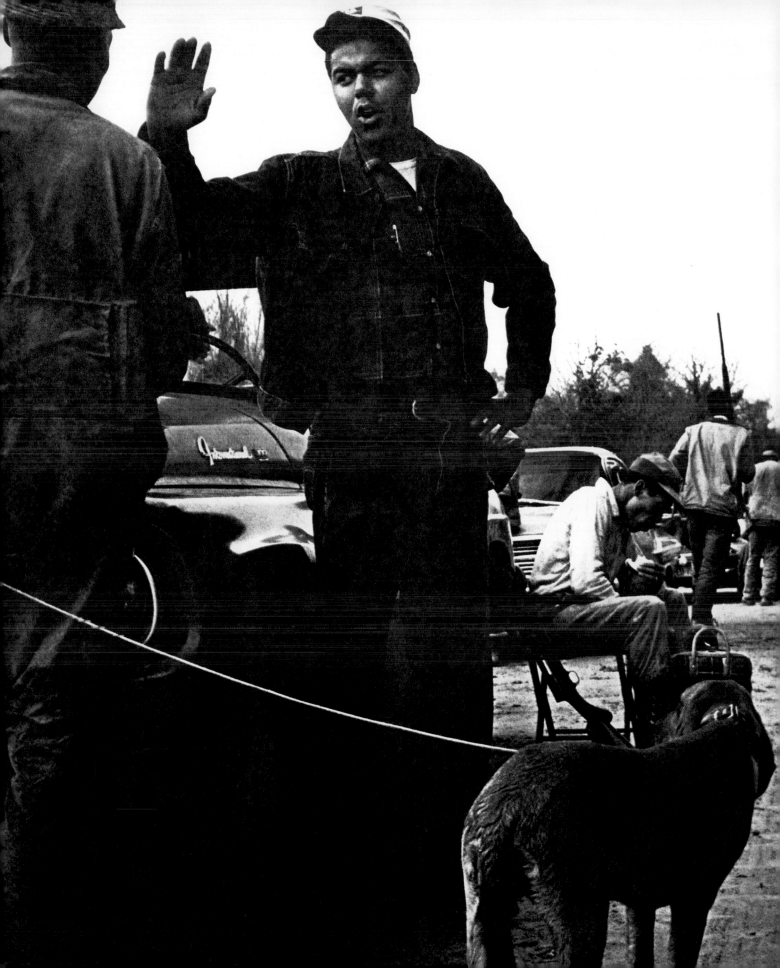

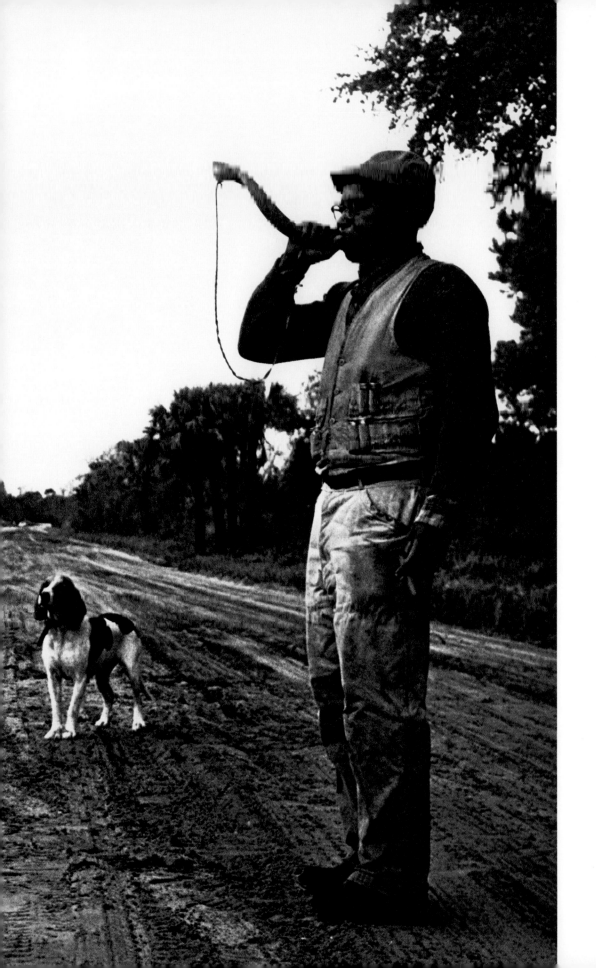

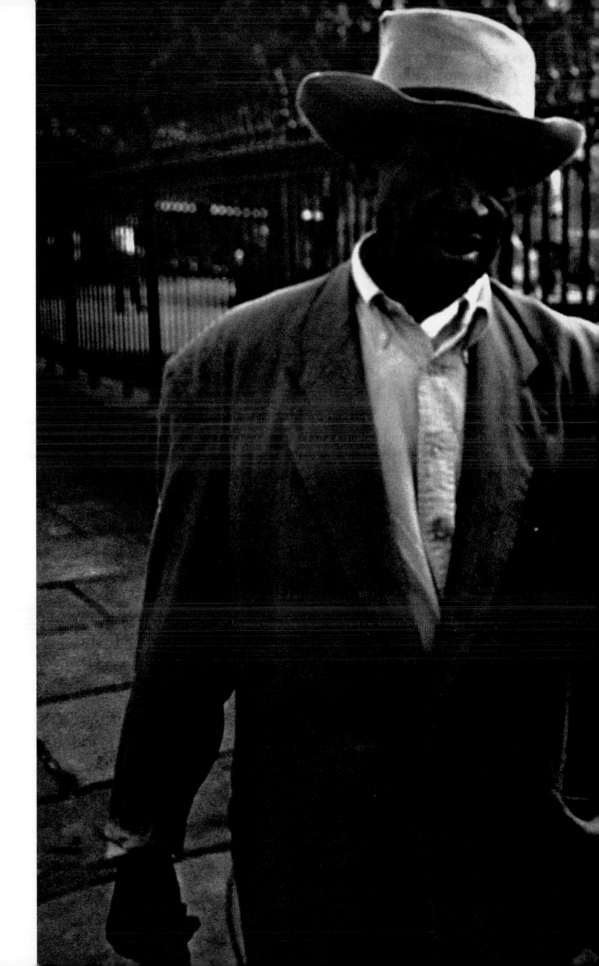

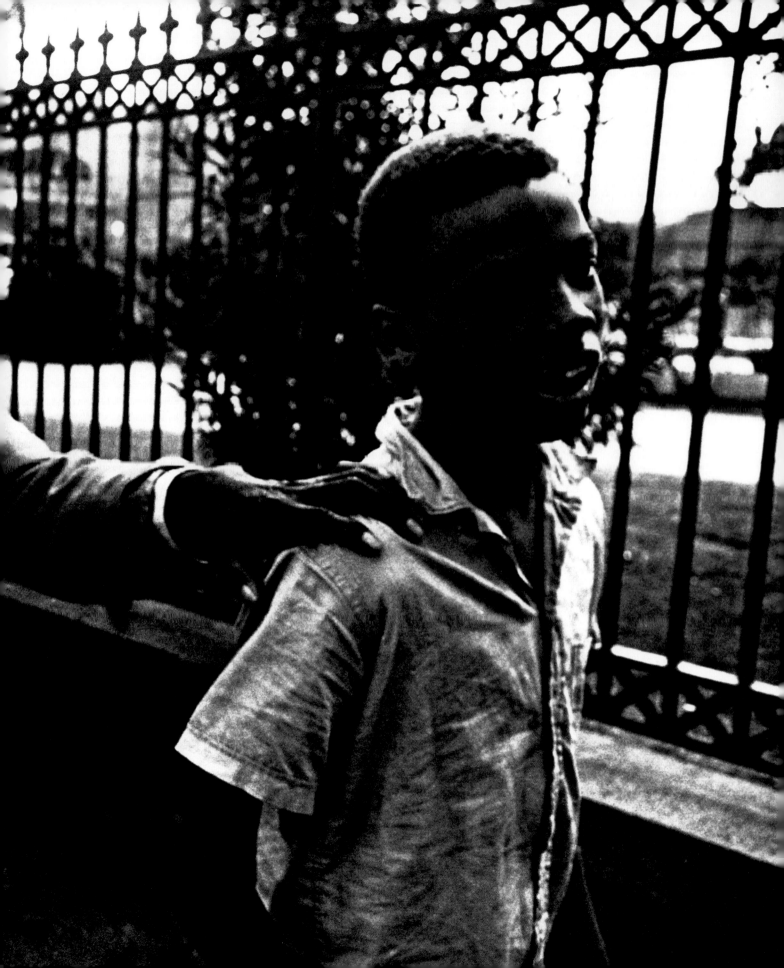

Chapel Hill, N.C.

First he tried to study, then to read; his roommate and buddy was out seeing a girl and he was restless. Blond, blue-eyed and healthy – like a newborn babe-in-arms – that was my roommate as I watched him from my cot. I had been here a week. 'Most unusual,' the college office girl had said over the telephone after my having rung up to ask permission to stay in one of the many student domitories.

'I'm only here for a short time,' I had said. Relieved, they had gone back to the routine of study, dating, pillow-fighting, joking, ice cream, milk shakes, and the talk of girls, autos, football, basketball, the kind of girl they were going to marry and the breasts she should have, large or small.

Once, while they were out on dates, I looked through their books. Seemingly they read only what was required of them, school books.

My time was spent in worlds apart, the days in the Negro ghetto of this Southern town, nights with the white students. They had no real idea of why I was here, nor did they seem to care.

Suddenly he jumped up, slammed his study book down, and went out, shortly to return with a clump of ice cream half as big as his head. He sat on his desk with his feet over the chair, solemnly eating his ice cream. Then he started talking of his life back home, warming up as he dwelled on the joys to be found in his little Southern town. With pride he told me of his family, especially a sister, a real beauty by the looks of her photo. Suddenly stiffening, he questioned me, 'Been talking with any of the Niggers around here?' My heart pounded while the blood drained from my face. Trying not to commit myself as he had come on me so unexpectedly, and knowing we were now on very delicate ground, I said, 'I've talked to a few.'

'I mean, are you interested in this Nigger problem?'

'Well, yes. It's one of . . .'

But he wasn't listening, something was troubling him.

'Sometimes, I get so damn mad hearing all this talk about the Niggers. Makes me want to break a few heads open. At home it's always a fight about the Niggers, it's no fun being home anymore. I go home week-ends and sometimes it's just hell.' He was now emotional and I wasn't quite sure what he meant. 'There they are,' he continued. 'Dad, Mom, Sis, all of them, all shouting at me – Christ, how can they be so stupid. They see only one side to this question. It's just narrow mindedness. It's their side, always their point of view that's right, won't hear anything else. The way they act one would really think I couldn't see their view on this Nigger question.

'It must be the university that makes me different from them: meeting all kinds of people here, some with pretty strange ideas on life, Christ, you can't stop them from attending class with you, just for that.'

His father owned a barber shop and wasn't going to cut the hair of any Negro. The first Negro that tried to enter his shop his father would shoot dead on the spot and so kept a gun on hand. He could understand his father and was also for the rights of the individual, but now integration was the law of the land and everyone had to obey the law. His father was always saying – and now the law said – his barber shop is a public service open to the public. 'Well, damn it! Isn't the Nigger a part of the public!' The Negro should have the same rights as whites but should avoid breaking any law while obtaining such rights.

'Can't understand him,' he continued. 'My father would cut the hair of any Jap, Chinese or black African if they walked in, but he dammed well won't cut the hair of any local Nigger.'

His buddy, now returning rejuvenated from his evening's love affair, heard a few words of the conversation and cried out, 'Christ, are you on the colored again?' Then looking at me, 'Yep, that's the law now, the law has changed things. You can hate a man for his arms, legs, head, eyes, teeth, bones or hair but you sure as hell can't hate his skin – that's the law.'

I told the barber's son about the graduate student from Mississippi living downstairs who, when giving out mail, had told me almost word for word of the same kind of family conflict. The Mississippian had begun to think differently after living in Puerto Rico where he was treated as a minority white. He went through a period of mental reflection and became convinced of the injustice of it all. Being a religious person, he decided that it was now his mission to convert the whites back home to the truth. Only as true Christians could Mississippians be saved and the blacks and whites live in peace. But now things had become so difficult for him that he could hardly go home any more.

The two students stood looking at me. 'I talk with him almost every day,' the blond said, 'I never knew he felt that way.' He seemed overjoyed to hear this; then, more to himself than to me, he said, 'It's true about us Southerners being a religious people; when we see the light and know the truth we convert. We've then got to make other converts and build a church for all to enter. After that, we must again go out into the wilderness preaching the gospel.' The light was out and I lay there thinking how in the moment of truth, when the liberal Northener faces the actual challenge of living in equality with the Negro as a next door neighbor, he moves his family to the suburbs. The Southerner, a religious man, faces the problem as an apostle of his faith. Living in what is still a rural community, he has a very personal and human relationship with his neighbors. His problems involve day to day contacts with the people of the community, not the more abstract social interaction of an industrialized society. If he is a lawyer, the problem will be (he is always sure of his own position in the community) should he permit a Negro lawyer to enter his home, and if yes, should he greet him at the front door or make him walk to the back entrance, like the other colored. What will the situation become as the South industrializes and the problems involved become more complex? As more and more Southern whites become tolerant, the white convert to racial equality will become less opposed to and less isolated from the community – what then? Will he still carry the fire within and see the injustices? Will

he be able to cope with a more abstract situation? As Southern society is still in the first stages of industrialization, the South has a unique opportunity to avoid the mistakes of the last hundred years – industrial expansion over the land, towns and people. It can still avoid the destruction of the human relationships still to be found in its towns and cities, and the important relationship of town to the countryside. What an ideal place the South would be if the white man were to accept and follow the teaching of his religion and the words of the constitution before complete industrialization sets in and while the South is still thinly populated. (For here the Negro is not entering a saturated society, as in the North, nor is he an immigrant – but is on land he knows and may even own, which holds centuries of his own traditions.) If the natural wealth should be justly divided among rich and poor, black and white, while black and white still live side by side – the South might yet find a formula for the future. Why is it that the Southern whites have to say, 'We want to be Christians but God's graces can't be rushed. We must wait and pray, it shall all come in time. Human relations can't be hurried, just leave us be to do it in our way. You don't know the South, it shall all come about some day.' But there is no time, for the South is changing at an accelerated pace – in a few years it will be too late.

What then? Will the solution then rest with the Northern liberals? The liberal who having fled from one suburb to another, finds he must now come to grips with reality? Will he then flee to South where – because the Negroes are squeezed out economically and flee North – he may still avoid the realities?

Talked long into the evening with a conservatively, very well-dressed twenty-one year old fellow staying with me in this respectable, if run-down, Y.M.C.A. for Negroes.

'I have never had a day's pleasure in my life,' he kept repeating to me. Kept saying he was always working, always thinking, had no time to waste as he wanted to be a lawyer. At the moment he was working in insurance, learning its business methods. Thinking it rather odd my being in the hotel, he took the liberty of approaching me. He said that he wanted to know – to know is knowledge and knowledge is wealth. He felt the time talking with me could be beneficial to him.

Coming out of a family of nineteen children, he felt very much alone in this cold, hard world. He said bitterly that his father is now the richest Negro farmer in his Mississippi community, that he had worked his way up from once being a poor farm hand. 'Saves all his money. My father wants all his children to become farmers, wants them to start out as farm hands as he did. He's a real Jew. I don't mean he belongs to that religion, just he won't give money for the education of his children. Now all the children are leaving the farm, leaving him; he wouldn't pay his children but he's going to pay the hired help, that's for sure.

'I'm working for a future, that's the important thing. This talk of civil rights and voting only leads to worries, I can't concern myself with such matters when I've got my future ahead of me.' Leaving the farm in his teens for Louisiana, he attended an integrated Catholic school, shortly afterwards converting to Roman Catholicism. 'I've learned all my efforts must go into developing an investment that will make me independent from others. Once I worked for some whites and that I never want to repeat. The trouble with being dark is the other people, wasting their time and money instead of investing it constructively.' Unlike his brothers and sisters whose interests ranged little further than autos, clothes and women, he is thinking of his children's comforts. 'I'm untroubled, I know my mind and what I want from life.'

His concerns were with personal health and appearances, the law and business. Extremely sensitive to his religious needs, he had studied the history of the churches and yet, strangely enough, had never heard of the ancient city of Constantinople and believed it was the Jews who sacked Rome. Farming, if you kept out of trouble and minded your own business, could give a fine living, still it wasn't for him. The main trouble was that too many Negroes were constantly being killed. The whites realize that shooting looks bad, so they now have taken to less conspicuous methods. He advised his father not to vote because many of those killed were just the ones who did vote or made the attempt. Why should his father jeopardize his good name and a valuable farm when he gets along so well with the whites! Recently six Negroes were found asphyxiated in an auto near the farm; the police reported it as an unexpected mishap, saying, 'Stupid Niggers, don't they know when to get out of a running car?' But the local Negroes know and the whites know (even when they refuse to believe it) that the six were held in the auto at gunpoint while the whites closed the windows and started the motor running. No Negro dares question the police or the doctors. The white-run hospitals never object to how a Negro dies so long as he is dead. The Negro fear of the doctors and hospitals runs deep; many Negro men and women have unknowingly committed themselves to being sterilized while under the surgeon's knife. Bitterly he then said, 'When the whites think a Negro is getting ahead of them, they kill him to intimidate the rest. Last year, a twenty-three year old Negro returned home from the North to visit his parents. Three days later he was found smashed in his auto; it turned out he was the first in town to have this new model, and the whites didn't like the way he was showing it off. My twenty-four year old cousin got the treatment a few years back when he sold his cattle in Texas because of the better prices. Foolishly, with the extra money he bought a cowboy suit, hat, boots and all and thinking himself now a fine dandy, went about town bragging of how well he did in Texas. A few

days later he was caught on a lonely road by white youths, two of whom were deputy sheriffs, and he was so beaten that now both his arms are paralyzed for life. Fortunately he is a war veteran, so the government gave him free medical aid. To protest is useless; better paralyzed than dead.

'The whites won't bother my father as long as he never votes, doesn't permit civil rights literature within his home, minds his own business, and is helpful and friendly to the whites. But it's not just the colored that's got to be careful. A few years ago a rich white bought a ranch near my father. Had a wife, two children and an airplane, trouble was he kept to himself, took no interest in the other white farmers, and in three years was run off the land. The whites don't like strangers. If he had been like them, confided in them, he would have been in order. He was too independent and this frightened them.

'When I visit my parents, they drive me in and out of town under cover. One time in town I could hear the storekeeper and some others discussing this Nigger who spoke English properly, wondering where I got such a good education. When it was found out in town that I wanted to be a lawyer, they had little talks with my mother. She's now fearful of my being killed and doesn't want me seen in town.'

I wondered at his speaking so freely with me; some others in the hotel had pointed him out as a strange one, never giving a straight answer; but now he seemed to feel it important that I know of his tribulations. I asked him what it would be like if I were to visit his home town. If he were me, he said, at home he wouldn't dare wear a good, clean suit, nor a tie: this might give the whites a bad impression. But they would probably invite me in their homes. 'Just don't stay too long in town without a good explanation or let them suspect you of having sympathy towards the Negroes; this might lead to your being run off the road one night.'

The rich Negroes (like his father) and the whites have now found common cause to unite. The tendency has been for the young Negroes to move out (anywhere but there).

Thus for the first time the whites are coming into the majority; but without the cheap Negro labor, who will work the land? As yet machines can't do all the work. To whom are the local white store keepers going to sell? In the past the whites would buy cheaply in the big towns but the Negro farm hands were forced to buy at high prices at the local store. Thus what the whites gave out with one hand came back to the other. The tragedy is that most of the whites don't care; as long as they rule at the farm, the ship can sink.

He feels the South to be his real home but first he must go North to get law experience in various competitive fields, something he would never be able to do in the South. He even dreams of spending a few years in Europe so as to shed his Southern Negro provincialism.

I asked him if he knows others like himself. 'Not many,' he said, 'Most of the people are the living dead, they've given up hope in a future for themselves or the Negro.'

'What do you think of the civil rights organizations?' I asked.

'Its effect is felt only in the big towns, nothing has changed on the land. The N.A.A.C.P. (a conservative organization) is the best. I would join it if I could, but I can't. I'm Catholic now and the church has not given its approval.' It is his opinion that if a Negro farm hand saved one dollar a week out of the fifteen he earned, at the end of the year he'd have a tidy sum in the bank. Knowing its value, he should then invest it to improve his position in society. Things are changing for the Negro, he said, and he wants to go where he can best take advantage of the situation to earn money. 'Equal job opportunities, that's what we need. What's the good of all equal rights if we've got no money to buy a meal?'

'I don't believe my parents ever rested except for a few hours on Sunday and in church. Happiness for my father is having money in the bank. What is happiness? I've never had it. I don't know a day where I haven't been thinking of what to do next. Just think, in my home town it's not good for any dark man to wear a tie except for church.' Then he said, 'My father has a good

social life with the whites, some even come to his front porch to sit and talk.'
'Do they ever go inside?' I asked.
'No, whites don't mix that socially.'

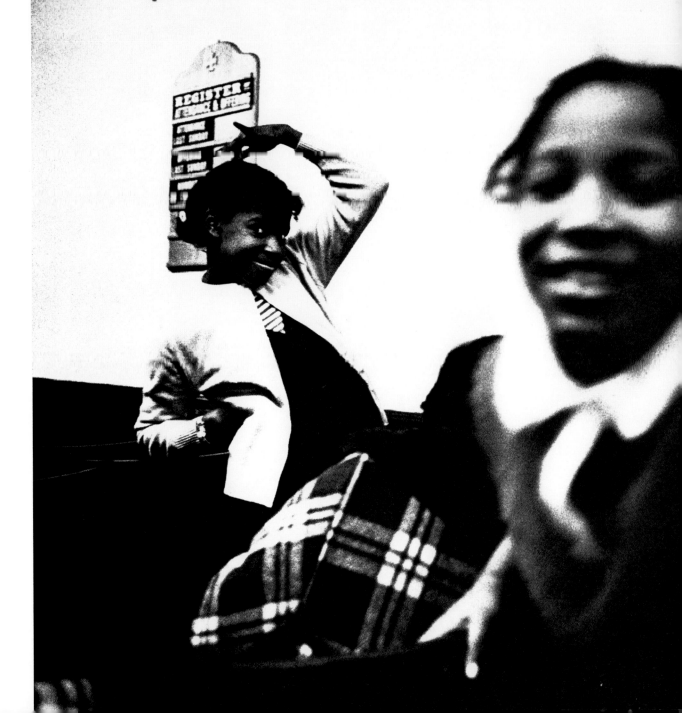

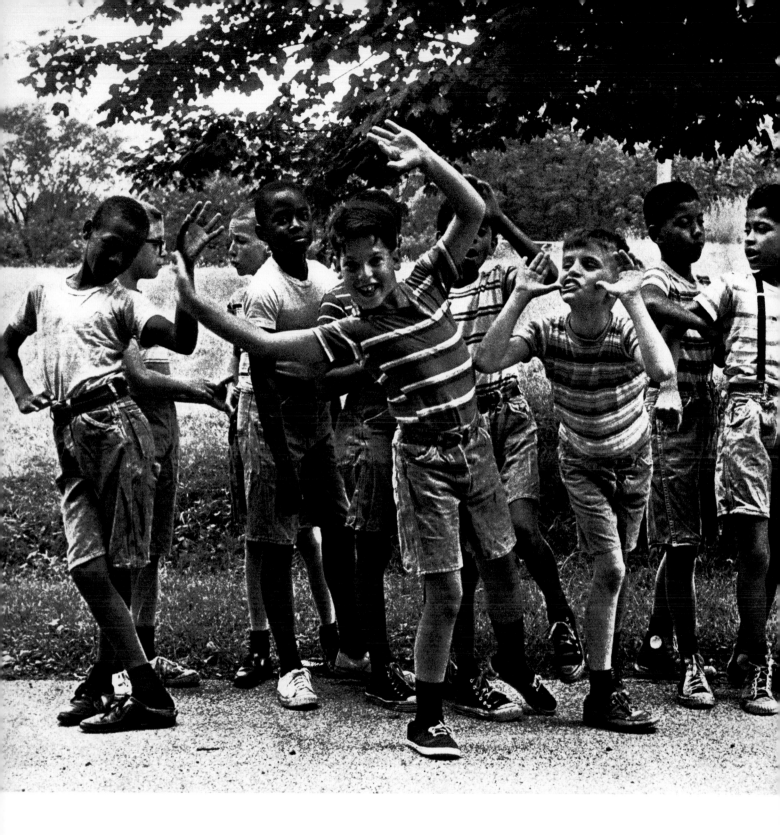

New York State

**A summer camp for the poor children of
the cities.**

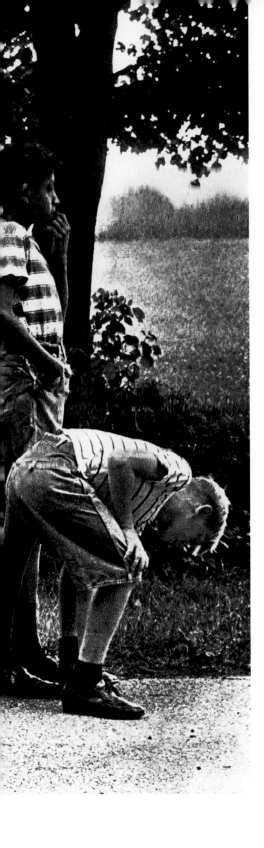

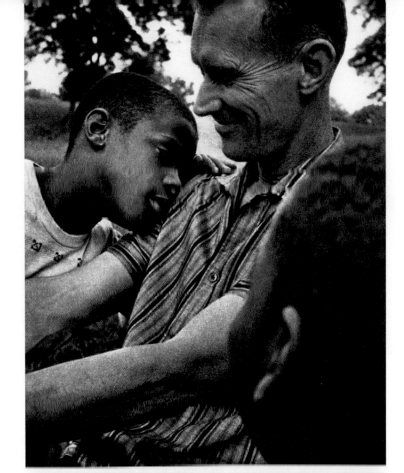

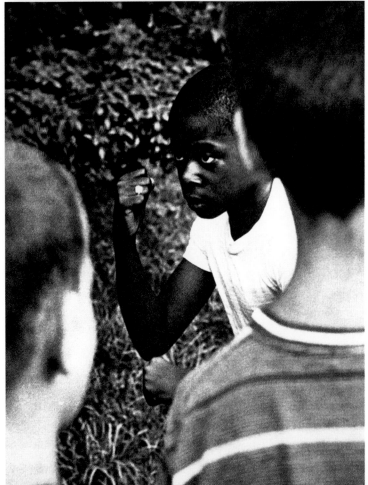

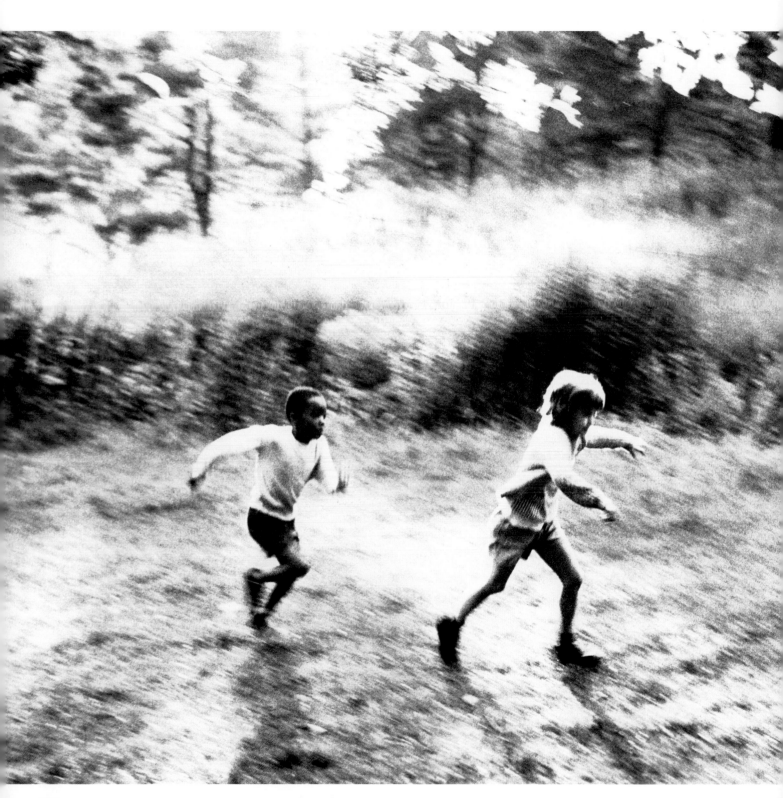

*Excerpts from an address
by Martin Luther King Jr.*

. . . even though we face the difficulties of
today and tomorrow, I still have a dream.
It is a dream deeply rooted in the American
Dream. . . . that one day this nation will rise
up, live out the true meaning of its creed:
'. . . that all men are created equal.'
I have a dream that one day even the state
of Mississippi, a state sweltering with the
heat of injustice, sweltering with the heat of
oppression, will be transformed into an
oasis of freedom and justice.
I have a dream that my four little children
will one day live in a nation where they will
not be judged by the color of their skin but
by the content of their character.
. . . So let freedom ring from the prodigious
hilltops of New Hampshire. Let freedom ring
from the mighty mountains of New York.
But not only that. Let freedom ring from
Stone Mountain of Georgia. Let freedom ring
from every hill and molehill of Mississippi,
from every mountain side.
When we allow freedom to ring . . . we will
be able to speed up that day when all of
God's children, black men and white men,
Jews and Gentiles, Protestants and
Catholics, will be able to join hands and
sing in the words of the old Negro spiritual,
'Free at last, Free at last, Great God
a-mighty, We are free at last.'

p. 203:

The old teaching the young: belief, custom,
stories and songs are orally transmitted
from one generation to another.

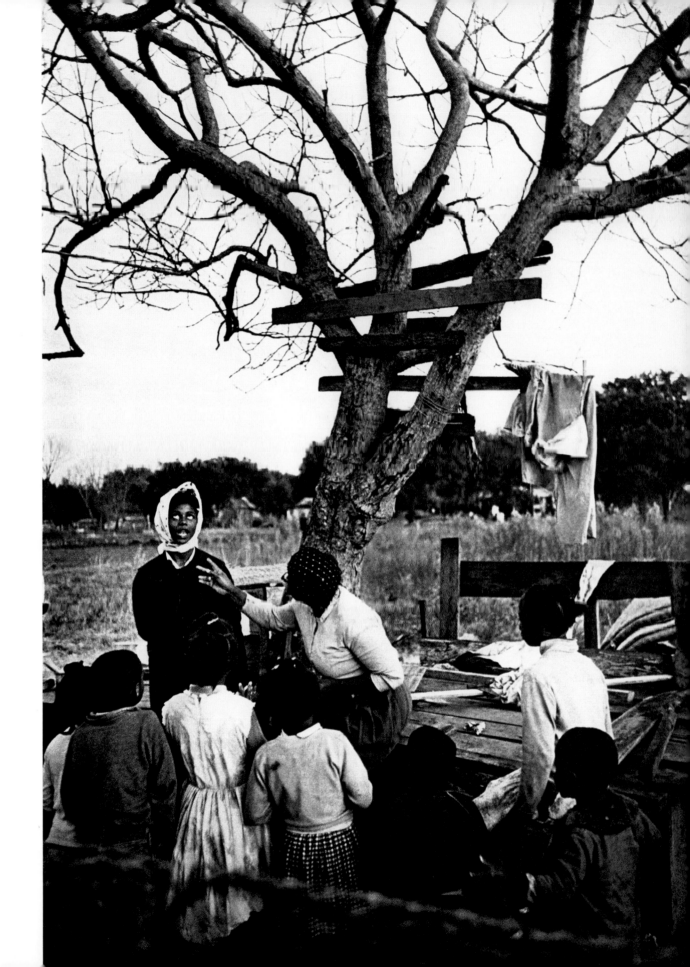

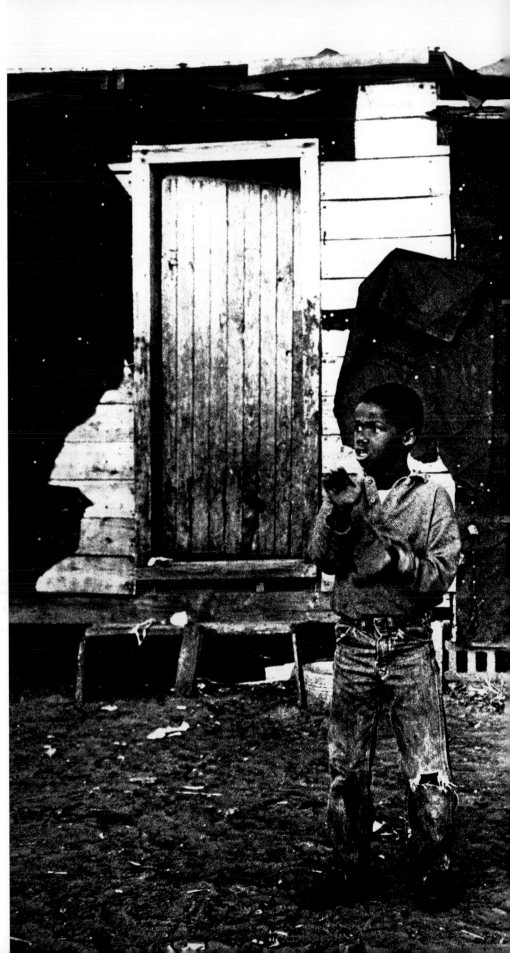

Washington, D.C.

'Imagine a race riot here in Washington with the Congress, the President and Vice-president of the United States captured by us Negroes and held as hostage until our demands were met: you sure as hell would see some senators calling for job opportunities then.'

We met at the poor man's Negro lunch counter and he showed me the unemployed like himself as they congregated in back rooms of cheap eating places or sat alone at home trying to sleep the time away. 'The government knows they're surrounded by us,' he went on, 'and that's why they're scared, scared we might take it into our heads to do something. The whites are fleeing this town, but the government can't run away, we've got them trapped. If something's not done soon, there's going to be a race riot all around the white man's White House.' He then pulled out a newspaper article stating that the Negroes now constituted sixty-three percent of this city's present population.

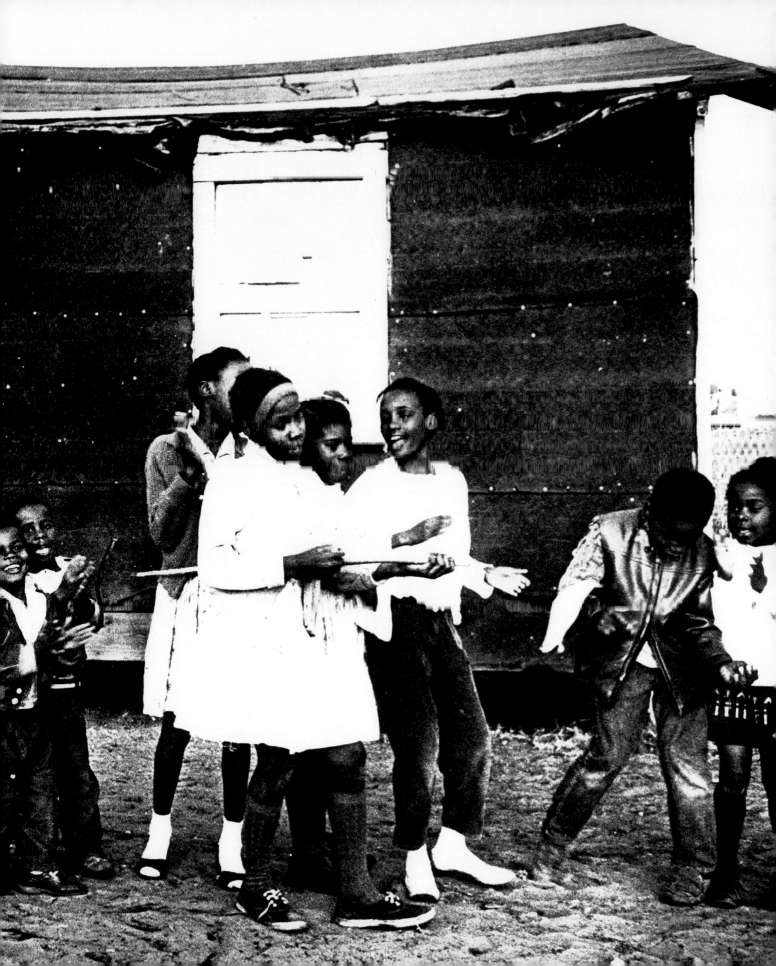

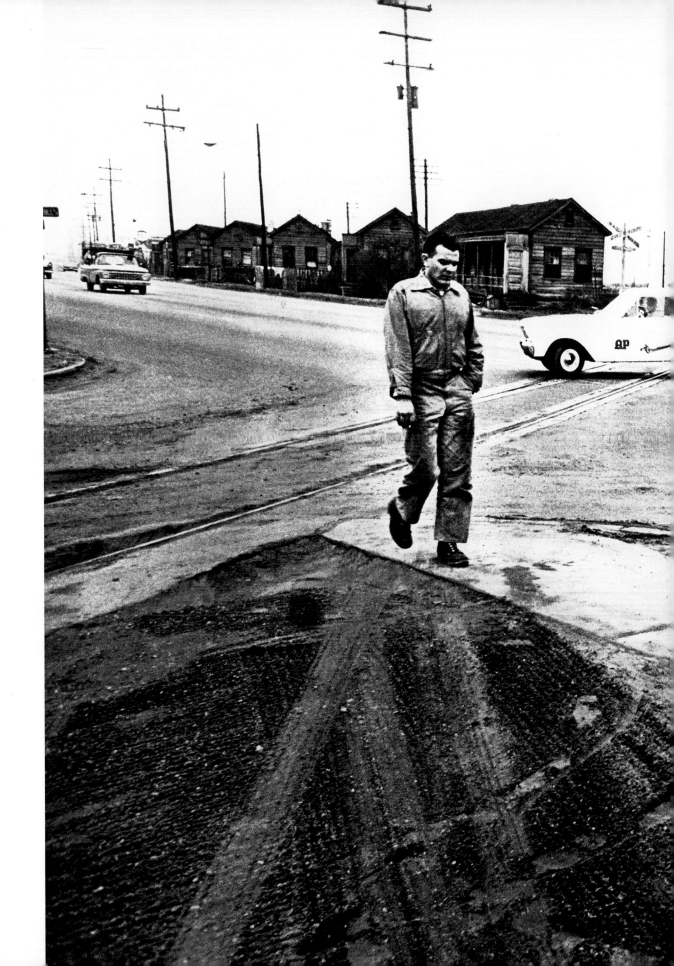

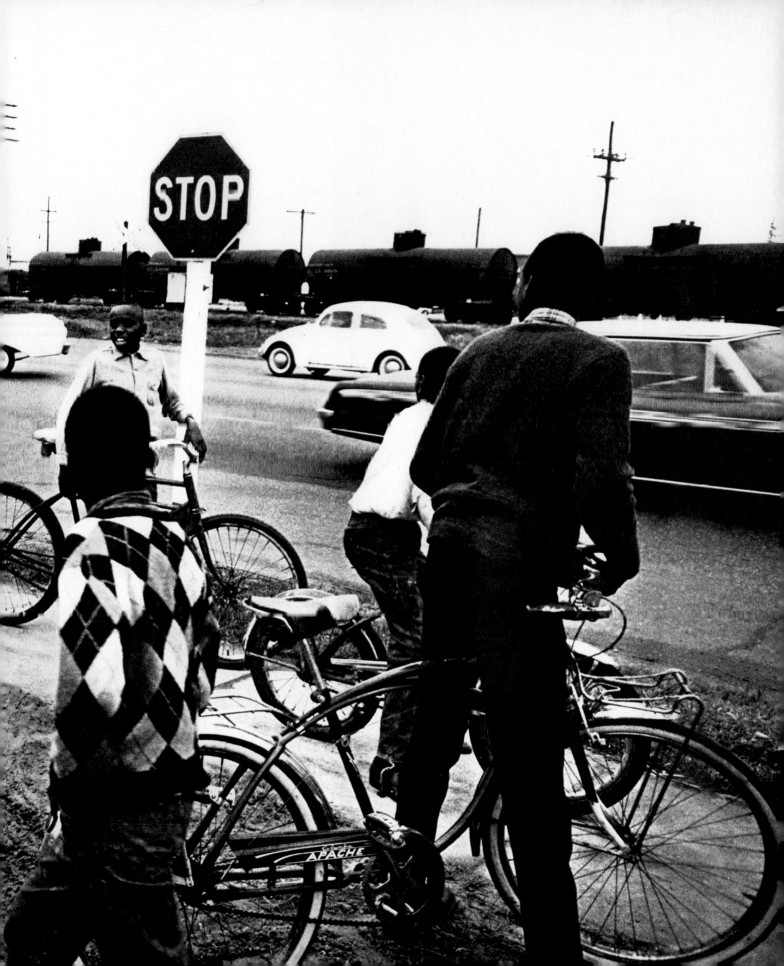

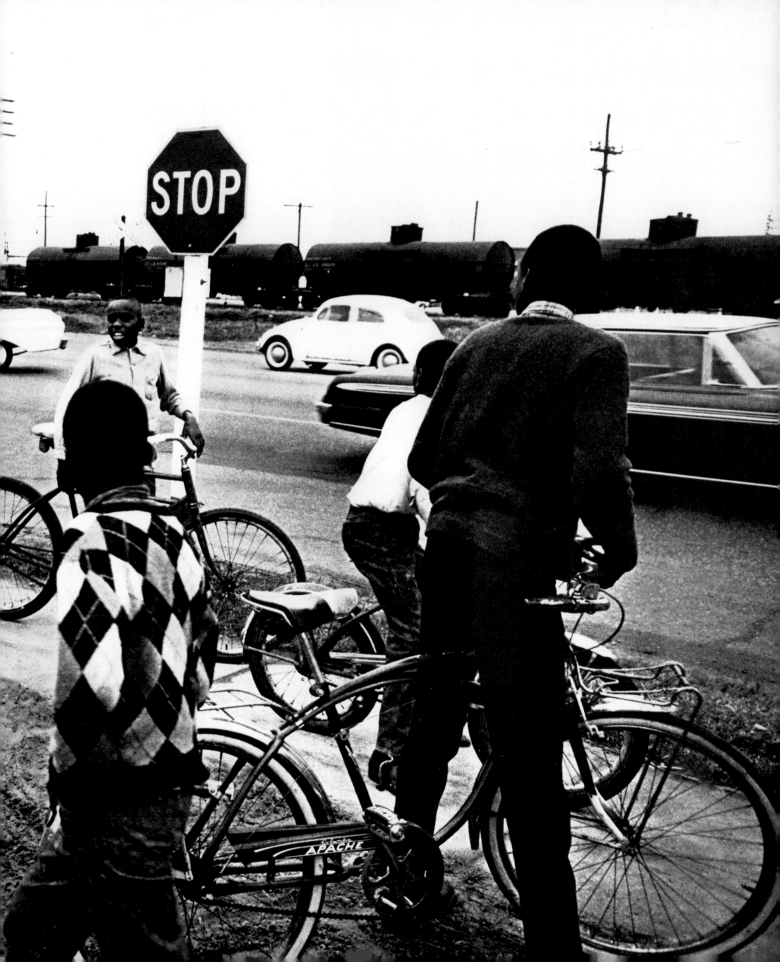

For Susannah and Brigitte.